Quite a
Sightly
Place

Quite a Sightly Place

—⚭—

A
Family Dairy Farm
in Vermont

—⚭—

Photographs & Text
by David Middleton

Commonwealth Editions
Beverly, Massachusetts

To Roger, Trish, Hugh, Joan, Ben, Ike, and Rob.
I'm afraid you're stuck with me now.

Library of Congress Cataloging-in-Publication Data
Middleton, David, 1955–
Quite a sightly place: a family dairy farm in Vermont / David Middleton.
 p. cm.
 ISBN 978-1-933212-91-3 (alk. paper)
1. Dairy farms—Vermont—Pictorial works. I. Title.

SF232.V5M53 2010
636.2´14209743—dc22 2010000063

Cover and interior design by John Barnett/4 Eyes Design
Printed in Korea

Commonwealth Editions is the trade imprint of Memoirs Unlimited, Inc., 266 Cabot Street,
Beverly, Massachusetts 01915. Visit us on the Web at www.commonwealtheditions.com.

Visit David Middleton on the Web at www.davidmiddletonphoto.com.

Contents

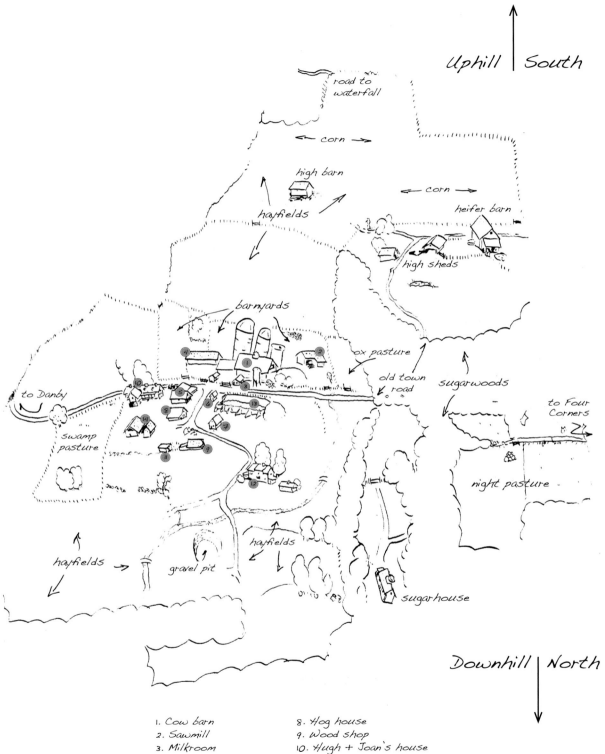

Uphill | South

road to
waterfall

← corn →

high barn

← corn →

heifer barn

hayfields

high sheds

barnyards

ox pasture

to Danby

old town
road

sugarwoods

to Four
Corners

swamp
pasture

night pasture

hayfields

hayfields

gravel pit

sugarhouse

Downhill | North

1. Cow barn
2. Sawmill
3. Milkroom
4. Back barn
5. Horse/Calf barn
6. Oil shed
7. Blacksmith shop

8. Hog house
9. Wood shop
10. Hugh + Joan's house
11. Chicken coop
12. Roger + Trish's house
13. Manure pit
14. Garages

Acknowledgments

This book would not have been possible without the generosity, patience, assistance, enthusiasm, good humor . . . did I mention patience? . . . of the Bromley family. Why they allowed me to intrude on their lives is beyond me, but I will be forever grateful.

Many people in Danby and the area helped me as well, especially Chuck and Pete Gaiotti, Stephen and Bridget Bromley, Janice Arnold and Bobbie McClellan of the Town Offices, Teressa Eaton, and Daisy Chapman. Elby and Sue Crosby introduced me to Roger, the farm, and a lifetime of pictures and stories.

Over the last five years I have told farm stories and showed farm pictures to many people, in particular Kermit Hummel, Karin Womer, Pat Shannon, and David Lyman. Their encouragement helped me realize that there are farmers and cows and hay in many of us.

Webster Bull of Commonwealth Editions believed when others didn't, and Ann Twombly and John Barnett made sense of my words and images. This book is the happy result. Thank you.

Claire, my better half, lovingly supports all my projects and endures all my time away. She should know better by now but, thank goodness, she sticks it out. She also tolerated, grudgingly, all the new smells I brought home and added to our lives. And finally, Abe, my black lab, best buddy, farm helper, and chief manure tester. He enthusiastically rolled in all those new smells and proudly spread them far and wide.

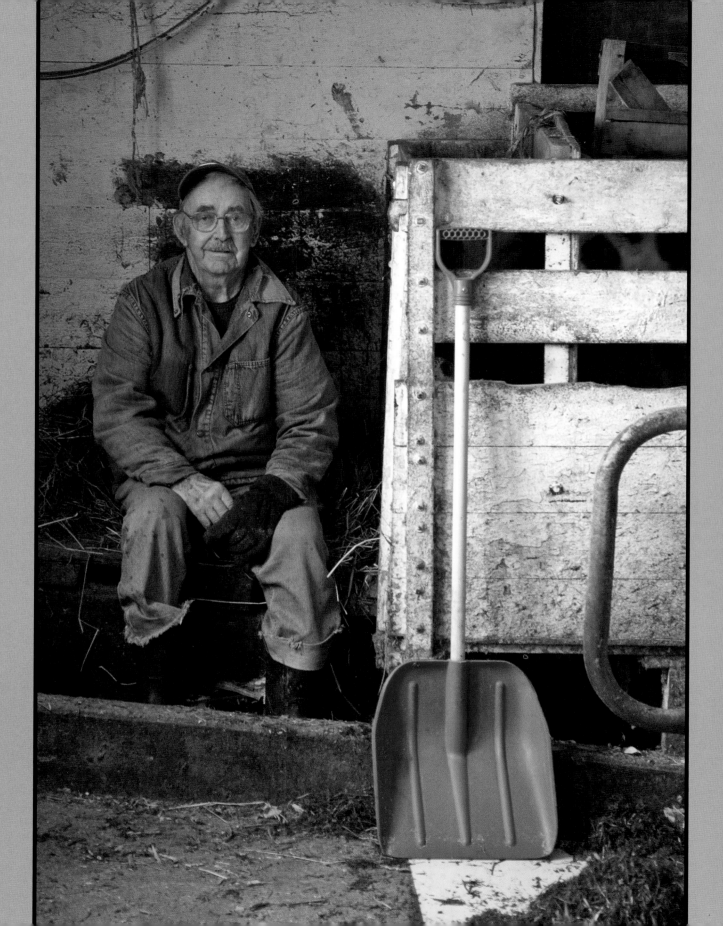

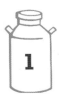

1

Good morning, Hugh

"Good morning, sir," I say as cheerfully as I can this early in the morning to the old man in front of me. We are standing in the cow barn, in the cross aisle that separates the old part of the barn from the really old part. Fifty Holsteins in two parallel rows stand to either side of us, eating their haylage as they wait to be milked. Their chomping sounds like a column of soldiers marching by in stocking feet.

"Huh? Whad you say? Morning? Morning you say?" the old man replies as he notices me at his side and turns to see who I am.

"Yes, morning, morning it is, looks like morning, yup, it's morning." I reply a tad louder and a tad too eager, a smile smothering my face.

"Is it?" he says, staring up at me.

"Well, yes it is, yes it was, at least I think it is, it was when I got here, morning that is. Yup, morning all right. Morning it is." I answer, babbling like a magpie at dawn. At least I am doing so loudly and with a smile, I think to myself, taking little solace in either.

The man looks at me closer now, leaning in a bit, staring up at me. I get a very clear sense that he is marveling at the first madman he has ever seen in his barn. A jet of urine rockets from a nearby cow and splashes across our feet.

"Huh!" he says, and with finality and with authority spits on the floor.

I'm at a loss now. "Huh" is pretty much a conversation stopper, especially when followed by a definitive spit. I fidget but say nothing. A pause starts to grow between us. My smile begins to slip off my lips. Silence. I fidget some more.

I can't really argue with the man; these are his barn and his cows, and I am standing in . . . God knows what I am standing in, actually. And it is very obvious that he has seen far more mornings than I have. But I do have a pretty clear idea of what morning is, or I thought I did before this moment.

It was my intention to make a good impression on my first official visit to the barn, or at least not to make a bad one. I knew very little about dairy farming and had never worked on a farm, so the chance of my doing or saying something stupid was pretty high; it was perhaps even inevitable. I just didn't want it to happen right away. It was now obvious to me and certainly this old gentleman and all the cows within hearing (which was all the cows) that at this I was failing and failing miserably.

I had gotten to the barn at what I thought was the right time in the morning and had met Roger as he walked up to the barn from his house.

"Good morning!" Roger says brightly upon seeing me sitting on the concrete steps of the milkroom

leading into the cow barn. "Are you going to take pictures this morning?"

"No, not this morning," I say. "I thought I would see if I could give you a hand, maybe help you out a little bit."

"Well, come on in. The old man is in here some-where, I imagine. I'm sure we can find something for you to do." Roger says this with a wink. It is his typical mixture of mischief and understatement that I find irresistible to this day.

I follow Roger through the milkroom and into the barn. It's dark inside; no lights are on. Only the soft

I try another approach, determined to stand there with Hugh until I begin to make some sense and say something intelligent, no matter how long it takes.

"So, these are the cows," I say loudly.

"Huh?"

"Some cows," I say, practically yelling.

"Huh?"

"COWS!" I am yelling now. This is in part because immediately above our heads the compressor that runs the vacuum pump that feeds the milkers is now running noisily and in part because I can't think of anything else to do. I am going to have to stand here

Looking up the long meadow from the sugarhouse bar way.

light of the growing dawn illuminates the cows. The "old man" is standing Yoda-like, leaning on an old broom, keeping watch in the gloom.

"This is Hugh," Roger says to me, keeping his introduction brief.

"This is David Middleton," he says to the old man. "He's a photographer. He's here to help us this morn-ing." With that, Roger heads for the cows, flipping on switches and grabbing an armful of milking equipment on his way. Roger is not much for small talk when there are cows to be milked. I am left with Hugh.

a bit longer, I think to myself, if I'm waiting to make some sense. Another pause germinates.

Hugh is Roger's father, ninety-two years old and still coming to the barn every day and doing what chores he can. He is a squat, solid man, mostly steady on his feet and mostly clear in his mind. A stroke some years ago, an artificial knee, bad feet, and nine decades of hard work have taken their toll, but his eyes are still bright and his grip is still strong, and I adore him.

Hugh at ninety years of age

Three-month-old calves in the cow barn.

I had been told about Hugh—warned, actually. To many people of Danby, Hugh is known as either that old bastard up on the hill or just that old bastard. But to me Hugh has always been friendly, even charming at times, and always patient. His patience started on this first morning.

"Who are you? What are you going to do?" Hugh asks me, mercifully breaking the silence.

"My name is David Middleton. I am here to help you, Hugh."

"Milton? Milton you say?"

"Middleton."

"Middondon?"

"Middleton."

"Milltown?"

"I'm here to help."

"Milltown," Hugh repeats and lobs another blob of spit toward the floor.

He says it again. "Milltown, I'll be goddamned, Milltown."

He is smiling now. It occurs to me that he might be having some fun with me. Or he might not have heard a thing I said. He shuffles off toward the milk-room door, muttering and laughing to himself as he goes, "I'll be goddamned, Milltown."

As I watch Hugh head out of the barn Roger comes round the corner, heading to the milkroom to grab another armful of milking stuff, his face covered in a huge smile. As I have struggled to make conversation, I have seen him beyond Hugh's shoulder peeping over the cows at us, shaking his head and quietly laughing.

He has been listening to the entire conversation as he has been doing his pre-milking chores and enjoying every bit of the theater. As he passes me, he puts an old long-handled metal scraper in my hand and says, "Here try this," and nods to the piles of manure behind each cow. "It all goes in the gutter. You'll figure it out."

He then puts a hand on my shoulder and says in a quiet, chuckling voice, "Welcome to the farm." ✑

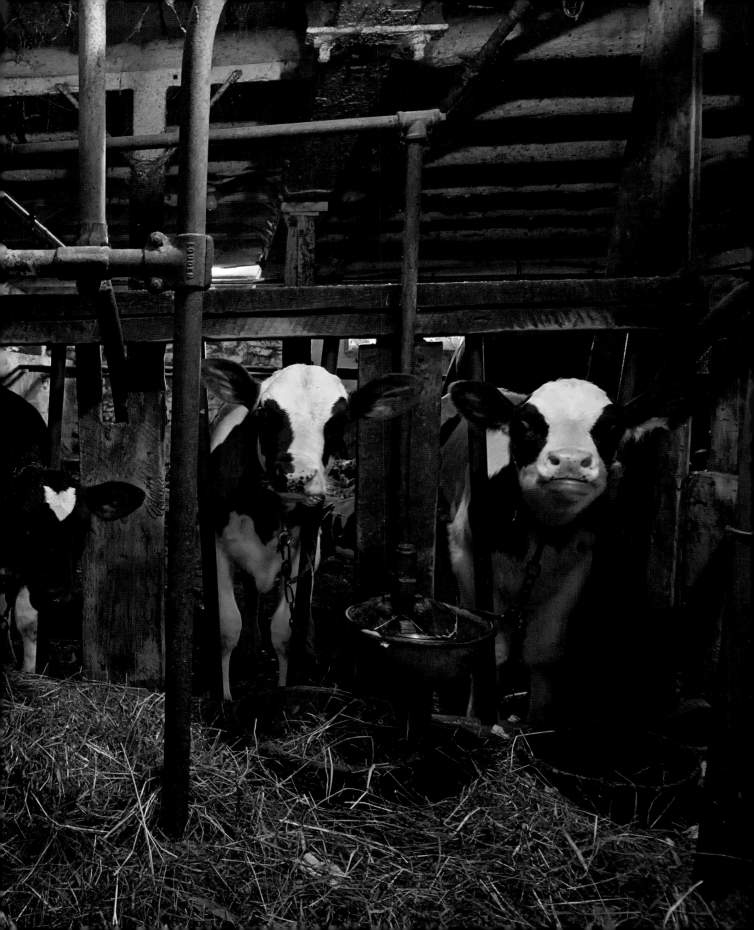

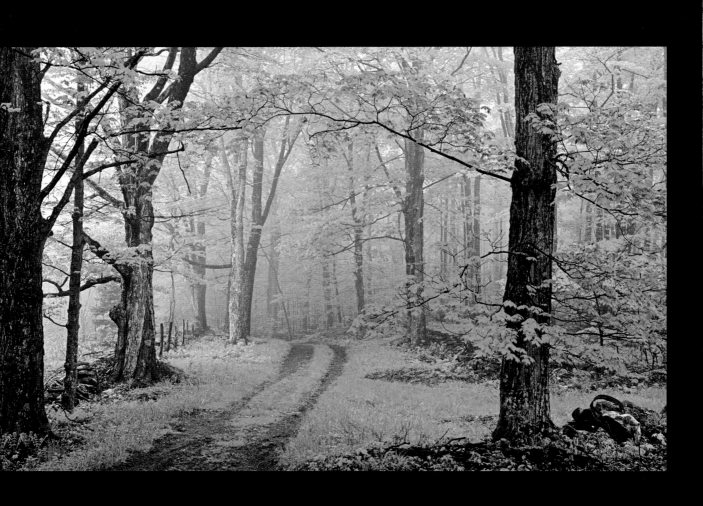

Cow paths

Fifty years ago in Danby, this small, overlooked town in southern Vermont, there were fifty family dairy farms. Today there are but four. Fifty years ago these family farms produced milk, cheese, cream, hay, and maple syrup and shipped them to Boston, Saratoga, Albany, New York City, Providence, and Hartford, to name but a few.

Fifty years ago dairy farms defined this place, this state where I now live. Dairy farms, along with general stores, churches, and granges, sustained and anchored Danby as they did all other rural communities fifty years ago.

Now, fifty years later, most of the granges are gone and general stores and churches are few. Fields that were planted fifty years ago lie fallow. Barns that were bright fifty years ago are dark and empty, and tractors and hay wagons once indispensable are left in the weather to rust and sink into the soft spring ground. As it is here on the family farm, it is everywhere.

The cows are the first to go. One morning some trucks arrive and that afternoon the dairy is dead. The farm may still survive, but without cows the heartbeat stops. Without cows a dairy farm is hollow and aching, and the farmer is idle and adrift. Nothing is sadder or more haunting to a dairy farmer than empty stalls in an empty barn at milking time. The farmer may still cut meadows for lack of anything better to do and may sell some hay for a neighbor's horse, but it is all small change once the cows have been gathered and hauled off to another farm or an auction house.

The days of cows don't completely end with the passing of the herd. There have not been cows on the former dairy farm where I now live for forty years, yet I still walk their paths when I traverse my steep woods. Decades of daily movements between barn and pasture have pushed their footsteps into the earth, even where what was then field has grown into what is now forest. Like wrinkles pushed into a brow, the old hillside cow tracks etch the passage of time, a step-by-step record of long-ago times.

In my wanderings I follow these old cow paths. They lead me to gaps in stone walls where gates used to stand and to corners where pastures once ended. I find grand old maples that once cast shade in an open pasture and stands of young ash and soft maple that grow now where cows no longer crop their stems. If I link the gaps and connect the corners and mentally clear the forest, I am led in my mind back to the days of a dairy farm I never knew. The barn must've been here, the young heifers over there, I reckon as I walk, reading the hidden farm landscape. Cow paths, stone walls, and trees are the lines on which the history of a New England farm is written.

The old town road at the head of the little meadow.

A cow path on what was once the old town road.

I now read the lines and find the stories on another old dairy farm a few miles from my home. It is the Bromley farm, and it is one of the four still remaining in Danby. Roger Bromley does most of the work, his wife, Trish, helps in the milk barn after she comes home from work, and his father, Hugh, now ninety-two, still drives tractors and pushes around scrapers. Hugh's wife, Joan, also ninety-two and growing infirm, mostly stays inside now, watching the barnyard through the picture window in her house. Roger and Trish have three sons, Ben, Ike, and Rob, all in their twenties, who come and go on the farm, depending how busy their own lives are. An odd collection of neighbors who help more or less also come and go. I am one of those odd neighbors. I will leave it up to you to decide if I am on the more or less side of helping.

The farm remains timeless, an old-fashioned farm on which things are done the old-fashioned way in a new-fashioned, twenty-first-century world. Where

once only one light could be seen across the valley at night from the milking barn, now the far hillsides twinkle at night with the always-on security lights of newly built second homes. And yet the Bromley farm survives and even thrives doing things the way they have always been done while the Bromleys rely on the wits and wiles of their own stubborn optimism.

I still wander cow paths and walk old stone walls, but now I follow the footsteps of living cows and trace the edges of working pastures. The paths I find lead me to actual gates that need to be opened or closed or repaired and to farmers very much alive. The lines I read there and the tales I hear there lead me to stories and to long-ago times that remain fresh on this farm. The pictures I take and the words I write are the stories of "once was" that are lived in "still is." These are the stories, the traditions, the ways of our grandparents. This is their landscape; a landscape diminished but not entirely lost. It is also our landscape, our history, and our community of neighbors, no matter how far away we now live.

Come walk with me and I'll show you around; there are stories that are still forming and pictures that are still developing. Pull on your Wellies and watch where you step—this is, after all, still a working farm. Take your time and have a good look around; there is much to see, to hear, to find here. The farm is still, as Joan described when first seeing it sixty years ago, "quite a sightly place." May it always be so. ✑

The big doors on the third floor of the barn.

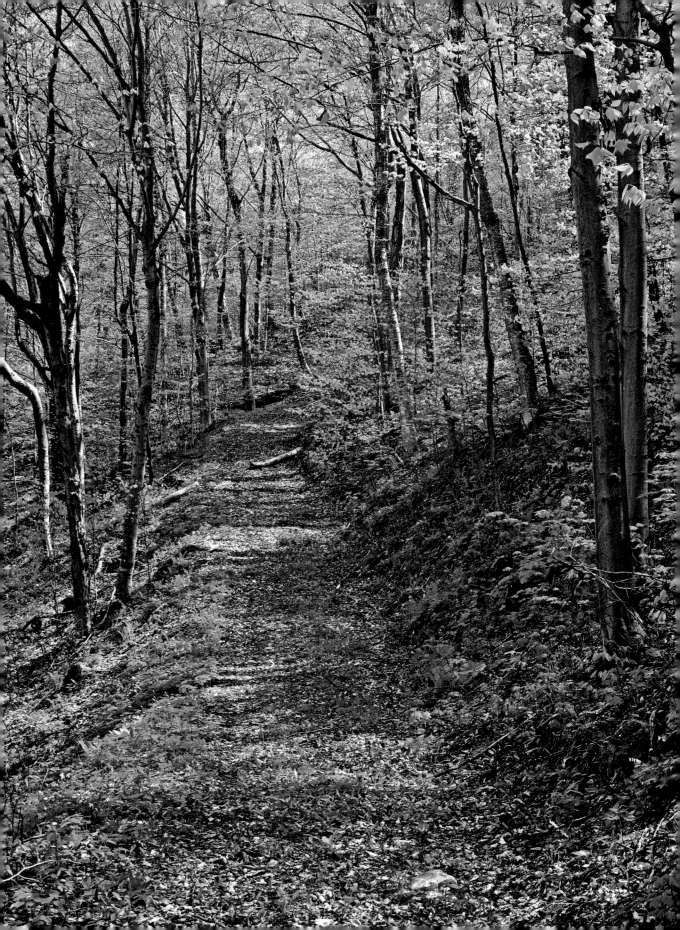

Just like Hawaii

A few years back in the middle of April I walked into Crosby's Lumber down in the village to get a pair of work gloves. I had plenty of work gloves, but it was a cheap excuse for me to get out of the house and practice being pleasant. All Vermonters need practice interacting with neighbors in early spring, after a winter of social hibernation.

It was, though, not a day for happiness. It was more a day for hunkering; a day of hunched shoulders, hidden faces, and warm thoughts of crackling wood fires. The day felt like it was still the middle of March; windy and cold—bracing, an optimist would say—the landscape soggy and drab, the color of old, wet wood. Miserable, a native would say.

"Good morning!" I call to the folks inside.

"Good morning to you," Elby replies. Elby Crosby, that is. "Come over here, young fella, I want you to see something."

"What have you got, Elby?" I say, veering toward the counter.

"I want to show you a waterfall that looks just like Hawaii." That's how Elby put it, although he denies it now.

"I could use some Hawaii. You gonna show me a picture."

"No, not a picture, it's right here."

"Right where?" I ask, picking up a molding sample and looking underneath.

"Right here in Danby!" Elby says, taking the molding from me.

"Hawaii, Elby?" I reply, glancing out the window at the leafless black trees covering the dull, brown hillsides. I must be missing something.

"A waterfall that looks like Hawaii?"

"Yup."

"Here?"

"Yup."

"Now?"

"That's right, looks like something you might see in Hawaii. I was up there last weekend . . . looked just like Hawaii."

I pause and give him a good, close look.

"Have you ever been to Hawaii, Elby?" I ask slowly, deliberately pronouncing each word. It's raining now, can't be more than 40 degrees outside. Hawaii?

"Hup, hep, yup, yup hup," Elby sputters, cocking his head as he tries to give me a stern look through a growing smile. "Are you coming or not?"

"Ah, well, um," I answer, trying to come up with a quick excuse.

Elby butts into my stalling: "I'll see you this afternoon after work. Supposed to clear up and be nice. Come by the house." He turns and shuffles back to his desk.

It was the "just like Hawaii" part of the description that hooked me. As a professional nature

Old woods road leading up Dorset Mountain to the waterfall.

photographer, I am always on the lookout for new subjects to photograph, especially those that are close to home and are as popular as waterfalls. But I have grown skeptical after years of chasing down promising leads to "spectacular" and "beautiful" places that turn out to be nice but really not picture-worthy.

I didn't expect this trip to be any different. But it was Elby, and he did say Hawaii. I knew that the chances of finding a piece of tropical paradise in the mountains of Vermont in mid-April were remote, but I was up for an adventure and I had nothing else going on. Besides, just going along for a ride with him would be worth a story or three, and I live for stories.

Elby is what most people would call a character. He has been in Danby all his life and has personal relations and long histories with every ledge, high meadow, stone wall, and old barn in the area. Elby and his wife, Sue, own and operate Crosby's, the hardware store and lumberyard in town. Elby got the store from his father, Goody—that's Elbert and Goodwin to more formal types. Goody died a few years back, but many of the older folks around remember him well and still think of Elby as running Goody's store.

Elby is a compact man with thick, old maple limbs for arms and legs and a thicker, gnarled old maple trunk for a torso. Up top, just below where his hair used to be, is a bark gray beard and two eyes that are more often crinkled in amusement than twisted in anger. He considers my profound lack of local knowledge his responsibility to remedy, and he often tells me stories over the paint cans and nail bins. My favorite times with him, though, are on the back of his four-wheeler, Elby driving and chattering away as I clutch the side rails, trying my best not to be left in a ditch.

Elby and Sue live on Easy Street, even though they both work all the time. I met him that afternoon in his driveway. It had turned into a nice day as Elby had predicted, the skies clearing and the sun warming the late afternoon.

"You ready to see Hawaii?" Elby asks as he gets up on his four-wheeler.

"You bet," I reply, sitting behind and awkwardly straddling Elby. It is not a comfortable position. With my legs spread like this and my impending sense of discomfort, I feel like I am in a motorized birthing chair. He starts the engine.

"All set?" he asks.

"WHAT?" I yell, trying to be heard over what sounds and feels like a two-cycle jackhammer beneath me.

"Here we go!"

"WHAT?"

If you stay on Easy Street, you'll soon be in South America (let that be a lesson to you), an old name that makes no sense for a part of Danby that most locals don't know about. Elby was giving me a running commentary that I couldn't quite hear, but I had stopped yelling "WHAT?" after the first mile. Past South America, the road dissolves into a trail and then finds another dirt road and begins to rise again, climbing the northern slopes of Dorset Mountain. Popping out of the trees, the road traces a level course across the early spring stubble of a farmer's field. This is the Bromley farm, a six-hundred-acre dairy farm that stretches between Mill Brook below to my right and the upper reaches of the mountain climbing above me on my left.

As we go through the first hay fields I notice that Elby is still talking. I think he is telling me about the history of the farm we're driving through—150 years (or it may be 150 cows), something about "all boys" and a lot of "they do it the old-fashioned way" (or he may be saying something about "their old station wagon"). We speed across sloping pastures and scruffy hay meadows, past a big white house, a big red barn, a small white house, another, smaller barn, and more than a few sheds. Everywhere I look I can see potential photos.

Elby keeps right on going, and soon we are back in the woods and once again turning uphill on an old dirt farm road that leads to higher pastures, more

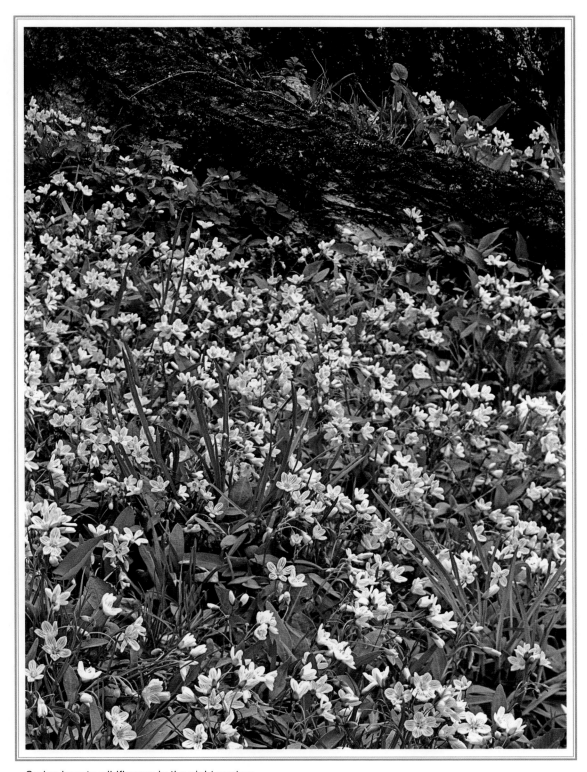

Spring beauty wildflowers in the night pasture.

barns, and more things I want to photograph. There are wooden gates and old stone walls, barnscapes and flower landscapes, apples trees and white-barked birch trees, grand old sugar maples and worn old tractors, barn windows and old plank walls. It is heaven to me.

Even though we are only a few miles from the center of Danby, it seems as though Elby and I have traveled back in time. This is how farms used to look fifty or a hundred years ago, I think to myself. Everything is perfect to me: perfectly authentic, perfectly weathered, perfectly placed, a perfectly beautiful working farm. If Hollywood ever wants to re-create an old New England farm for a movie, this is what they should build. I've been here only a few minutes but I have fallen head over heels for this old farm.

Elby slows as we get to the last barn on the last sort of level spot I can see. "You might want to hold on here, it could be a little rough in spots ahead," he says as he gives me a moment to reset my position. As he guns the engine, we turn uphill onto a rough cow track full of ruts and rocks. Ahead of us are the highest meadows and the forests that surround the top of the mountain.

In the farthest southern corner of the highest pasture, an old logging road curls eastward around the mountain. A half mile along this road, if the water is right and your imagination is bright, you'll find a waterfall that looks like it could be in Hawaii, or at least a long, tumbling cascade with some ferns around it. We stop and walk up to the base of the cascade. It is a lovely scene. Elby was right: the numerous braids of water splashing down over mossy green rocks, the long arching fronds of evergreen ferns, the delicate patches of spring flowers.

"There was more water last week," Elby says disappointedly.

"It really is quite pretty, Elby, certainly worth a picture," I say, practicing being nice but actually meaning it.

"I can sort of see Hawaii," I remark, trying to slow the fading of Elby's enthusiasm.

"It needs more water. Last week it was Hawaii, this week it is Vermont."

"It's still pretty. Maybe a hula dancer or a palm tree would help."

"That I'd like to see!" Elby says with an easy laugh.

We return down through the woods to the close pasture; I'm on foot looking for spring wildflowers, and Elby is stopping to repair a gate that won't close. We meet under a broken old sugar maple at the edge of the wood to rest and admire the view. To the west are the rumpled Taconic Mountains, to the north and east the sturdy granite spine of the Green Mountains. Closer, we gaze over barns and nearby farms and over the little village of Danby in the upper reaches of the Valley of Vermont. Below us the day is fading to twilight as lights begin to twinkle in the village. A robin's song stirs the air as the day slowly turns toward evening.

"This is the prettiest place in Vermont," Elby says, breaking the admiring silence.

"Can't argue with that, Elby," I reply.

"Can't say I've ever seen any place any prettier," Elby adds. "I come up here often just to have a beer and sit and enjoy the view. Glad I could show it to you."

"I'm glad, too, Elby. I don't expect it will be the last time I come up here," I say.

"I don't expect it will be. It kind of grows on you, gets under your skin."

"Yes, it does."

We fall back into silence as the day tips into night.

"Say, would you mind introducing me to the farmers?" I ask. "I'd like to meet them so I could ask for permission to photograph here."

"Oh, boy," Elby says through a chuckle, "it'll be my pleasure," and he laughs again. "They're quite some family. You'll like them."

On the way back down through the pasture on the four-wheeler, past the high barn and then back through the woods to the big barn below, Elby tells me about the Bromley family, who is married to whom, how old the children are, what everyone is like—a complete family history, I think.

He is still talking when we pull up to the door of the milking barn. Turning the four-wheeler off, Elby turns toward me and says: "This is the cow barn. Roger will be in here milking and doing the evening chores. Come on inside, I'll introduce you."

Stretching, he heads to the door. As he gets there, he turns to me and says, "Pretty amazing about being all boys, don't you think?"

"I'll say, Elby, pretty amazing . . . all boys."

I didn't know what else to say. I hadn't understood a word of it. 🙶

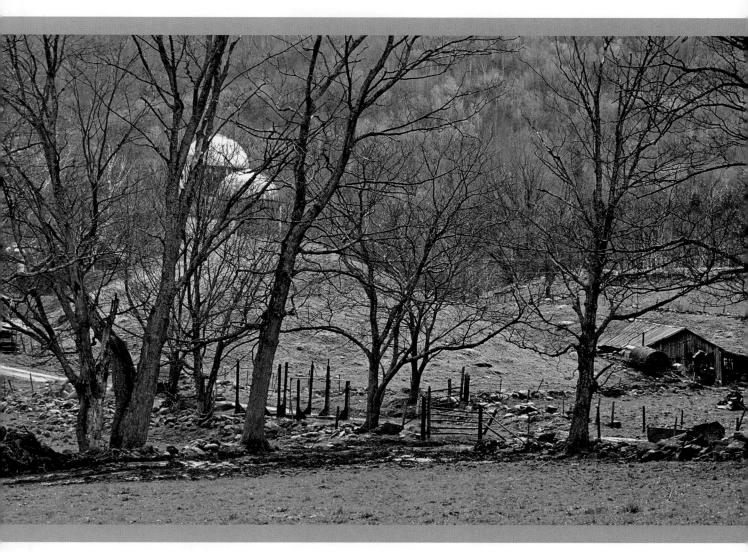

Looking east in early April at the sawmill (on the right) and the cow barn.

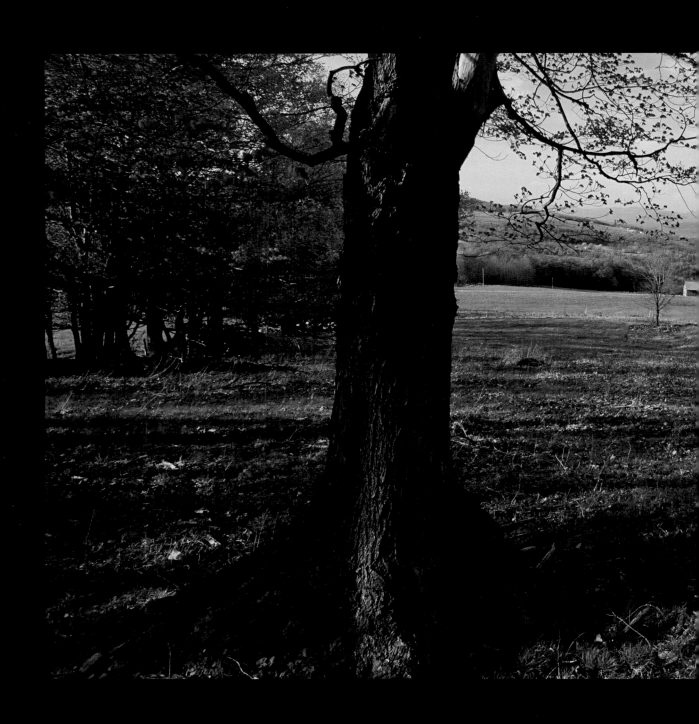

View from the upper meadows looking north over the high bar

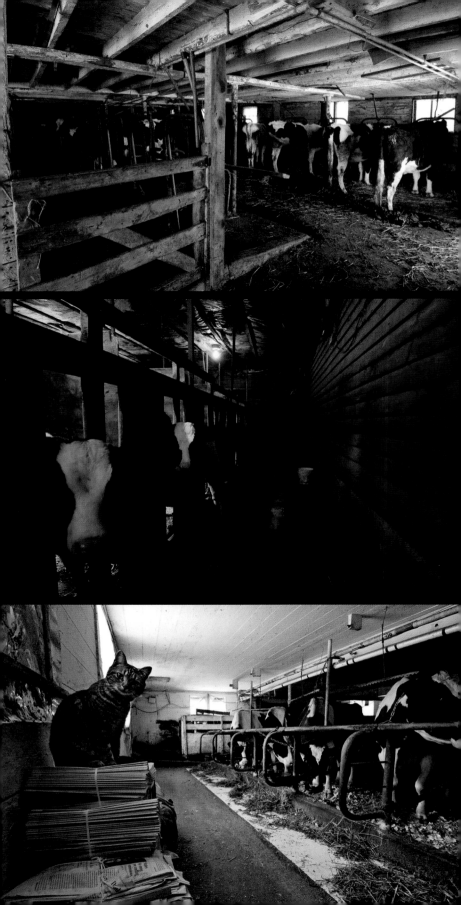

4

The barn

Like most old New England barns, the cow barn on the Bromley farm was built with economy of effort in mind. Accordingly, hay is stored on the floors above and animals are kept on the floor below because it is easier to toss bales down from the second or third floor than it is to heave them up from the first floor. Barns have been built this way for as long as hay has been fed and people have tossed it.

Unlike most New England barns, or barns anywhere, each one of the three floors of the Bromley barn is a ground-level floor with a ground-level entrance. This is because the barn is built into a three-story-tall hill. This makes it possible to drive a tractor into the basement as well as into the eaves without alcohol being involved.

The barn is oriented with its long axis going east–west, and each of its ends appears quite different from the others. The eastern end is three stories tall and has the big door on the bottom through which the cows go and come. The western end is also three stories tall, but all that can be seen is the top story. This is because this end of the barn is built into a bouldery knoll that wraps halfway around the north-facing front side of the barn.

From the front, public side, the barn appears to have a basement level full of cows and two floors above, the middle level accessed by two large wooden sliding doors. From the back, south, uphill, three-silo, pasture, yearling, darn-cold-and-windy-in-winter side, the barn appears enormous, a huge, red, wooden block.

The original, largest part of the barn was built in 1883 by Erasmus Kelly, who cut the trees, sawed them into timbers, pulled them from his mill with oxen the mile or so up the hill to the farm, and then built them into this barn. A few years later a smaller, one-story barn, the back barn, was built, long and narrow, on the southeast corner of the main barn.

For reasons that no one can remember, the back barn's foundation was built a few feet higher than and at a bit of an angle to the main barn. When in 1964 the cow barn was enlarged to accommodate a growing herd, the corner of the new barn addition bumped into the back barn, creasing its roof. This happened despite the slight bend that was put in the new foundation to avoid just such a collision. Imagine parking a fifteen-foot car in a fourteen-foot space and you will understand the positions of the buildings.

When the barn was built, the area had already been farmed for more than a hundred years. John Johnson, in 1774, was the first person to clear and farm the land that was in part to become the

Top: Heifers in the heifer barn.
Middle: Hugh feeding milk to the calves in the calf barn.
Bottom: Piper, barn boss, in the cow barn.

Bromley farm. He passed it on to his son William, who eventually sold it to Hiram Kelly, who owned the sawmill down on Mill Brook. Hiram, the father of Erasmus, expanded the farm by buying eight other original lots. In 1856 Martin Bromley and his older brother Frank bought the farm from Hiram. It has been in the Bromley family ever since.

According to the "Danby Centennial Report," written in 1876, Martin and Frank "have by perseverance and industry acquired a good property and are thrifty farmers." According to a certain older current Bromley, Frank was a "no-good, miserable son of a bitch." This difference of opinion might result from the fact that Frank was a bit of a drinker. Or that he abandoned his wife and family without notice and went to Pennsylvania for seven years. Or that he was a "good-for-nothin' bastard." Hard to tell.

When Frank finally returned, Martin was displeased and didn't allow his brother in his house, feeding him on the porch like a stray cat. I am thinking that things would've gone better for Frank if he had said something about his trip south.

Martin Bromley was one of fifteen children, his father was one of nine children, and his grandfather was one of eleven children. Back in the eighteenth and nineteenth centuries is was hard to swing a stick around Danby and not conk in the head someone named Bromley. Today this is harder to do but no less worthwhile an endeavor, according to some in the village. Memories, grudges, and maple trees live for a long time around here.

Despite his large family, Martin himself had only three children, all of them boys. His middle son, Delos, took over the farm when Martin became too old to do the work. Delos had only three children, all of them boys. His middle son, Hugh, took over the farm when Delos became too old to do the work. Hugh had only three children, all of them boys. His middle son, Roger, took over the farm when Hugh became too old to do the work. If you are thinking about starting a family, with, say, three children, and you want boys, arrangements can be made.

By the way, Roger has only three children, all

of them boys. His middle son, Ike, is living in Utah because his father, Roger, is not too old to do all the work. But Ike does love the farm, as do his brothers, Ben and Rob.

The first things that most people notice when they walk into the barn where the cows are milked are its low ceiling and high smell. The ceiling actually gets lower as you walk to the right, the west side of the barn, but nowhere is it so high that you can stop thinking about knocking your noggin on something unless you are a practiced stooper or shorter than most. I am neither and so my noggin is now notched from repeated knockings.

The smell is described either as strong and unpleasant by those unfamiliar with cows and old barns or as aromatic by those like Elby who have pictures of cows on their walls. I think most of the smell comes not from what cows do but from the sweet perfume of fermenting hay and corn.

"Are you sure it is okay, Elby?" I ask as we head into the barn, unsure of what I am walking into. I had never been in a dairy barn and had never seen a cow milked other than from behind a rope at the county fair. I was familiar with the concept of milk, hamburger, and leather, but that hardly made me an expert on cows. Besides, ground beef and belts are not something I feel comfortable bringing up in this company.

"Oh, sure, I come in here all the time. You'll love it," Elby says, ducking through the doorway out of the milkroom and into the barn.

I follow him in. It's a dim, close space, almost intimate, like an old-time men's club in the movies . . . if you added cows and hay and all things dairy. And it is of another time, strongly so, in a compelling, endearing way. It's like an old pair of boots you never knew you had that fit and feel right the first time you put them on.

"I know he is in here somewhere," Elby tells me, looking down the two sides of the center aisle at a parallel line of bony, black-and-white cow butts. They all look pretty much the same to me.

"Is that you Elby?" we hear one of the boney butts say. Turns out the smaller, skinnier butt up on the right wearing the worn brown corduroys is who we are looking for. It is an honest mistake.

"I have someone I'd like you to meet," Elby says as we walk toward the voice. When we arrive, Roger is standing up between two bulging cows.

"I'd like you to meet David Middleton. He lives at the old Billson place. I just took him up to see your waterfall."

"Hello, Roger. You have a beautiful farm," I say, shaking his hand.

"Hello to you. Pleased to meet you and thank you," Roger says as he moves past us and squeezes between two other cows across the aisle.

"David is a photographer," Elby adds helpfully.

"Is that right? See anything you'd like to take pictures of?" Roger disappears between the cows to check on the milking gear.

"Oh, a few things," I reply to the back end of the cows in front of me. I assume Roger is in there somewhere.

"Well, help yourself. Go wherever you want," Roger offers as his head bobs to the surface, only to disappear again as he turns to ready the neighboring cow. I assume whatever he is doing down there is important, necessary, and legal, although I wouldn't really know, this being my first time in a dairy barn. He does seem busy, though.

"I might ask some questions and probably get in the way. Are you sure?" I ask, giving him another chance to think about what he has just agreed to.

"Sure, enjoy yourself." He rises now and crosses back to the cows on the other side. "What's the worst that could happen?"

I try to come up with something to say but my mind is suddenly abuzz with vivid possibilities— cows stampeding down the road, gallons of milk spilled in the ditches, collapsed buildings, impalement, dismemberment, and, even worse, personal embarrassment. I shake my head trying to clear it of those alarming calamities.

Roger interrupts my thoughts. "You'll be fine. Take all the pictures you want," he says as he taps a cow on the butt to get her to move over.

I am taken aback by Roger. This is a man who has known me for less than a minute, and he is giving me the freedom to wander all over his farm, his life, his livelihood, inside and out. He doesn't know me, doesn't really know what I am thinking about doing, and yet he is unfazed. I am dumbfounded. It is the first of many times I am amazed by and grateful for his generosity and trust.

"I won't mean to get in the way, but you will see me around," I respond, softly volleying over the backs of the cows one more chance for him to say no.

"No problem. The place is yours," he says, submerging once again. I am vaguely aware that he might be saying all this just to get me out of the barn. I am aware that my life has oddly changed and is suddenly brimming with possibilities. I can't really believe that this man is allowing me to freely photograph his gorgeous farm, a place that already seems almost magical to me. I feel like a kid walking down the stairs on Christmas morning, eyeing an endless pile of presents.

I consider asking Roger again, but Elby is tugging at my elbow and Roger has moved on to milk another cow. Seems like I am close to becoming a pest, and it is obvious Roger has no time for pests. He has twenty more cows to milk all by himself. Maybe I could do something to help, I think, but now Roger has again disappeared and Elby is halfway out the door. I am way out of my element here. I decide to retreat.

"Thank you," I call out, heading toward the door.

"Thank you," I hear Roger call through the legs of several cows.

What a delightful place, what a beautiful farm! I can't wait for the morning to come. There are barns to explore, fields to wander, new things to photograph, new stuff to learn. So much that I know nothing about and so much I want to know. If this isn't heaven, I don't care what is. ✑

Third floor of the cow barn with haymows and empty hay wagon.

Quite a Sightly Place

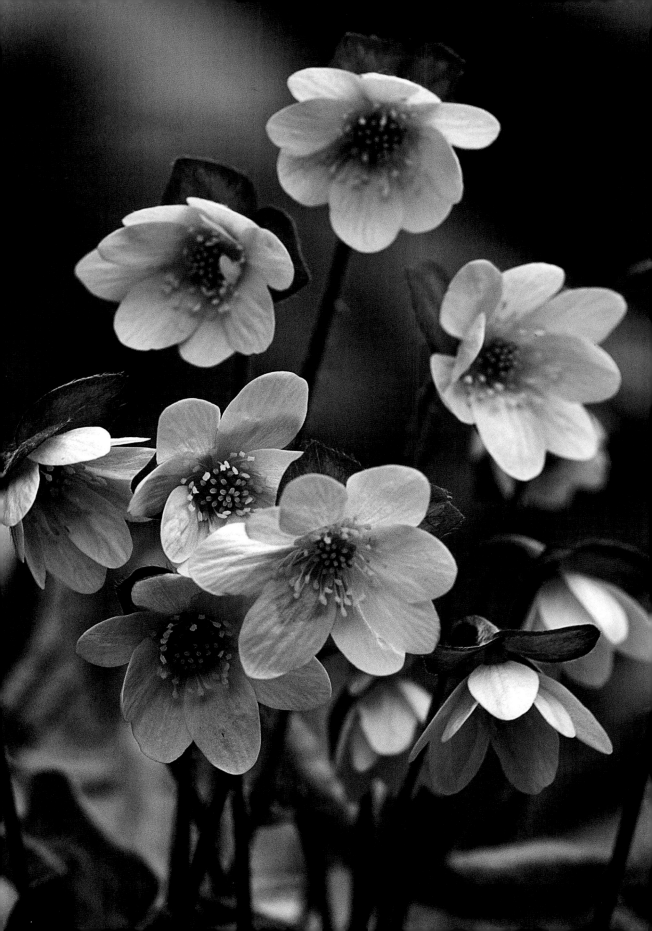

Anybody see some cows?

"Fifty cows," I mutter to myself as I stumble through the pasture. "How hard is it to find fifty cows? This is a dairy farm, for Pete's sake, not a parking lot. There are supposed to be cows wherever you look on a dairy farm—but not this morning, not here. How can I not be able to find fifty cows?"

When the morning and evening milking is finished in the warm months, the barnyard gates are opened and the cows shuffle themselves out of the barn, down the road, and into a pasture to graze and chew the day or night away. This is pretty much an unsupervised group effort on their part; the older cows lead the way out of habit, and the younger cows follow because they mostly haven't a clue what else to do.

Usually, the only human intervention in this process is the opening of one gate or another to let them into the chosen pasture and then the blocking of the road so an alternative route is not taken. The cows are not consulted on their choice of destination but go along with it because, well, they really haven't a clue what else to do. A person behind the cows, urging them along with sweet words of encouragement, helps move the bovine parade along at a good, steady saunter.

At dawn and then again at dusk, when the cows come back into the barn, they are typically massed at a gate waiting to be let through. This is the only time cows will show enthusiasm, their eagerness due to their full udders and the smell of fresh silage waiting for them in the barn. But every so often the day is not typical and the cows are not at a gate awaiting to be afed and amilked. Then a roundup, by foot or by voice, is necessary to get the herd heading back toward the barn. This is usually my job because I really haven't a clue what else to do.

This is not a hard job, finding a herd of cows in a fenced pasture. In fact, of all the jobs on the farm, this may be one of the easiest. This explains why Roger gave me the job thirty minutes ago. "Just go out and open the gate to the night pasture and then walk behind the cows to the barn. They know the drill, won't be any problem," is how he put it. "They'll be happy to come in and have a bite to eat."

I know this is the night pasture; I made sure of that. I walked down the old town road past the young heifers, past the gates to the ox pasture and the long meadow, and this was the next pasture. But there are no cows to be seen, massed or not. I open the gate, walk through, and follow the fence line down to the old sugarhouse. Then I cut through the stone wall by the spring, walk over the knoll, and turn back at the edge of the woods toward the sugarhouse. No luck. Thirty minutes now and I haven't seen one blasted cow. Other than Hugh on his four-wheeler up by the gate I haven't seen much of anything.

Hepatica wildflowers.

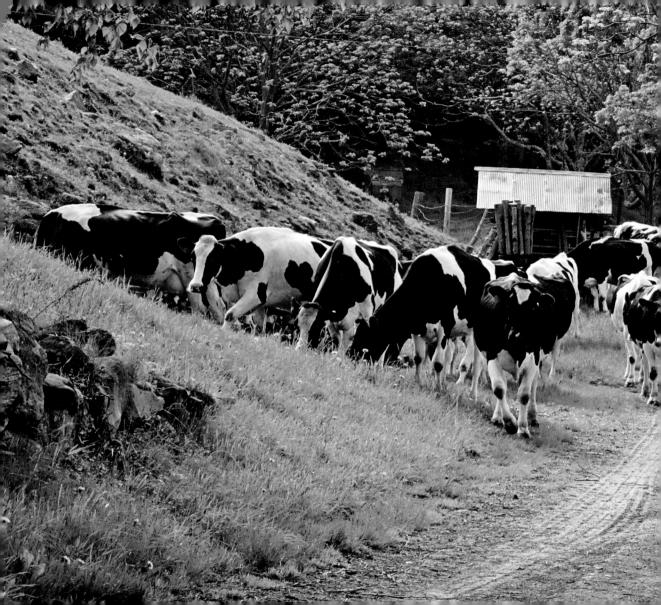

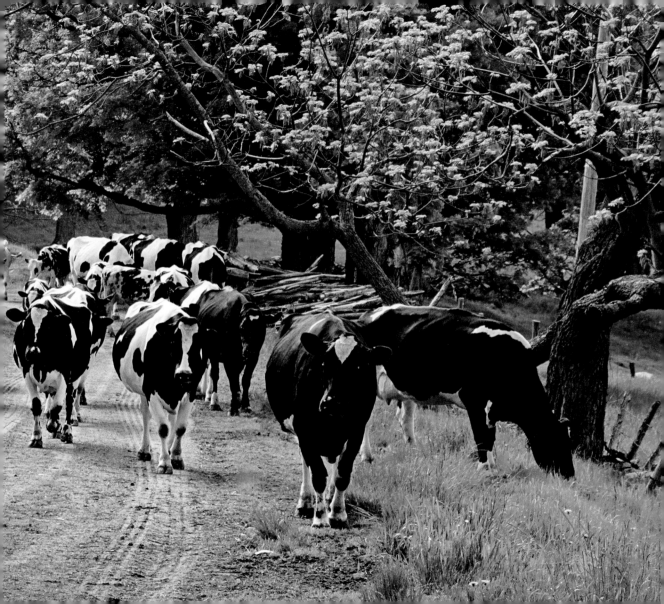

That is not completely true. I have seen beautiful, pink-tinged drifts of spring wildflowers in the old sugar woods and the tiny, delicate flower clusters of sugar maples dancing on the branch tips in the light dawn air. The views from the knoll north and east over Danby and the valley below are gorgeous in an early spring kind of way, subtle and soft, a palette of pastel greens and pale reds. It is a lovely walk, cowless but lovely.

April is one of my favorite times of the year in Danby, and it has become one of my favorite months on the farm. Every day in April something new is happening; a job is added to the day, something different is blooming, or a bird has returned to the farm to nest once again. Phoebes return early in the month, followed by bluebirds and swallows, hawks and sparrows. I find new wildflowers in bloom every time I go out in April, and it seems each morning is warmer, longer, and greener than the morning before. After four months of winter April is a much-needed tonic.

I turn back toward the fence line, rehearsing what I am going to say to Roger. I could be defiant: "Nope, you were wrong, there were no cows there. You must've put them somewhere else. In my experience, they're pretty easy to misplace." Or I could be distracted: "What a nice walk, lots of wildflowers and the sugar maples were flowering, too. It was both subtle and soft." Or I could be spacey—"Oh, right, fifty cows. I'll get right on that"—and hope for better luck the second time out to this pasture.

None of these excuses seems very good, and none of them makes me feel any better about not finding a herd of cows. All I really want to do is show Roger and Hugh that I have some usable experience, buried somewhere under all my heaps of inexperience. There are some things I can do, many actually; I just can't find a way to make any of them handy on the farm. There is little need to identify birds, explain the fine points of photography, take a picture, or juggle, as far as I can tell. But I was confident that I had some skills that were relevant and would be welcome on the farm. I just didn't know when I was going to find them.

Now, finally, this morning, there was something I knew I could do—walk out to a pasture, find cows, walk back. At last, something I could do on the farm that didn't require any help, explanation, or supervision. All I had to do was walk and look. I can do that. After fifty years, despite an undistinguished beginning, I had mastered those skills.

With the bar set so low and my expectations so high, and not unreasonably so I might add, it is a particularly unsettling blow to my ego not to find any cows. If only Roger had said that it was going to be difficult, "A real struggle to find a herd cows, not sure you're quite ready for the ordeal," or "It takes years of experience to see a cow out in a pasture—you're going to have trouble," I could live with my lack of success. But instead he said, "No problem," and implied that anyone could go out into a pasture and find fifty cows. He actually hadn't implied that, but right now it sure feels like he had. I guess I am not just anyone; I am the one who can't find fifty cows! This is a hard lump to swallow before the sun comes up.

I get to the fence line and I hear Hugh's four-wheeler faintly puttering along off to my right. He has gone farther down the road, right past the gate I had walked through. That's curious, I think to myself. I wonder why he did that? What's he doing? And then through the trees I hear the oddest sound, part song, part yell, and all Hugh. "Cummmmm-byyyyyyyy, Cummmmm-byyyyyyyy, Cummmmm-byyyyyyyy." The call rises in the middle, drops and then rises again before trailing off. "Cummmmm-byyyyyyyy, Cummmmm-byyyyyyyy, Cummmmm-byyyyyyyy."

Huh, that's strange, I think. I wonder why he is making that sound. It doesn't take long to figure it out when I see a parade of fifty cows trooping down the road toward me and Hugh riding slowly behind. The cows weren't over here, they were over there where Hugh is, and rather than walking all over the pasture looking for them like a blind fool he had simply gone down the road a bit farther and called them to come back to the barn. This seems like something I should remember.

I meet Hugh at the gate after all the cows have shuffled past.

"Good morning, you have a nice walk?" Hugh says to me pleasantly.

"It was a very nice walk and good morning to you," I say cheerfully, trying not to let escape the real purpose of my walk.

"Did you see anything?" he asks, his mouth slowly unfurling into a smile.

"Not as much as I would've liked." I say, cha-grinned, realizing that he had been watching me from the road the whole time.

"I see that," he says, his smile gaining on his face. I wait for more but he is too much of a gentleman to go say anything else, at least at this time of the day. A feeling of a profound lack of competence washes over me.

"Well, hop on and I'll give you a ride back to the barn."

Defeated, I slide onto the back of his four-wheeler, Hugh riding sidesaddle, as he always does, on the left side, and I nestled on the right side. We putter after the cows at a walking pace, slowly following the cows down the dirt road to the barn.

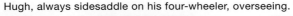

Hugh, always sidesaddle on his four-wheeler, overseeing.

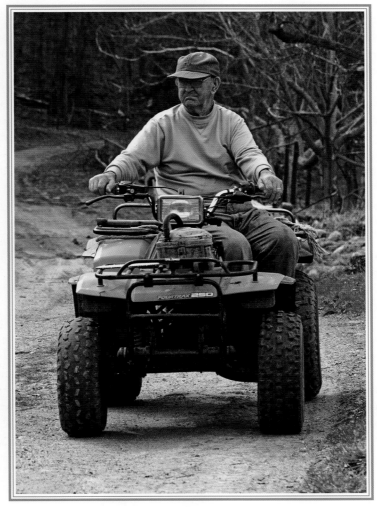

"What was that you were calling, Hugh? It sounded like 'come by.' "

"Cummm-byyy," he calls quietly. "Something you learn as a kid. Prit' near every farmer does it."

"Seemed to work," I say, not letting a chance to state the obvious pass me by.

"Well, I have a few years on you still. Next time you go out for a walk in the morning you should try it, might have more luck finding things. But bring a pail of grain with you just in case."

"A pail of grain?" I ask, confused, thinking he wants me to carry provisions with me in case I get lost. "And just in case of what?"

"In case they hear the grain and not you. They'll do anything for some grain," he says, spitting on the ground. "It makes the lookin' louder."

"So how'd it go?" Roger asks when we get back to the barn. "I see you found the old man out there."

"He found me. He also found the cows," I admit unhappily.

"Well sometimes they are not where you expect them to be. You go out tomorrow and they won't be where they were today." This is typical Roger, always kind and understanding. He seems to appreciate any effort of mine, even if it is entirely wasted and unproductive.

"Besides, it gave the old man something to do," Roger adds, still being supportive.

"Glad I could be of help, Roger. Anything else you want me not to get done today?"

"No, you've not done enough already," Roger laughs. "Come on," he says, turning toward the barn, "we've got cows to milk. They'll be easier to find in here." 🐄

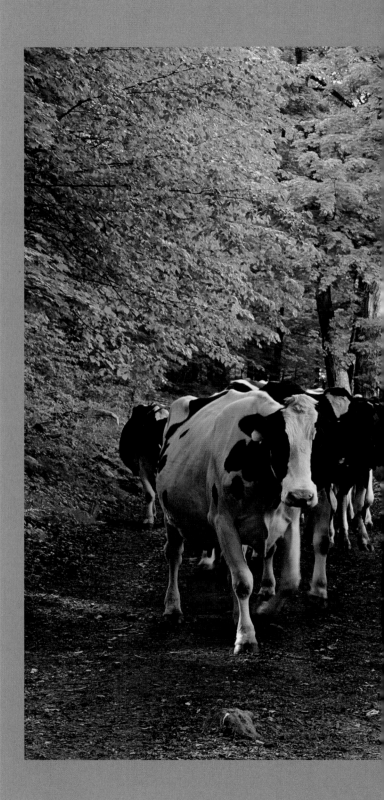

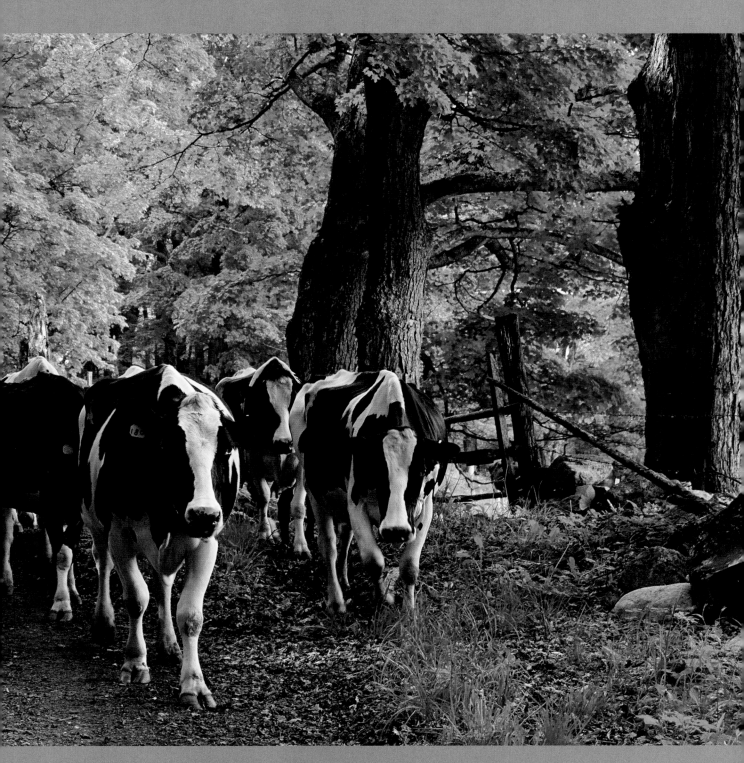

Best get out of their way, their udders are full!

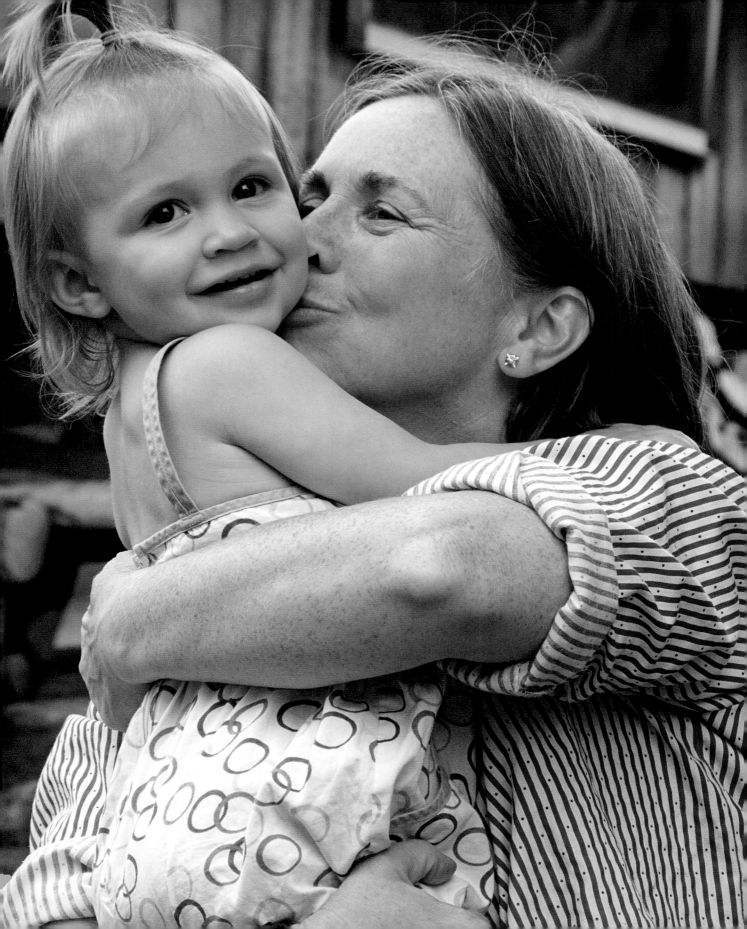

6

Treasures

I see Hugh through the open barn window, shuffling over from his house, cane in one hand and something I don't recognize in his other. I go to the milkroom door and meet him as he comes in and leans against the milk tank.

"Whatcha got there, Hugh?"

"Here, I thought you might want to take a look at this," he says as he slides a thick, ancient-looking book journal over to me across the tank's lid. The cover is dark leather, crinkled and worn on the edges, and the pages and binding are yellowed.

"What is it, Hugh?" I ask as I take off my work gloves and carefully open it.

"It is my grandfather's ledger, his farm account book. Thought it might be handy to you. It goes back over a hundred years."

My God, I think to myself as I look over the pages, there is treasure everywhere in this place.

The first entry in the ledger is in early 1877, a bit over twenty years after Martin and his brother Frank purchased the farm. The handwriting is thin, precise, and tight, almost stern looking. The words crowd the lines with letters stacked up on each other as if they were waves piling up against the margins.

Most of the entries are accountings of what was charged by the farm's hired workers at a general store in town or at "The Corners." Danby Four

Corners, as it is properly known, is the original location of the little village of Danby before it moved down and east to its present location in the valley to be closer to the new railroad. There isn't much context in the ledger, just needs and numbers, the reckoning of everyday life.

In 1877 Horris Cane spent
 56 cents for 8 pounds of cheese
 75 cents for a pair of socks
 $5.05 for 101 pounds of beef at 5 cents a pound
 75 cents for a calf
 10 cents for a dozen eggs
 7 cents for a pound of sugar
 25 cents for a pound of lard
 15 cents for a pound of butter.

In 1880 Hiram Edgerton spent
 12 cents for candles
 20 cents for butter
 4 cents for a quart of milk
 90 cents for 20 pounds of flour
 50 cents for 5 pounds of pork.

In 1882 Ella Sherman was paid $2.25 a week to work on the farm, although what she did was not recorded in the ledger. She spent $1 for a shawl, 12 cents for buttons, and a whopping $4.25 for a hat.

She also spent $10 on a visit to Dr. Whiffle, reason not noted, but it is pretty obvious, based on her crazy hat spending, that she was trying to get her head on straight.

On March 31, 1887, Joseph Perry bought
> 66½ pounds of sugar
> 292 pounds of pork
> 14 gallons of maple syrup.

I can't tell what Joseph had in mind, but I would've liked to have been invited.

In 1878 Mrs. Navan worked nine days when her husband, Brassy, went home, and then three more days when "Brassy went to Church." Makes me wonder what he did during those nine days at home.

One of the last entries in the ledger is the penny-by-penny, nail-by-nail accounting of all the material Hugh's brother Mott used to build Roger and Trish's house in 1943. The cinder blocks, the slate sink, the oak flooring, every gallon of paint is recorded in the ledger. In total, Mott built the house for $1,613 . . . oh, and 13 cents.

"Do you remember Mott and Priscilla living in this house, Roger?" I ask that evening, my fork buried in a pile of spaghetti as I enjoy dinner with Roger and Trish at the kitchen table. I had brought the ledger along to ask them questions.

"When I was a little guy I remember them down here, but they were soon gone, moved to town. Priscilla was tired of the farm by then, I guess, and wanted to live on the paved road in town. We had renters living here for a while and I moved down in the late seventies from the big house. Trish moved in after we got married in 1981."

"That was nice of you to let her move in, Roger."

"I didn't really have much choice, now did I?" Roger says loudly enough for Trish to hear him as she brings over a dish of hot vegetables.

"I don't remember having to convince you very hard," Trish replies, smiling.

"Don't imagine you did. I didn't have any better offers!"

The table is tucked into a narrow ell off the kitchen, under a large picture window with a magnificent view north over the rolling pastures and wooded hillsides of town. It is from here that Roger does much of the farm business, reads his magazines and newsletters, and makes his phone calls. The table is also where most visitors come to sit and stay a while.

"What is your earliest memory, Roger?" I say as I watch him pour white wine into his iced tea.

"I remember my grandfather Delos, sitting in an old ladderback rocking chair out under the big maple in the front of his house, sulking."

"Sulking?"

"Yes, sulking. I was pretty little when he died but I remember him as tough and generally unhappy."

"Was it an unhappy place?"

"Hell, no! I had a wonderful childhood. In fact, one of the other first memories I have is riding an old buckboard during Delos's fiftieth anniversary party. Martin and I used to sit on the reach, the pole between the axels, and ride it down the road by the big barn, but during the anniversary party I remember we were told to stop doing it. Somebody thought a six-year-old driver and a three-year-old rider were going to hit some of the parked cars! Can you believe it?"

"How silly of them. So do you remember your father as unhappy?"

"No, I wouldn't say unhappy, just stern. He had his way of doing things but he let us be kids. We played in the barn all the time; my kids did too. I remember riding my tricycle up in the hayloft. My kids built a skateboard ramp up there. But the rules were the same: not while the cows or the old man was in the barn.

"All us boys were expected to do some work. We were all expected to help out during milking. I can remember carrying pails of milk from the cows to the old milk tank and dumping them in. We didn't have the automatic system then. I remember scraping up and feeding hay. Oh, and I remember doing my

homework on top of the milk tank between milking chores."

Roger never really thought of being anything other than a farmer. When he graduated from high school his older brother, Stephen, joined the Coast Guard for four years. When Stephen came back, Roger joined the army and was stationed in Germany for two years. It was his chance to get off the farm and see some of the world. When he came back to the farm, Hugh bought another farm ten miles north of Danby and Stephen moved there to farm it.

"I never really thought of doing anything else. It was hard work but every day there was something different and I was happy. So I stayed."

"It was happiness that brought me to this farm," Trish pipes in as she pours Roger some orange juice.

"I didn't know that, Trish," I say distractedly as I watch Roger top his orange juice off with some V8.

"It was spring and I was in Connecticut and I wanted to see what it would be like to live on a farm. My family had some friends who had a house up here and they knew some farmers, so I came up. I wasn't thinking forever, just to try it out.

"Well, the first farm I went to the people were sad and I didn't want to stay at a place that was sad. So then I came here and here the people were happy. So I spent the first night upstairs in the big house. That was April. Next time I left the farm it was Christmas."

"That's quite a story, Trish," I say as I move a soda bottle away from Roger.

"Wait, it's not done yet. I was nineteen and I liked working and being outside. I remember the first night here. I got to ride a horse. What do you think of that! Riding a horse and they hardly knew me. That was really something. Roger helped me catch it. It was the last horse we had on the farm, Comet. She was a good horse.

"I pitched right in doing chores and all. I got yelled at a few times for doing something wrong . . ."

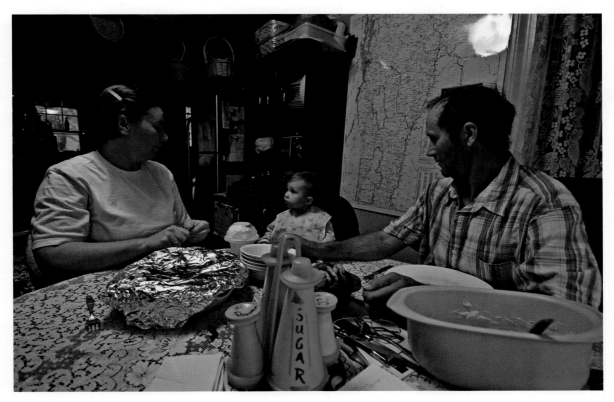

Trish, Macy, and Roger sharing dinner.

"By 'wrong' she means not the old man's way," Roger growls, reaching for the milk pitcher.

"I remember up at the heifer barn, letting the cows out one time and the bull walked out the wrong door! He ended up on top of the frozen manure pile, outside the fence. Can you imagine that, the bull standing on top of the manure pile? I thought I was in some trouble then, but thank goodness there was nobody else around. I managed to get him back inside. That was a close one.

"After Christmas I came back and stayed another year. I thought about leaving once but I just started bawling, I couldn't do it. I liked it here and Hugh told good stories and I was happy, so I just stayed."

"Seems to be a lot of that going around, the just staying," I say, pushing the cranberry juice to the far end of the table. "You get a lot of strays here, happy strays."

"And some even stick around for a while!" Roger adds.

"Well, I was working outside, something was always going on, and it was so beautiful. Every day was different. I did go back to Connecticut the next winter for a few months, but I missed everyone so I came back in the spring. I'm glad I did."

A year later Roger and Trish were married, and Mott's house had a new family in it.

"I remember exactly when I proposed," Roger tells me. "One weekend my parents were down visiting Trish's parents in Connecticut. Both mothers

Roger taking a quick nap after lunch.

were British and Bob, Trish's dad, was lots of fun, so Hugh liked him. We had the whole place to ourselves. I remember it was a warm spring night with a gentle rain. We went out to the porch to brush our teeth and I proposed to her right there."

"You proposed while brushing your teeth?"

"It was so romantic!" Trish beams.

"It wasn't all work around here, you know," Roger adds, leering and laughing at the same time. "There were other things going on!"

"It was very romantic!" Trish repeats.

"Come to think of it, my mouth was full of toothpaste. Who knows what I said!"

"You might have asked her if she would carry seed," I suggest not so helpfully.

"You're right! This all could be one big misunderstanding!" Roger says in mock horror.

"You two! It was very romantic!"

"You know, Roger, I didn't see your proposal mentioned in the ledger."

"Oh, the costs of some things were just too steep. We kept a few items off the books."

"Priceless, is what he meant to say," Trish replies, her beaming undiminished.

"You two were meant for each other," I say as I shake my head and smile. What a pair. Roger and Trish are the real treasures here, I think to myself. Priceless treasures. 🍃

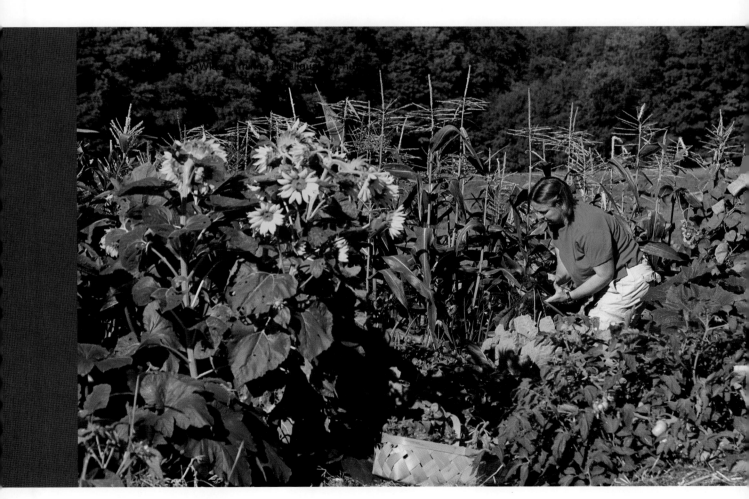

Trish harvesting from her garden.

Roger and Trish bringing in a wagonload of hay bales.

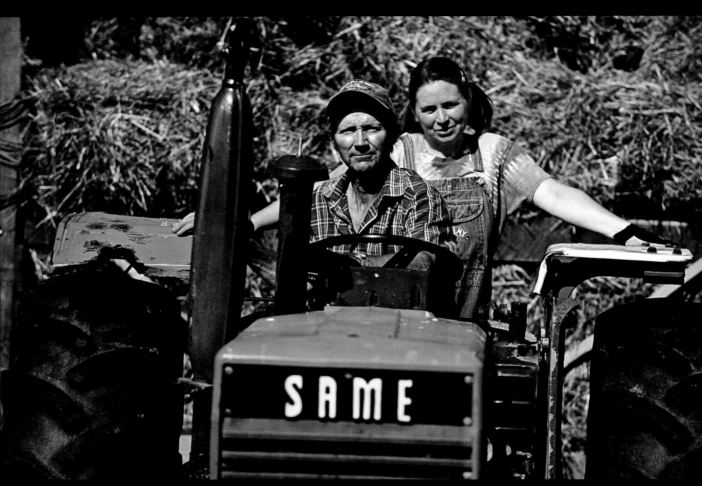

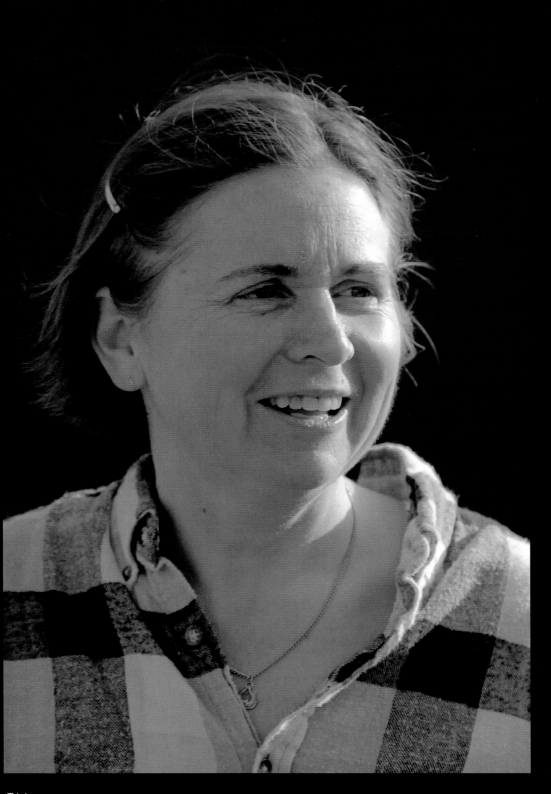

Trish.

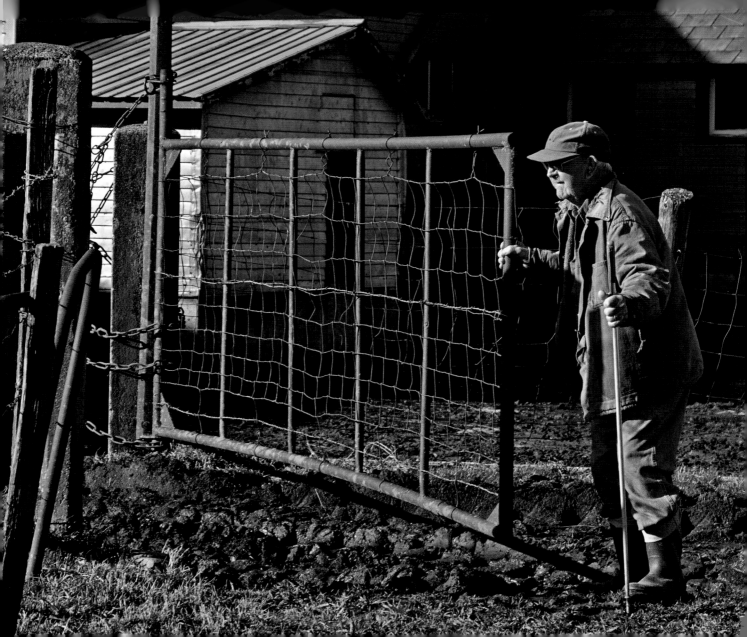

7

New boots

"Hugh, I bought a new pair of farm boots today."

"Oh, yeah, whadcha get?"

"Oh, just a pair of rubber boots—barn boots—for the barn and the mud."

"Like these?" he asks, pulling up his pants leg to show me a pair of old brown rubber boots he has probably had since the Great War.

"Sorta like those, but I didn't buy mine in Paris during the war," I say, unable to resist the temptation to needle him about his old, old boots.

"You must mean World War I!" Hugh says with a laugh. I can always get him to smile and sometimes laugh when I purposely misstate the age of something he is wearing or a piece of equipment he is using. Old things are an old source of amusement to this old man.

"But, Hugh, even if yours were new, my boots would be different from yours."

"They would?"

"Yes, mine are blue."

I say this with considerable trepidation, knowing that Hugh doesn't embrace new things quickly, especially if they are different from old things that have worked perfectly well for many, many years. He actually doesn't embrace new things at all if the old things are working. A firm handshake is about as

familiar Hugh is going to get with anything new.

"Blue? Is that what you said? Your boots are blue?!?"

I might as well be telling him that I have wings. Boots are not blue. Boots are brown or boots are black, that's it. In Hugh's world if something has been the same way forever then it should stay that way forever. When things work you don't change them, and blue boots don't work. Blue boots have never worked.

"Yes, dark blue with a red line around the tread. Is that okay?" (And would you mind if I took a little spin around the place on my new wings?)

"Dark blue with a red? Those aren't any damn good," he says, his eyes alive with mischief, I think. Then, turning his head and spitting on the ground (it's his visual exclamation point, always placed at the beginning and end of important sentences), he says to me, "Take the bastards back. Yes, sir, take the bastards back."

I laugh, nervously, uncertain how serious Hugh is being. Perhaps it wasn't mischief after all.

I didn't take the bastards back. They were brand-new and they were comfortable and I kinda liked the blue color. But every time I wear them on the farm I get blue boot trauma. It's a side effect of not-knowing-what-the-hell-I-am-doing-itis. The last thing

Hugh at the barnyard gate wondering what the heck is going on.

I want to do is embarrass Hugh when I am around him on the farm. But I also don't want to embarrass myself by looking like some farm yokel. This was the type of thing I worried about when I first knew Hugh and started coming to the farm.

I still worry.

Just the other day Hugh noticed me wearing my blue boots with the red line around the tread as I walked by him on the way to the calf barn. He was standing in the middle of the road, apparently waiting to direct traffic that would never come. In a voice loud enough for only me to hear, he muttered, "Take the bastards back, yes sir, take the bastards back." Then he turned and shuffled off, shaking his head and quietly laughing. ✑

Roger's picture of me not working.

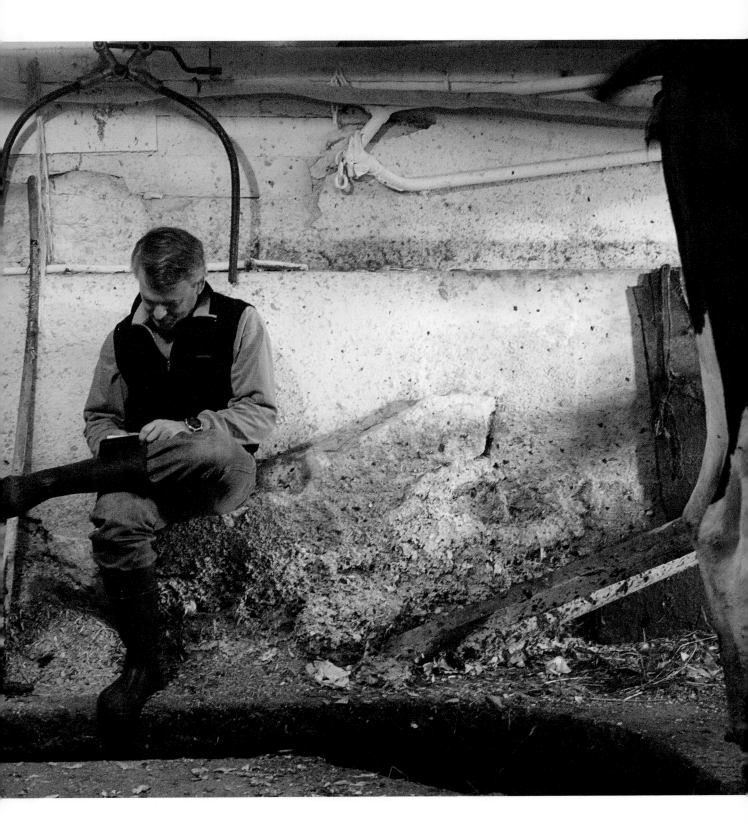

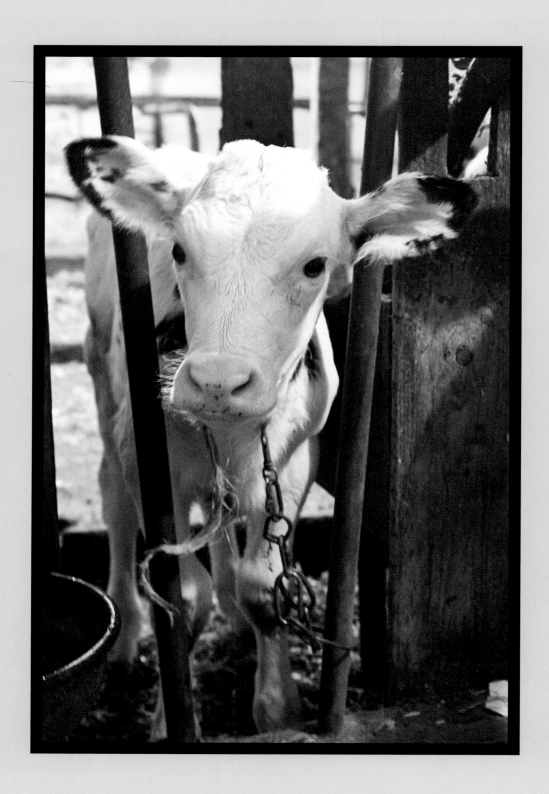

8

It'll be interesting

"Hi. This is Roger," a voice squeaks through my phone. "Whatcha doin'?"

"Ahh, nothing," I say suspiciously, knowing that I often am but he seldom is, especially at this time of night, when there are still chores to be done on the farm.

"Why don't you come on over to the barn?"

"It's after dinner, Roger, I'm already in my jammies," I fib, slouched in my chair, my feet up, an adult beverage in my hand, and my head blissfully empty.

"That's okay, the cows don't care! There's something in the barn you've gotta see. Come on over. It'll be interesting."

It had been only a few months since I had met Roger, but I had already learned to recognize what he just said as a unique form of verbal communication called Roger-speak. In Roger-speak "Come on over" translates as: a cow has done something really stupid and you're not going to believe it unless you see it. This is the first part, the innocent part of his offer. It is the second part, the "It'll be interesting" part, that is not so innocent. "It'll be interesting" in Roger-speak means: it is a real mess and I'm not sure how I am going to work it out, but it would be nice if you were here to help me and get as dirty and frustrated as I am going to get. Roger can say a lot with a few words.

And so I go, leaving beverage and bliss behind. It's not as if I had any choice. Roger knows that I can't resist an invitation like that.

It's seven o'clock when I leave my house, the slow part of the day, when everybody (except farmers) (and those who help farmers) has gone home to relax and enjoy a drink slouched in a comfortable chair . . . feet up. In the car I replay in my head the rest of the conversation.

"One of the heifer calves got unhitched in the barn and got herself turned backward and hung up over the hitching rail."

"Hung up?" I ask, bewildered.

"Yes, hung up," he says with a mixture of pride and exasperation.

"On the hitching rail?"

"Yes, she is hung up on the hitching rail . . . the rail we tie the cows to.

"You have a calf hung up over the hitching rail . . . backward?" I ask, still perplexed—comprehension is slow to make my acquaintance.

"Yes. We have a calf hung up over the hitching rail and she's backward." The change in pronouns is not lost on me despite my continued confusion.

"Her front end is in the stall with her feet in the bedding, and her back end is up over the hitching rail so that her rear feet are in the food, in the

manger. The rail is running between her ribs and her hips so she can't go anywhere. She didn't seem like she was minding it much so I left her right there so she could think about things and went down and had supper."

"This could be interesting," I think, rising from my chair. "I'll be right there."

"I'll see you at the barn," says Roger.

Arriving at the barn, I meet Roger as he walks up from his house. Roger is in his mid-fifties, willow thin (he would have to gain twenty pounds to be called skinny), with scraggily hair and a twinkle in his eye that borders on devilish. The middle son of three, he started feeding calves when he was a wee boy, and, other than a few years as a sergeant in the army, Roger has spent his entire life on this, his family's farm. Far from being worn out, though, he remains invigorated. He still works harder than anyone I know, and he does so with a smile, an easy laugh, a slow gait, and a generous spirit.

As we walk into the barn Roger grabs the long-handled metal scraper and starts to clean up the center aisle. I turn quickly right and walk to the manger in front of all the cows to take a look at the calf. I know Roger is watching me as he pretends to be busy. I know this because Roger loves these episodes. To him, it is like watching live TV in the barn. And I know what he wants to see. He wants to see me jump and exclaim and celebrate the astonishing stupidity of this particular calf and all cows in general. He gets great satisfaction whenever he can have this primary bovine trait confirmed. It is a combination of "How big a fool can a cow be?" and "How big a fool must I be for depending on them to make my living?" Roger is not your everyday dairy farmer.

I come back scratching my head, downplaying my astonishment at what I just saw and allowing him only partial satisfaction—even though I am quite impressed with the idiocy of this animal. The calf really is stuck backward over the rail. She looks just like an old black-and-white pillow thrown over the back of a very ugly chair.

"Maybe if I get in front of her I can push her back and she'll be able to squirm her way over the pipe, " I say not very convincingly.

"She's hard stuck," Roger replies. "I don't think this is a one-man job."

"Well, let me try, and if I can't get her off I'll come back and we'll think of something else." The change of pronouns is not lost on Roger.

I walk back to the end of the barn and step between the two calves lying in their proper places. The circus calf stands above them, quietly chewing, looking contently at me. I put my hands on her head and push hard, trying to turn her to one side and then the other. I figure that if I can get her head turned, the rest of her will follow. Nothing doing. I then try to push her straight back, but she is having none of it. Push a calf forward and she'll go backward. Push her backward and she'll go forward. This is the first rule of bovine thermodynamics. Besides, even though this is just a calf, she is still a big animal, perhaps 350 pounds, and no one I know (or want to know) is ever going to push her off this rail.

I stop and ponder and then I try again adding a few grunts and choice words to my workout. Again nothing. The calf has barely noticed my efforts. A small bleat of angst would be nice, but she remains unruffled, never missing a chew. She just stands there, hung up, staring blankly at me. I have no idea what she is thinking. I have no idea if she is thinking. I have no ideas.

For effect she lifts her tail and, well, does what cows do best. Cows are generally not good communicators but they can be quite expressive. This one, it seems, has a lot to express.

As I give up the brawn approach, Roger arrives carrying an old, dirty piece of rope with a loop on one end. I have never seen this rope before.

"Where was that hiding?" I ask as a way to stall and catch more of my breath.

"I keep it behind the ladder, behind the yellow rope and the come-along. It hangs on a peg with my hat and an old rag. I don't use it much."

"Good to know," I say, wondering what else is

hanging on these old barn walls. I look at the rope and I look at the calf and I look at the rope and I look at the calf, and I realize I have no idea what he is going to do with either. I am stumped.

Understand: I come by it honestly. I have no experience unhanging heifer calves. I was not taught this in school. I have read no books on the subject. It is not a popular topic for TV shows. You never see this on ESPN. It has never, ever come up in idle conversation, and it is not something anyone I know has any experience with. Anyone, that is, except Roger.

Roger has fifty years of experience in the barn, and he has seen and had to deal with fifty years of idiot cows. He may not have dealt with this exact situation, but I figure he has dealt with plenty of situations that are similar to this one. I am sure he has had cows hung up on fences or gates or across downed tree limbs before, and since I haven't seen any skeletons draped over any of these things on my wanderings around the farm, he must have been successful in unhanging the hung. Getting a calf off a hitching rail is just another opportunity to use those same old tricks.

Furthermore, this is exactly the kind of thing farmers do talk about. Listen in on a conversation between farmers and you will hear either complaints about the weather and prices or stories of the things that went to hell: the tractor that broke down, the hay wagon that got stuck, the bull that was too lazy to do his job, or the raccoons in the silo.

Even if you were to make up an absolutely ludicrous predicament, some farmer somewhere would surely say: "Yup, I remember up on the old Smith farm. A heifer calf was flying around there once doing loops above the barn. Wouldn'tcha know she got herself stuck up in the old birch tree? Old man Smith had a helluva time getting her down; used his old flying-calf rope he had behind his ladder hanging on a peg behind a rope, behind a hat, behind a rag. I've had a flying-calf rope ever since just in case."

"Pushing didn't seem to work," I say, leaning on the calf.

"Nope."

"Have any other ideas?"

"Yup."

Roger paints a beautiful picture with words.

"Best let these other two calves go before all hell breaks loose," he says. "We don't want them getting stepped on and adding to the confusion."

I reach down and unclip the two properly placed calves as Roger waves his ball cap above them. With a yell and a prod we get the two calves up and out into the center aisle and away from trouble. Roger hands me one end of the rope.

"Grab this and pull," Roger tells me as he climbs over the rail into the manger, "I'm going to get the legs. Careful."

This is more Roger-speak. What he means by this is: "Grab the end of this rope and put it over the hitching rail. I am going to loop it around her back legs and then try to lift them over the bar. When I lift her legs up pull hard: we don't want to lose any ground when she starts to fight us. Once we get the legs over the rail she will tumble down into the stall and we can get her straightened out. Oh, and stay out of the way if you can. She'll likely be out of balance and there's no telling which way any of her parts might go. I'll try not to get kicked myself. And don't forget about the gutter right behind you, it's full of shit."

It's as easy as that. Roger puts the loop around the calf's back legs, cinching them together as I pull the rope taut. He then grabs the back legs and lifts them, struggling to get the heavy end of the now mildly curious calf high enough to get it over the rail. I pull on the rope, not letting any of the hard-won height get lost between each lift. A few minutes later and a lot more lifts and pulls, lifts and pulls, the calf tumbles over into the stall. I lurch here, the calf lurches there, we all lurch everywhere, and then we all stop. The calf, her back legs now loose, stands up and resumes chewing. I stoop over, hands on knees, and Roger retrieves the rope. Except for our loud breathing, the barn is back to normal.

I manage to come away with only a few glancing

kicks to my legs, and Roger has
pinched his hand, but no blood is
gushing from either of us and the
shit has stayed mostly in the gutter.
The calf, still chewing, acts as if
nothing has happened. The opera-
tion is a success.

"That wasn't so bad," Roger says,
almost disappointedly.

"No, it really wasn't. It's good
she didn't try to fight us, too much."

"They usually go under the rail-
ing when they go," Roger adds, "but
not this one. She had to try to go
over it. It's always something.

"Do you think she learned
anything?" Roger asks, both not
expecting an answer and knowing
what the answer is. To him, a cow
learning a lesson, learning any-
thing, is as likely as a cow cooking a
quiche or quoting Keats.

"I don't think so, Roger. But at
least we know that she'll never be
the one that jumps over the moon."

Roger brightens and looks at me
eagerly. "We'd need a longer rope
but, who knows . . . it'd be interest-
ing." ◡

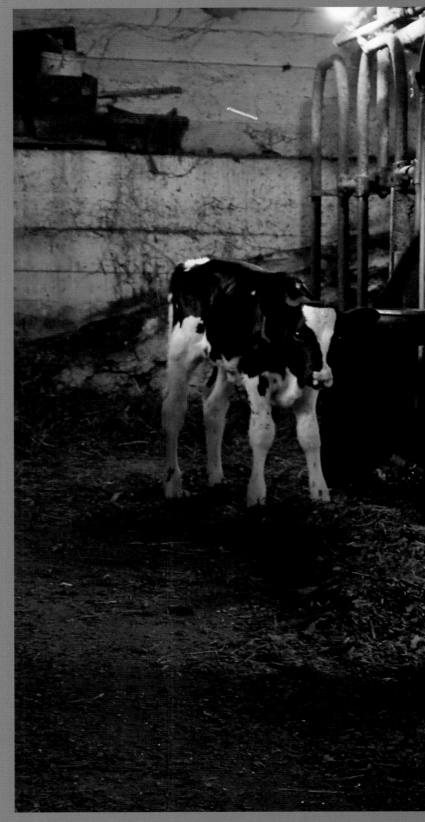

Mom looking at her new calf in the cow barn.

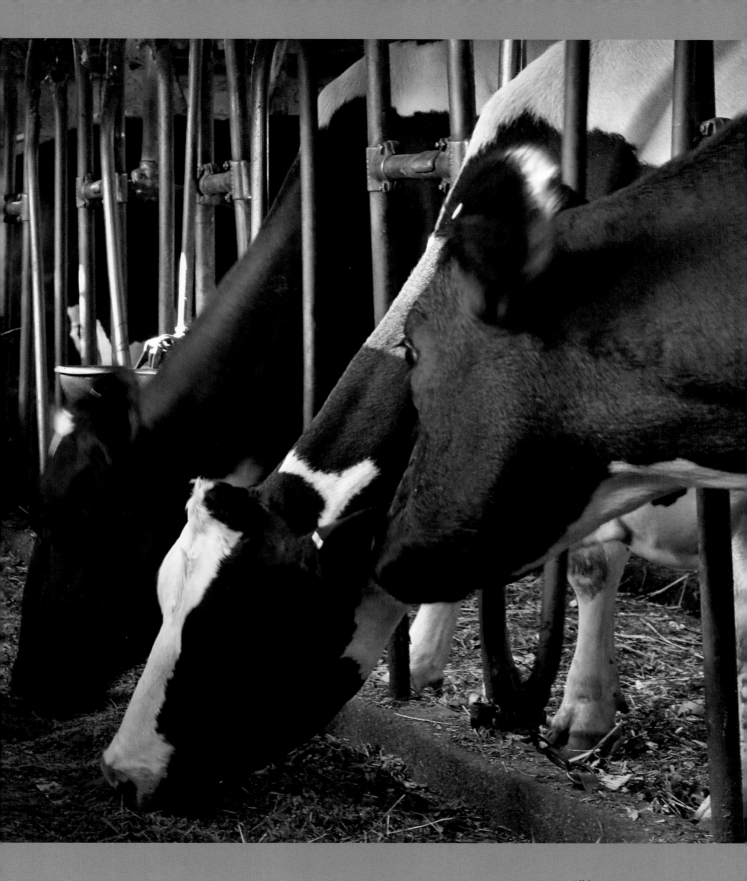

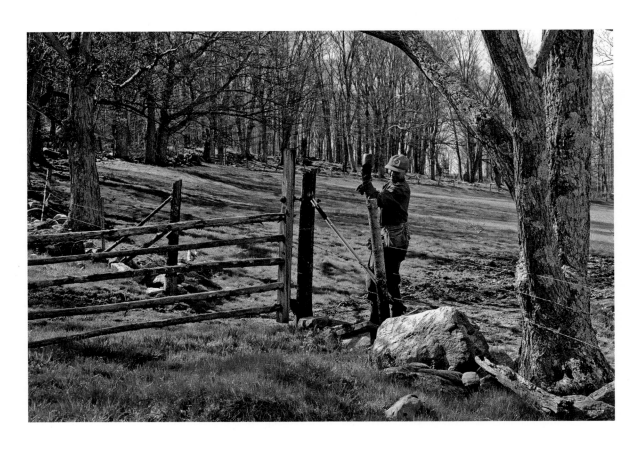

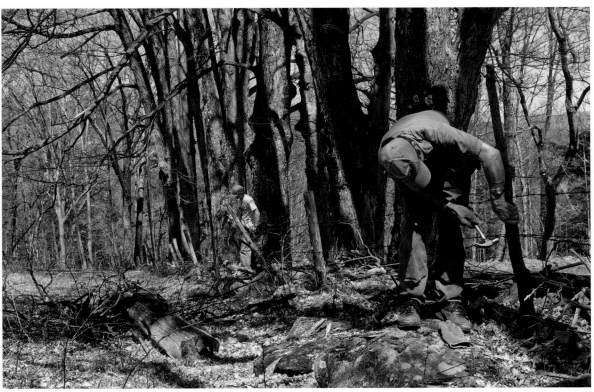

9

Grass

Grass—growing grass, drying grass, baled grass, chopped grass—is the engine that powers the Bromley farm. A cow turns grass into milk and manure. A farmer turns milk into money and turns manure into fertilizer to grow more grass. It is a simple yet elegant cycle, repeated every day, twice a day over the years, over the decades, and over the centuries.

The greening of the meadows and pastures is the signal that finally and formally closes winter's last chapter. Spring does not start with the longer days or the warmer winds or the now boot-high mud and muck out behind the barn. Nor is it the returning robins or the near empty silos and hay maws. These are all things of late winter, when we are all seduced by the calendar into believing the grass really is greener on the other side of the snow fence.

A dairy farmer sees growing grass as growing food, something that doesn't have to be shoveled or spread or unloaded or hauled. A cow sees growing grass as something different to eat, something succulent and tasty and easy to chew, not something dry and coarse and so, so familiar. They both see growing grass as a reason to get out of the barn and stay out of the barn: more time to eat, less time to clean up, and finally time to wander old paths.

But Roger knows the winter pasture, greening as it may be in early spring, is as wet and cold and ragged as an old towel left outside and forgotten. Put fifty cows out to pasture too early and the soft ground will be cut up like so much dirty confetti; they will kill the tender grass shoots before they really get started and ruin them for later grazing. A dairy farmer sees a greening April pasture as a May mud hole lying in wait.

The greening of the land does set off a cascade of activity on the farm, the end of each chore necessary for the beginning of the next. The back barnyard is scraped with tractor and blade, pushing up great blubbery mounds of mud and slop that ooze and sag and creep back toward the barn with every new rain. When the piles dry, they will be scooped up with the backhoe and trucked down the hill to the old Hopper place to be spread on the fields below.

When the last snow melts and the phoebes have returned with the April rains, it is time to mend all the farm's fences. Every fence line is walked and the top of every fence post—grown, cut, and sharpened on the farm—is given one firm "tonk" with a heavy iron mallet. Not two "tonks"—too easy to break an old but still usable post—and certainly not three. Just one solid "tonk," and one "tonk" only. If the post wobbles badly it is replaced; otherwise, it is on to the next one.

The miles of barbed wire are also inspected and repaired as needed; breaks are mended with spare lengths of wire, and sags are tightened with a tug

Top: Roger giving one tonk only while fixing a fence.
Bottom: Roger and Ike fixing a fence near the sugarhouse.

and a tap on the loosened or new staple in the post. Fence-mending goes on all summer and fall; as long as there are cows in the pastures there will be holes in the fences. Such is the relationship between a 1,400-pound animal and a one-pound brain.

Once the fences have been stitched back together and all the posts properly thumped, one "tonk" only, it is time to begin moving all the cows to their summer quarters. The first to see the other side of their fences are the oldest heifers, which have spent the winter in the old heifer barn up top. They get released into the wilds of the high pastures—part meadows, part forest, and completely unsupervised. They roam about like a gang of bovine teenagers, happy to be ignored but always in want of some attention. Roger won't have much to do with them until snow is in the air and the ground is well frozen.

Down around the cow barn the youngest calves come out and move into the barnyard, pushing the yearlings from behind the barn, where they have spent all winter, to across the old town road and into the long meadow above the sugarhouse. The calves are about a third of their adult size at this time, but they will gain three hundred pounds, a bit less than two pounds per day, by the time they come back to their wintering area behind the barn.

The yearlings, the graduating class before the calves, are also packing on the pounds. They will gain two hundred or more pounds over the next six months as they shed the last of their baby cuteness and grow into an adult's bulk.

The milk cows go up to the end of the old road and spend the entire day out and about, eating to their mighty stomachs' content. Each will be eating now for two, for every one, assuming the bull has done his job, should be several months pregnant. Soon, when there is enough grass to sustain them, they will stay out all night and the barn will be empty for much of the time.

When trilliums bloom in the woods and barn swallows nest in the many old barn nooks, it is time at last to turn the soil and plant corn seed. Once all

the manure piles have been spread on the fields—about two weeks of afternoons if the weather cooperates and nothing breaks down—each field is harrowed two, sometimes three times. Harrowing disturbs the top four to five inches of soil, the first row of blades shoving the soil to the right and the following row pushing it back to the left. Plowing goes twice as deep and turns over the soil better but it takes twice as much time and brings up twice as many rocks.

Roger tries to ignore the small rocks but he can't let the big ones go by. He knows that every year the rocks will reappear like stubborn weeds in his vegetable garden but he can't stop the gathering. It is a matter of pride for Roger to have a mostly rock-free cornfield. To Roger it is a sign for all others to see that he is a proper, hardworking farmer. A rocky field is a sloppy field and a sure sign of a lazy, careless farmer.

For every rock larger than a football Roger stops the tractor, climbs off, carries the rock back to the harrow and places it on the frame. After a few hours in the field the top of the harrow is a pile of rocks and Roger is tired and sick of lugging stones. But the field is smooth and soft and ready.

The corn seed is dropped, spaced, and covered with dirt automatically by the seeder towed behind yet another tractor. None of this is fast work and no rushing is allowed. No rushing is even possible, as the tractor plods along a scoosh faster than a walk when Hugh is driving and a touch faster than that when Roger is at the wheel. But despite the seemingly tedious nature of the slow back-and-forth it is not boring at all. There are more rocks to look for and fetch, field edges to scan, horizons to examine, swallows to watch, clouds to ponder, and ridgelines to trace.

When I ride alongside Roger, perched on the wide tractor fender like a Dalmatian on a beer wagon, I get the sense of sailing a boat on a small pond, tacking back and forth, slicing through the dirt, the mind clear but for the next turn as the grassy edge of the shore ever approaches. ✑

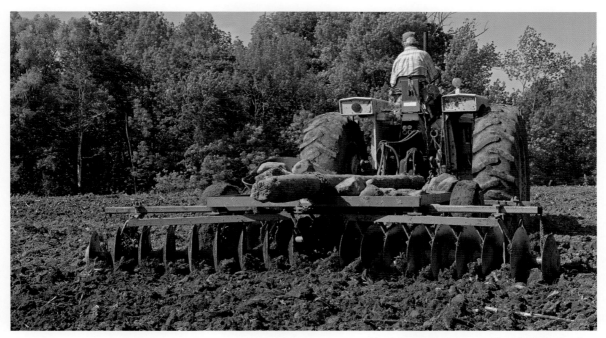

Hugh harrowing the cornfield before planting.

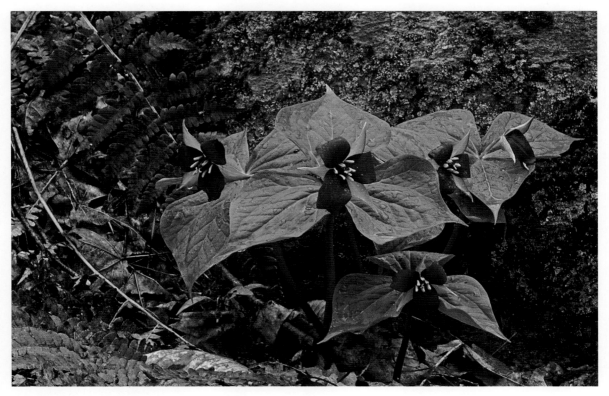

Red trilliums or wake robins.

Hugh mowing the Hopper meadow .

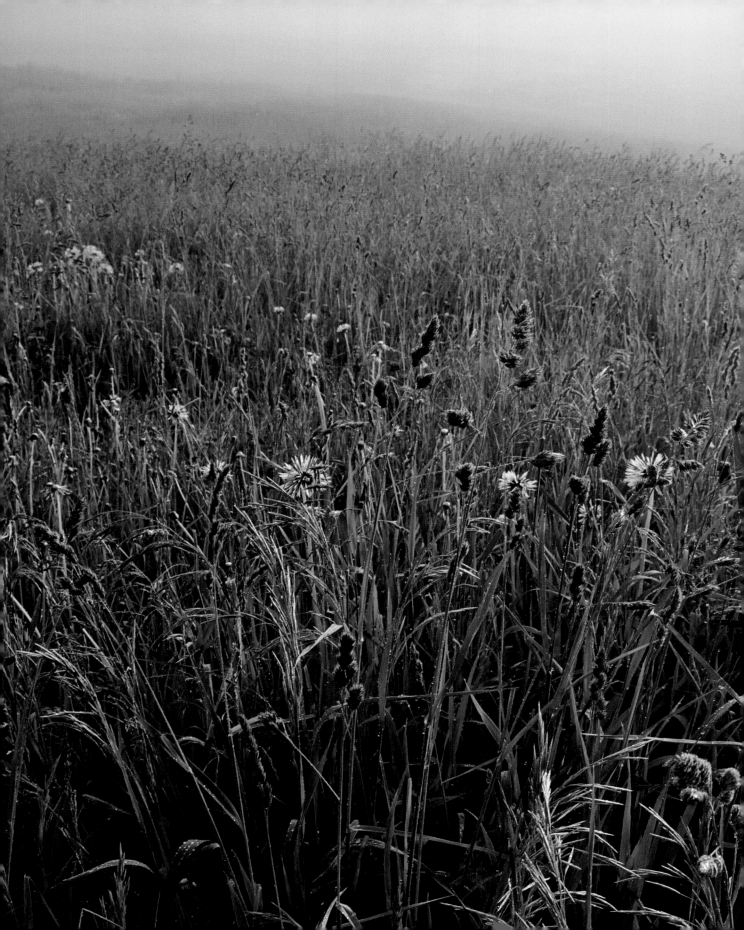

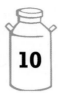

10

Haying

Haying is an exercise of laps—a repetition of back-and-forths across a meadow, around the farm and through the summer months. The work is repeated until each meadow is clean, the barns are full, and the months fade into fall. It starts in midsummer in the six-acre meadow that surrounds Roger and Trish's house and goes round and round to each hay field, changing tall green grass into cut green windrows and then to square green bales or chopped green haylage. And when all has been cut and caught and piled high in the barns and silos, haying starts anew, again at the six-acre house meadow, as a second cut of hay is added to the haymows.

Actually, getting thigh-high grass into thirty-pound bales is a study of circles. In spiral laps, working from the outside in, each field is cut, the grass tedded, then raked into rows, and finally baled. The orange tractor pulls the mower, the old blue tractor runs the tedder, another orange one operates the rake, and the big blue Ford works the baler and pulls the wagons. If everything is going well (I don't know why I even bring this up), Hugh will be cutting one part of a meadow as Roger is tedding another part, or Hugh will be tedding as Roger rakes, or Hugh will be raking as Roger bales, or Hugh will be doing whatever he goddamn well pleases.

"What exactly is 'tedding'?" I ask Roger, quite unsure of what I am saying. "Should I be getting you a dozen roses?"

"Not necessary. We are going to do it right here in the field, right now."

"I'm not sure I am ready for this level of commitment, Roger. You could've at least given me some warning. I might have taken a shower or at least changed my clothes."

"Your clothes are fine. Just get on that old tractor over there and drive around in circles for a while. The tedder is that spinning rake behind the tractor. It fluffs up the grass to help dry it out."

"Why isn't it called a fluffer?"

"Ask Ted. Now get on the tractor."

"Okay, but I have never driven that tractor before. Anything I need to know?"

"Not that I can think of. Oh, once you find a gear going in the direction you want, it is best just to leave it there. The gear box is a bit loose."

"Drive around in circles, spinning rake, pick a gear, any gear. That about right?"

"You're about to be an expert tedder."

"My mother would be proud."

The actual tedding is pretty straightforward. The rakes spin so that the grass is picked up and thrown about, which allows air to circulate around it. This speeds the drying and hastens the haying process. It's the driving of the old blue tractor that is the difficult part. Moving the gearshift around felt like I was stirring thick beef stew with an old wooden

spoon—every so often I'd hit a chunk but nothing much happened. I found reverse a couple of times but the idea of tedding backwards (is that even legal?) was just too much for me to think about.

When I did get the tractor going—first gear—in the proper direction—slowly—and engaged the tedder—carefully—it was sort of fun driving around and around the field, fluffing gaily as I went. Apparently, though, it is possible to over-ted. My repeated retedding retarded the drying. This caused a serious fluffation situation. It took Roger coming over on his raking tractor (raking puts the tedded grass back into ordered rows so the baler can pick it up) to tell me that I have fluffed enough. "Your tedding time is up" is how he put it.

After mowing, tedding, and raking comes either baling or chopping. Chopping cuts up the grass into little pieces that are collected in a wagon and then blown into one of the silos. The chopped grass is called haylage after it has sat and partially fermented in the silo. The partial fermentation adds vitamins and other nutrients to the grass, but because of the limited supply of oxygen in the tightly packed silo, the fermentation stops before rot sets in. Think about a gigantic pile of lawn clippings sixty feet high surrounded by cement and you will understand chopping, haylage, and silos. It takes about three weeks of chopping to fill the silo with grass bits and nine months of feeding haylage to the cows twice a day to empty it.

Baling takes long cut grass and transforms it into very tight thirty-pound rectangular bales that are automatically bound with baling twine and then shot into the trailing hay wagon. A hay wagon holds about 100 bales if there is no one catching and stacking the bales and 170 or so if there is someone in back packing madly. This all seems pretty straightforward, but

Hugh baling in the upper meadows.

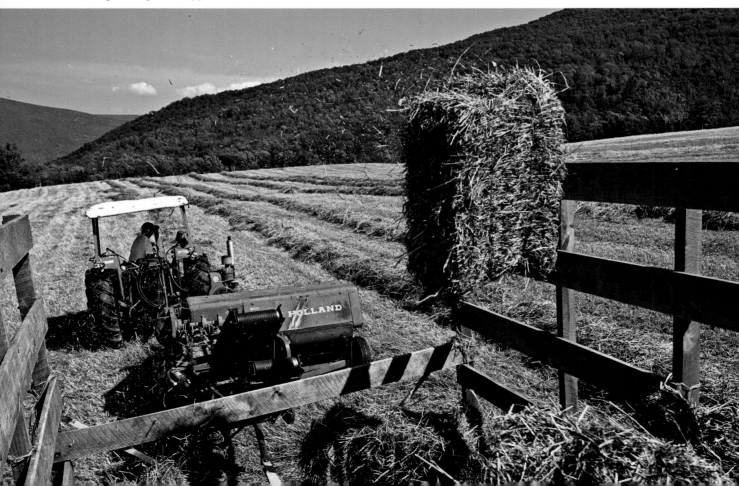

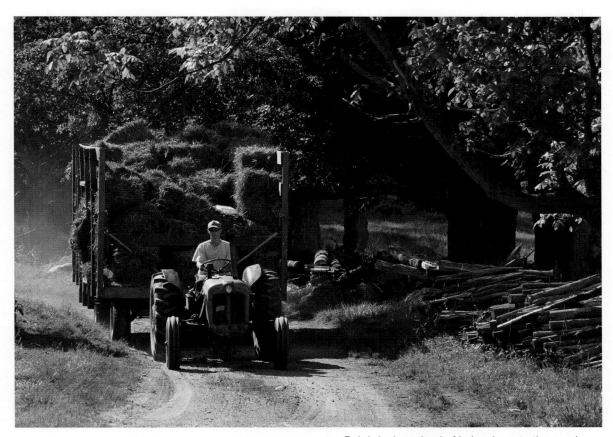

Rob bringing a load of bales down to the cow barn.

it is done on hot, humid summer afternoons, when grass finds and sticks to places that grass shouldn't be found or stuck to. Also, there are so many moving parts involved in the baling process—belts, chains, motors, knotters, pulleys, rollers—that it is likely that something will break soon or sooner. Still, catching and stacking bales is one of my favorite things to do on the farm.

I think of baling hay as a drinking song. It begins at 500 bales and goes round and round the hay meadow counting down until all the loose notes have been gathered up: "500 bales of hay in the field, 500 bales of hay. You pick one up and toss it down, 499 bales of hay in the field. 499 bales of hay in the field, 499 bales of hay. You pick one up and toss it down, 498 bales of hay in the field . . ." You get the picture. Only this song doesn't end for two months. It repeats every dry day, day in and day out, until Roger and

Hugh are so drunk with hay their hangover never really goes away.

Every afternoon the song changes to bales of hay in the barn, because what is loaded in the wagons must be unloaded in the barn. One hundred bales of hay in the barns, one thousand bales of hay, ten thousand bales of hay in the barn. Keep this up until you get to fourteen thousand bales, then take two aspirins and call me in the morning. Grow, mow, ted, rake, bale, stack, haul, pitch, fetch, feed, scrape, shovel, spread, grow. There is nothing next, the routine is a song forever stuck in its groove. It will never get to the rest of the song because there is no rest of the song. There is just the first stanza and it repeats and repeats and repeats. Tell me when the music stops and I'll quit dancing but until then, as long as the summer sun is out, I'll be do-si-doing with a bale in my arms and rows to go before I sleep. ꩜

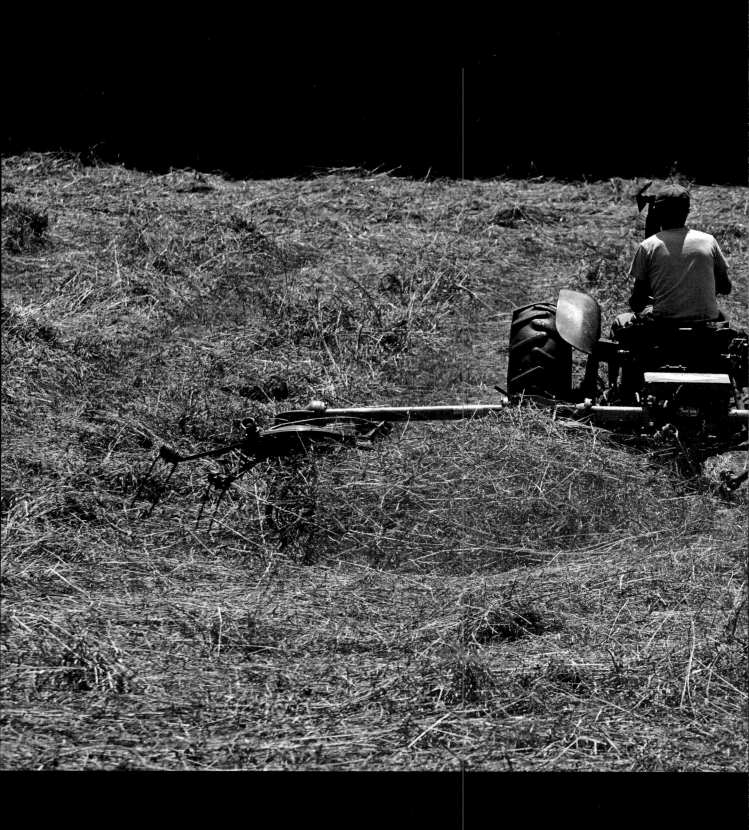

Roger tedding the freshly cut grass.

Farm time

"Do you know what time it is?" I ask Roger one day while we are switching a full hay wagon for an empty one during a break picking up bales. I have the tongue of the empty wagon in my hands as Roger is backing the tractor up to me.

"I don't know," Roger says over his shoulder looking down at the tongue, "after dinner but before supper—best I can do."

"What time is supper?" I say, trying to nail him down a bit.

"After afternoon chores. Is the tractor close enough?"

"A little more. What time are afternoon chores?"

"After dinner. How's that?"

"That's good. What time is dinner?"

"After morning chores and before afternoon chores. What part of this are you not getting?"

"I'm not getting what time it is," I say, dropping in the hitch pin and connecting the wagon to the tractor.

"Oh, is that what you want to know? It's time to get back to filling this wagon."

I have learned now not to ask Roger about time. There's no point because absolute time has absolutely no meaning on the farm. Unless Roger has an appointment he needs to get to or a meeting he needs to make, time on the farm is entirely fuzzy.

"I'll be ready at nine" is never said on the farm because exact time doesn't exist. "I'll be ready when the milking is finished. It may be around nine" is more like it.

On the farm time is based on getting done what needs to get done, plus all those things that come up that Roger didn't know needed to get done but still has to do. When done is done he can do what needs to be done, unless a new do has to be done in order to do what's left undone. His undoing is not knowing what dos need doing to get done what does need doing. Clear as farm time.

Farm time is all relative; relative to the cows needing to be milked or let out or let in, relative to how full the hay wagon is, relative to what still needs fixing and relative to the weather approaching on the horizon. Clocks don't make any difference. Nor, really, does hunger, at least to Roger. The practical reason for this is that it is often easier just to finish something than to stop, go back to the house and get something to eat, and then go back to the job later. This is why I always have snacks in my car or pocket if I think a chore is going to take longer than I expect. This is why I always have snacks.

But this is the seduction of farm time—time doesn't matter. Things are done when they need to be done, and then you go to sleep. Chores—eat,

The twilit cow barn at milking time.

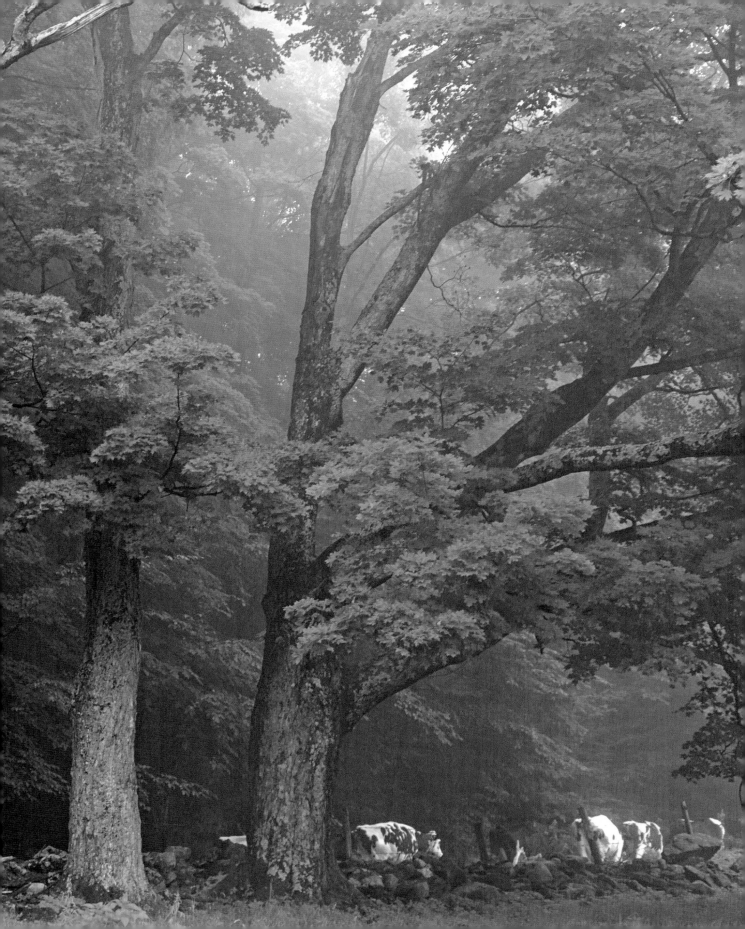

The blacksmith shop, hog barn, and big house from the long meadow.

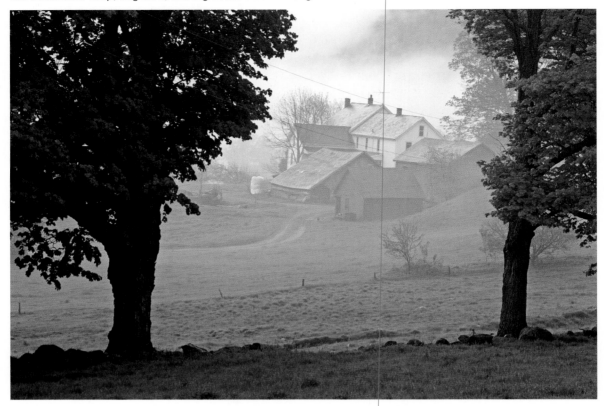

chores—eat, chores—eat, sleep. Repeat the next day. Lunch is in the middle of the day, breakfast is after morning milking, and supper is before evening milking. Just don't ask exactly when.

I have always thought that the appropriate farm clock would not have numbers on it signifying the hours of the day but instead should have udders of varying fullness on it to signify how close is the next milking. "I'll meet you at half an udder in the afternoon," or "It's getting to be full udder in the morning. Better get up to the barn."

Farm time also knows no days of the week. Monday, Tuesday, Saturday, Sunday—makes no difference. There are no chores on the farm that are dependent on a particular day of the week. There are no "If it's Tuesday it must be time to ——." Tuesday is just another day, as is Monday, as is Saturday; the chores don't change. The cows come, the cows go. There's milk to be collected, hay to be spread, fences to fix, silage to feed, stalls to clean. A day is a day and

they are all on the same farm time, call it anything you want.

Farm time is what I miss the most whenever I am traveling. The unforgiving everyday world of time kidnaps my thinking, and I spend my days a hostage to the clock. The plane leaves at 7:02. How many minutes to get through security? How much time for my connection? What day is the meeting? What time is the dinner reservation?

On farm time cows leave when the milking is finished and arrive when their stomachs and udders are full. Meetings are held until the wagon is full or the rows have been cut and connections occur twice a day when milkers are attached to udders. On farm time days stay in fields and barns and hours are kept in your pocket.

Even on a grander-scale farm, time ignores convention. Convention lets calendars control which days are for work and which are for play. They tell us when schools are out or when vacations are in or

when playdates or prom dates are scheduled. We all count the days as we look forward to something and tick off the months until it is such and such season. And holidays are defined by how many shopping days remain and when the sales begin.

Months don't matter so much in farm time. Haying begins sometime in June and lasts until late summer, but it may begin in late spring if it is dry or go into September if the weeks have been wet. "I have an idea of when I would like to start haying or moving the heifers or riding my motorcycle but I'm never really that close," Roger tells me. "It comes when it does and no sooner. It's hard to schedule the weather.

"Yeah, I know, I'm always behind. Or so it seems," says Roger whenever I report on the advanced haying or plowing or cutting I see on farms elsewhere in the state. "But it always gets done, so I don't worry about it. Some farmers want to say they were the first: first to mow, first to plow, first to fill their barn. As long as it gets done, that's all I care about." And somehow it always does get done. A week or two of rain will stop the haying or planting or spreading of

manure, but a few days of sun will set things right again. It may seem a bit haphazard, but that's because your timing is off.

"So who actually runs this place?" I ask Roger one morning in the barn.

"Run the place? Who runs the place? If you mean who does most of the work, then I guess I do—but the old man works, and Trish works, and you work here too."

"I mean make decisions, figure out when it is time to move the calves or start haying or cut corn."

"Oh, if that is what you mean, Dad and I talk about things but we never agree on anything. Mother Nature actually makes all the decisions around here. She sets the times, figures out the seasons, tells us when we can and can't do things. Mother Nature keeps the time, we just do all the work."

Mother Nature doesn't consult a calendar or a clock, things just happen. And when they do, Roger responds. With all there is to do on the farm, it's not hard keeping busy. When you work for Mother Nature you'd better work with her, or else you won't be working at all. ✑

Looking north over the cow barn to Killington Peak.

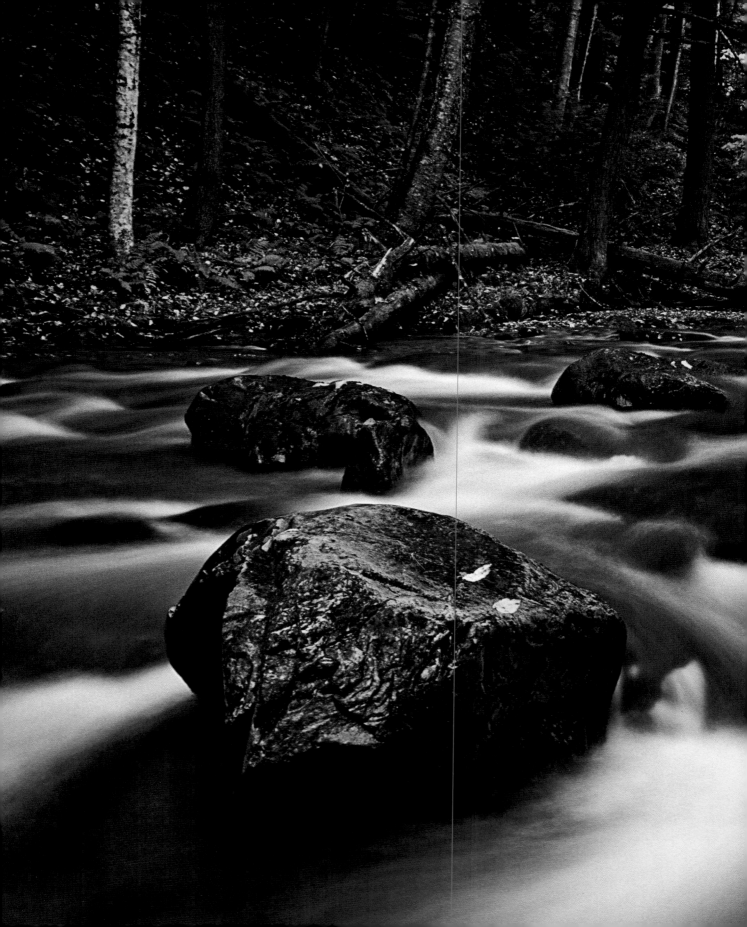

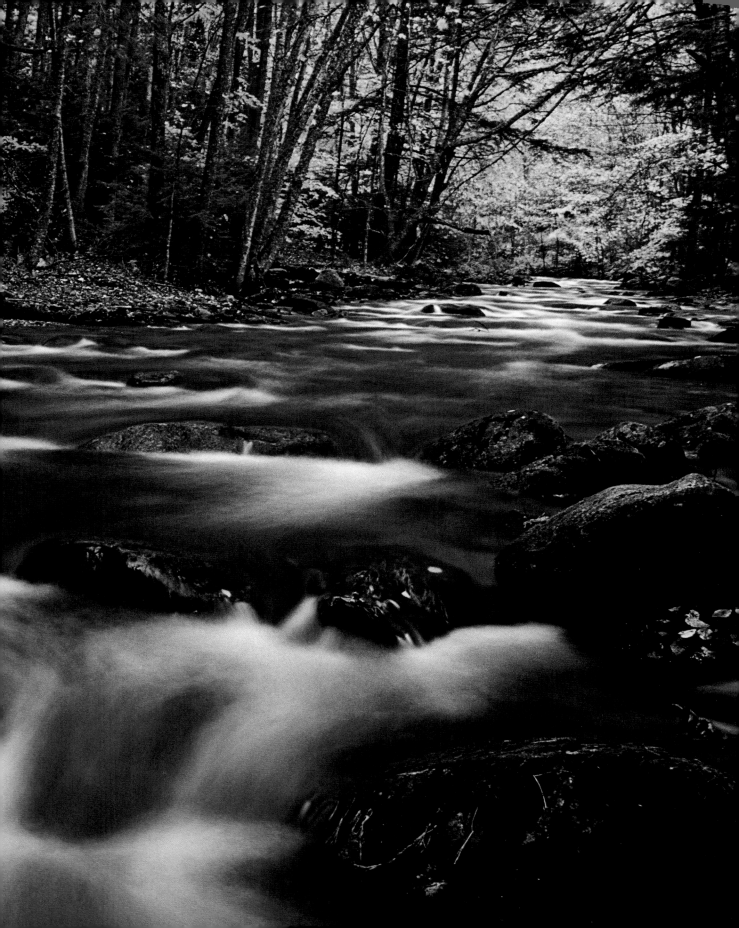

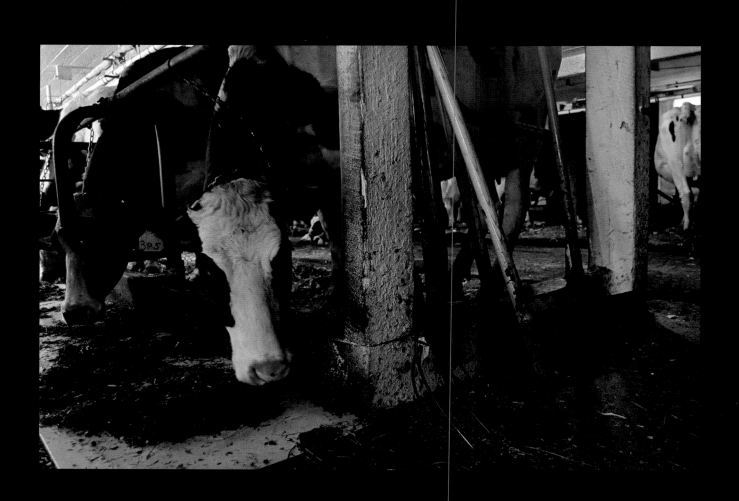

A hoe for Roger

It's nine o'clock at night and the phone rings. It's Roger.

"Hello, it's Roger."

"Hello, Roger. What's up?"

"When are you coming over to the barn in the morning?"

"It's usually after I get up."

"That's not always the case."

"Why do you ask?"

"The barn needs a new hoe."

"You're tellin' me. What happened to the old hoe?"

"I couldn't fix 'er. Got all loose and then I broke 'er.

"It'll happen if you use 'em hard."

"So could you pick one up on your way here tomorrow?"

"Where am I going to find a good hoe in Danby that early in the morning?"

"Go to Elby's, he's got hoes."

"Elby's got hoes?"

"Always has."

"That rascal! But to a hardware store to get you a hoe?"

"Yes, he's got some that are strong and wide."

"Strong and wide? What about good lookin'?"

"I don't care about good lookin'. I want a hoe that works hard."

"It's come to that, has it?"

"I don't care about pretty anymore. I want a long handle and a good head."

"Every man's dream. Am I paying for the hoe?"

"Yes, but I'll pay you back."

"So this is what it has come to: I am now supplying you with hoes."

"Well, I can't ask the old man—he wouldn't know what to do with a new hoe."

"Bet he'd like to try."

"And I can't ask Trish to get me a hoe."

"Wouldn't be right."

"She'd get one that was all fancied up."

"Couldn't have that."

"I need one I can handle easily; otherwise, it seems like work."

"Couldn't agree with you more. Don't you have a hoe at the house?"

"Used to have several."

"You're a lucky man."

"Not anymore. They're all gone."

"Nothing worse than losing a good hoe."

"You're tellin' me. It's hard as hell finding a good hoe."

"This is a big responsibility, getting you a hoe you like."

"Remember, I like a hoe with a thick neck . . .

"Got it."

"With a good curve to it . . ."

Pitchfork, scraper, shovel, and hoe in the cow barn.

"Uh huh."

". . . and sharp blade."

"Roger, what are you talking about?"

"What are you talking about?"

"I was talking about hoes."

"Oh, okay, so was I."

"And drive the truck, it'll be easier getting 'em in the back."

I call Elby.

"Hello?"

"Hi Elby, it's David."

"Why, hello, David. What can I do for you?"

"I need a hoe."

"Claire gone, is she?"

"No, it's not for me."

"Never is."

"It's for Roger."

"Roger wants a hoe?"

"Roger needs a hoe."

"So you now supplying him with hoes?"

"The man can't get enough."

"Tell me about it."

"It's for the barn."

"He'll be using the hoe in the barn?"

"Sure—between milking and chores."

"Not much time for a hoe."

"Roger is very fast. Grabs a hoe, a couple of strokes and he's done."

"Gotta admire a man like that. What does Trish think of this?"

"She's all for it, got her own hoes. They work better for her."

"Can't say that I blame her. What kind of hoe do you want?"

"Roger likes 'em with a thick neck, a good curve, and a wide bottom."

"It's a sad state of affairs. So just a plain ol' hoe?"

"Just a plain ol' hoe will do."

"Spray some WD-40 on the hoe before you take it to Roger."

"You want me to spray the hoe with WD-40?"

"Not where you grab it, just the bottom."

"You want me to spray the bottom of the hoe with WD-40?"

"Makes it work better."

"I'll be darned."

"And bring your truck. It'll be easier in the back."

"Easier in the back?"

"Easier for the hoes in the back."

"Roger said the same thing."

"Doesn't surprise me. He knows his hoes."

"Yes, he does, he surely does." ✑

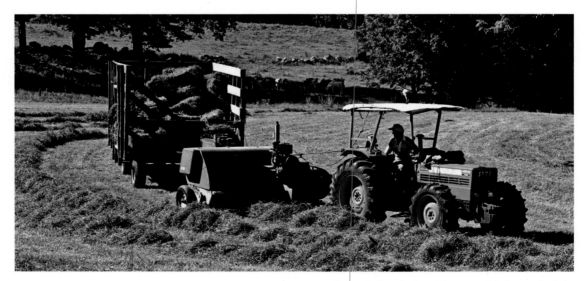

Roger baling first-cut hay near his house in July.

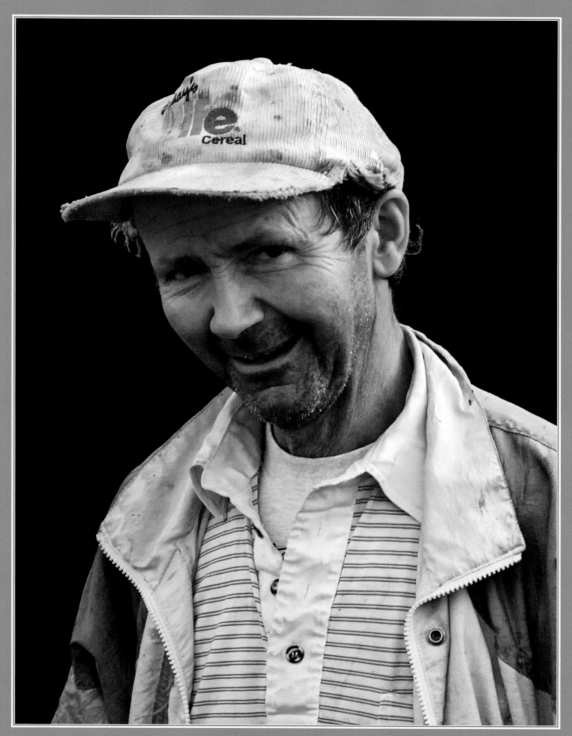

Roger.

Brakes

"Would you mind driving the yellow truck down to the barn?" Hugh asks me late one morning as we are just finishing up fixing a fence up by the high barn. "I want to take my four-wheeler down to the house to get something to eat."

"I would be glad to," I reply to Hugh as I put the heavy mallet and spare wire into the pickup bed and climb into the cab of the old yellow truck.

"Anything I should know about driving the truck?" I ask, knowing that every one of their vehicles is different and quirky and impossible for me to figure out.

"Well," Hugh answers, leaning against the side of the truck. "There's one thing."

"One thing?" I say, thinking that I can certainly deal with just one thing.

He turns his head and spits into the grass. "It has no brakes."

"No brakes? The truck has no brakes?" My mind races and then plunges wildly through the woods.

"Nope, not a one." He spits again.

"Okay, good to know. How do I stop it?" I ask calmly, in an about-to-go-off-a-cliff sort of way.

"Oh, you'll figure out a way," Hugh says, smiling, his eyes twinkling.

"Okay . . . and where would you like me to park it, Hugh?" I ask in a polite, really-won't-be-an-issue voice.

"Wherever you end up is fine," Hugh replies turning away from the truck and shuffling over to his four-wheeler. "Wherever you end up will be just fine." ✆

Hugh and Ike and the yellow truck.

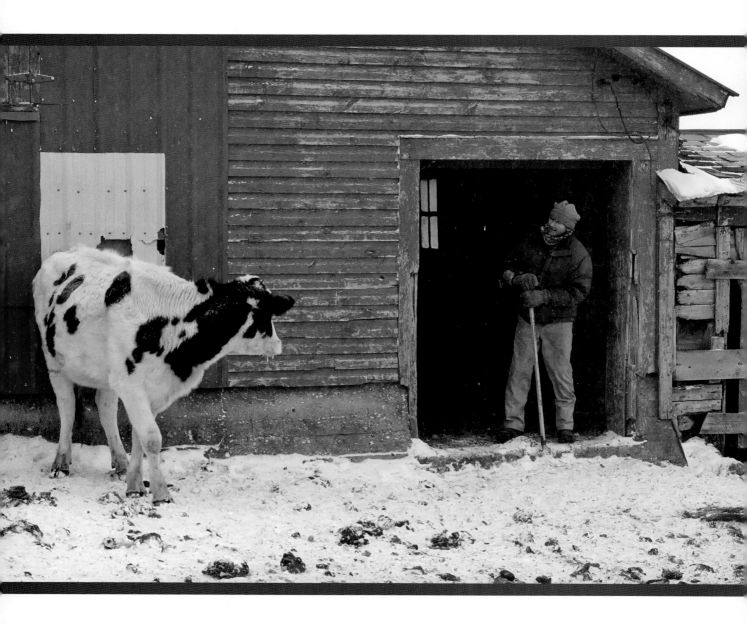

Cow smarts

I spend an unusual and probably mentally unhealthy amount of time thinking about cows, reading about cows, talking about cows, and even dreaming about cows. It's understandable but certainly not normal. This I take as a point of pride.

The fact that I am so cowcentric isn't very abnormal, considering that I spend hours every day pushing around their bony butts, scraping up their messes, tossing them flakes of hay, pushing their silage up to them, unhooking their chains, hooking their chains, bottle-feeding and then pail-feeding their young, bedding their stalls, opening their stanchions, cleaning their mangers, avoiding their shit, not avoiding their shit, scraping their shit from my clothing, pulling their tails to distract the new milkers, stroking their backs to comfort the new milkers, slapping their backsides to speed them up, tapping their front sides to move them back, and even dipping their teats in iodine to prevent infection. The intimacy of my relationship with cows now is second only to that of my relationship with my wife, Claire, though there is a lot more titty time with the cows, just in case you're wondering.

Cows aren't the brightest beings on Earth. In fact, in the great pantheon of all things that share this planet with us, cows' intelligence ranks somewhere between a dandelion's and a hot fudge sundae's. When you look into the black, golf ball–sized eyes

of a cow, it is like looking into a hazy night sky— lots and lots of deep, empty space and only a faint twinkle here and there.

The one time a cow shows any hint that her neurons are engaged in communication rather than just soliloquy is when a cow makes a decision. In all cases it is, without exception, a bad decision. Luckily for dairy farmers and all those peripherally involved with cows, decision making in cows is about as common as a banjo in a Beethoven score.

Cows are animals of routine, and the more mind-numbingly routine the routine, the better. There are few truer followers than cows; a herd of cows, functioning as one small, dimly lit brain, is a more dedicated group of followers than ever was found under a revival tent.

But every so often, about as often as a Baptist does the boogaloo, a cow will do something out of the ordinary and break the routine. With a total herd of a hundred cows, every so often happens every damn day.

Cow misbehavior is so common that its out-of-ordinariness is ordinary. "The spotted one is supposed to be up here in the barn, but tonight she decided she would rather be down there where the big white one has been for years. The white one couldn't go in, but she wouldn't go anywhere else, so she blocked up the aisle, keeping all the other cows

from getting to where they need to be. Once I got the spotted one out and the white one in, the spotted one didn't want to move either. It was quite a rodeo getting them all in to their right places," Roger tells me when I arrive in the barn one morning. Or "That cow is a real prize," Roger remarks when I notice a cow's feet far out in front of her in her stall. "She's lying with her feet in the manger and her belly up on the curb in the front of her stall, and she can't go forward or back because she is so far forward the hitching rail above her head is keeping her from getting her head up." Or "The heifers in the long pastures got out and spent the night fertilizing Trish's garden." Or "That cow got herself so far into the tangle of the tree fall that I don't think she could've gotten out by herself." You get the picture.

Sometimes their misbehavior is on a more epic scale. "She busted through the gate and started walking into town. I think the only thing that stopped her was her empty belly. She doesn't know they don't serve cows in town." Or "The big black one got through the fence and a dozen more followed her. They spent the night on the road; there is cowshit everywhere." Or "The upper heifers got out and the entire lot of them headed a mile off through the woods toward Harry's old farm. A log truck scared them back up from the high bridge, and when I got up to the heifer barn for my afternoon chores they were all milling around out front. The neighbor called and said he had watched them parade back and then forth in front of their place!"

All the Bromleys have a different understanding about cow intelligence. Roger has seen so many profound acts of stupidity that he holds the cows-are-not-very-smart theory more surely than he believes in gravity. He has sarcastically said, "Have you ever seen anything as smart as that?" so many times he should be wearing it on a T-shirt.

Ike takes a different tack to deciphering cow behavior. When he peers into those big, dark eyes he doesn't see emptiness—he sees deviousness. "They just play dumb, but they are watching us all the time, just waiting for the chance to make a break or try something different." He thinks each one is really a fox in cow's clothing and that we are the dumb ones for being so gullible, or in this case, cowible.

Trish takes the healthiest view on cow behavior and smarts. "Oh, they're just being cows!" she will say and not spend much time thinking about something she can't do anything about. There are times, though, when a group of cows will do something really stupid and she will say, "You know, we could sell them all."

Hugh, I'm afraid, doesn't ponder these things much. To him the words "cow intelligence" are about as comfortable together as a porcupine and a balloon. When I've pushed him on it, his response is clad in such a cacophony of cussing that I've never really understood him. He does spit a lot when the topic comes up though, the juice lubricating the emotions like a beer does a trigger.

Yet for all their cow consternation, it is not uncommon for me to catch both Roger and Hugh in quiet and unnecessary acts of gentleness toward the cows. Hugh forever wants to give the "best" cows more grain, and he walks the manger rubbing ears and talking to them every morning I see him in the barn. Roger, for all the complaining and eye rolling he does when calves start to pile up in the barn, increasing both the chaos and his work, will often take the time to rub a new calf's head or sneak it a little more milk. I would be hard-pressed to call it affection. It is more like an acknowledgment of another life, a recognition of a partnership. It is the gentle squeeze one dancer gives another after a particularly satisfying turn on the floor. ✑

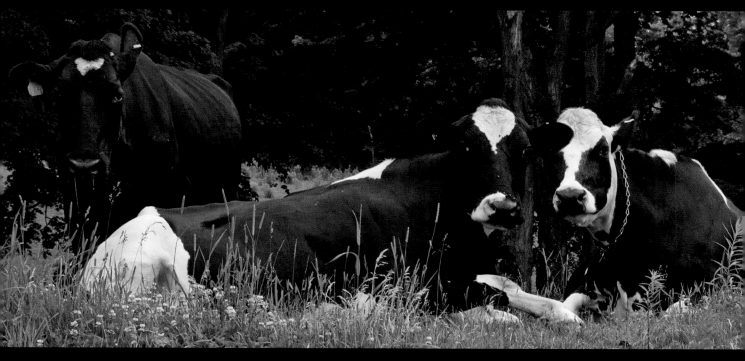

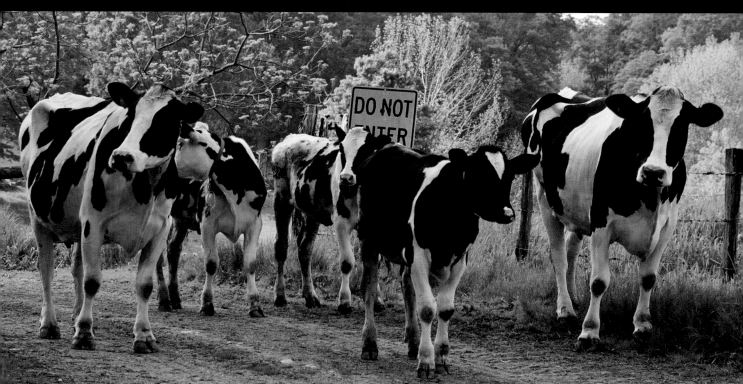

Calves and cows coming back to the barn for dinner.

Roger and a calf arguing about which way to go.

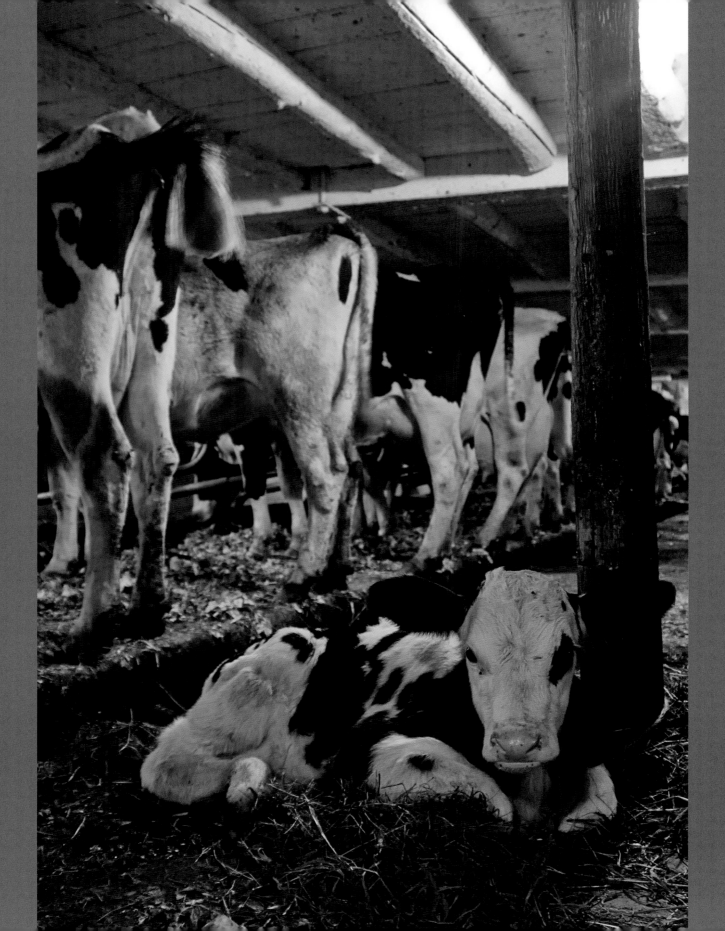

15

Freshening

"The vet will be here around ten to look at the heifer we brought in the barn this morning. Come on over, should be interesting," Roger tells me over the phone just as I am sitting down to have a much-needed breakfast. He knows I can't resist his "should be interesting" and that I have wanted to be around when the vet comes to the farm. I grab a bite and head back to the farm. A real breakfast will have to wait.

It is nine-thirty when Roger calls. I have just enough time to gulp down some food, change my shirt, and ignore the crap on my pants and regather my cameras before I head out the door and back to the farm. I arrive ten minutes later and find the mother in her stall, head in her stanchion, calmly nosing through the pile of fresh haylage in front of her. Behind her stands Roger holding up and out of the way her stub of a tail and another man, whom I have not met, who has his arm all the way inside the backside of the mother. It looks like either the man or the cow was moving with some speed toward the other and they met in a quite remarkable circumstance. On the basis of the cow's nonchalant attitude, I am guessing that these two have met before.

"Well, hello again. Glad you could make it," Roger calls to me as I come into the barn. "Things are just getting interesting." Roger loves when anything different and exciting happens in the barn, especially

when he is not responsible for it. He especially loves when something is getting done in the barn and he is not involved.

"This is Joel, he's the vet, but I guess you could've figured that out yourself."

Joel and I exchange hellos but I keep it short; he is after all up to his right armpit in cow. I consider extending my hand but a handshake seems inappropriate right now and, dare I say, undesirable. Joel is wearing high rubber boots and blue coveralls, over which is a protective rubber smock; on each arm are long plastic gloves that go past his shoulder. Joel is on the short side of tall and the compact side of lean, in his mid-thirties and wearing a crew cut, a pleasant face, and a ready smile. He lives over the mountain in Pawlet and runs his own dairy with his wife and his brother. To get the proper insertion angle and whatever added advantage he can, he is standing on a bale of hay. To say that I have never seen anything like this is probably unnecessary.

I take up a position off to the side, well off to the side, and watch Joel straining to get in even deeper with his arm. At any moment I expect to see his fingers poking out her mouth and tickling the hay in the manger.

"She's got a twisted uterus and the calf's head is turned and facing front, the wrong way. I'm trying to flip the uterus around and then turn the calf's head

Newborn calf resting under mom.

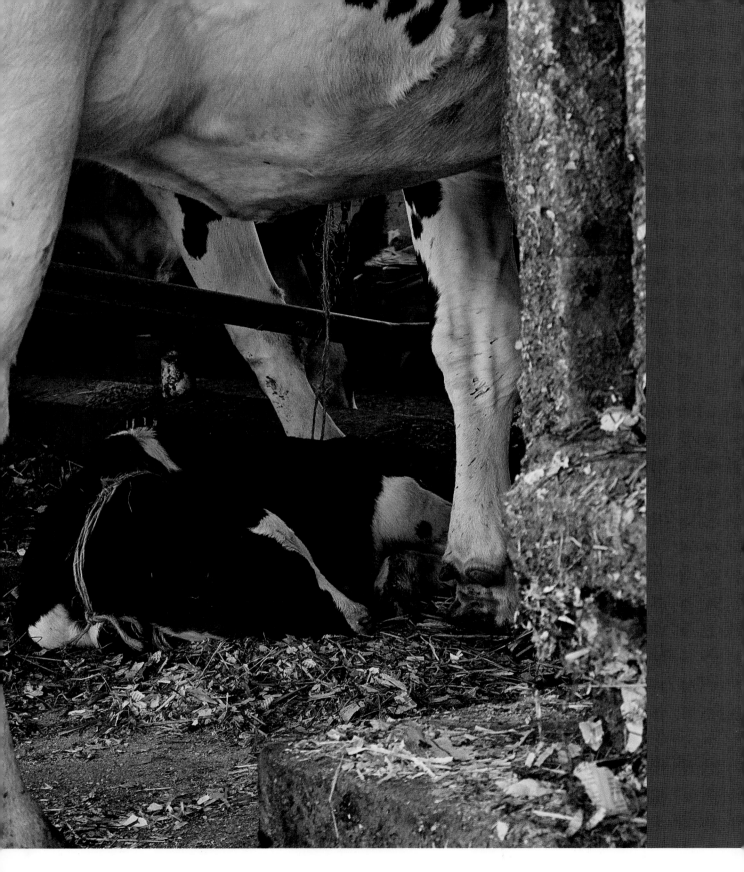

so it's pointing backward, toward mom's tail. I think I've just about got it."

He might as well have said that he's found a small piano inside her and is trying to tap out the allegretto from Beethoven's Sixth; that's about how much I can relate to what he is doing in there at arm's length and by feel. What I can relate to are the fountains of fluids that are gushing out of her backside every time Joel shifts his stance, causing me to take another step back and not offer to hold anything.

Joel, though, is in the direct line, and despite his rubber smock, long plastic gloves, and high overboots, he is getting drenched. Even Roger has stepped aside, out of range of the geyserlike blasts. None of this slows Joel's commentary, however. This is just another day for him. "Unlike in humans and horses, a cow's uterus is suspended on long tendons like a sack of water held up by bungee cords. The tendons are long and loose enough, especially in an old cow, where the uterus can jiggle around and get all twisted. Humans and horses have short tendons holding up their uteri, so in them a twisted uterus is very unusual. It's not that common in cows, but its not that uncommon either."

Joel shifts a bit, leaning into the cow as much as he can. A new splurge of goo rockets out of the heifer. "Old farmers used to think that it happened when cows were kept on hillsides, but I've seen as many in feedlot cows as I have on pastured cows, so I don't think hills have anything to do with it. It just happens sometimes; nobody really knows why."

I like Joel already. He is free with information, his explanations make sense, and he is effectively blocking the spray of bovine fluids with his body. What's not to like?

"Okay, Roger, I've got the head turned around and the front feet pushed back, we need to give a little pull to get the head past the cervix and into the birth canal." Extracting his right arm from inside the cow, Joel pulls out a chrome handle attached to a light chain.

"Does that come with the cow or do you have to buy it separately?" I ask, having missed the insertion of whatever the heck this device is.

"No," Joel chuckles, "this will definitely cost you. Now pull on this, Roger, and I'll make sure the head is where it is supposed to be."

Joel reinserts his arm and checks again that the calf's head is facing toward the back. He also follows the chain back to make sure it is properly placed.

"I've put the other end of the chain, the loop end, around the calf's head so we can pull it out. The head has to go first, then the front legs, or else it doesn't work."

"Okay, Roger, give her a pull now." Roger pulls the chain, making it taut but not appearing to make much progress. From my point of view it looks like he is trying to start a lawn mower the cow has just swallowed.

"Okay, the head is past the cervix and into the birth canal. Let me grab the two front feet—there's one hoof, there's the other—and get her in the proper position to finish the job. Now, Roger, if you have some rope we could get a good pull on the calf and help mom get her out of there."

Roger have some rope? Is he kidding? Roger has more scraps of rope lying around the barn than I currently have thoughts in my head, and my mind is churning.

"I have just the piece," Roger says, reaching for a stiff old yellow piece of rope hanging behind the ladder by the milkroom door.

"Loop it through the handle and then around that post and give it a good steady pull. We'll see what happens." What are the choices, I wonder?

Joel takes a plastic bottle out of his pocket the size of a baby powder bottle and shakes some white powder onto his hands.

"Is that a disinfectant?" I ask.

"No, it is a lubricant. Turns to a gel as soon as it gets wet and stays slippery for a long time. I'm going to put some more inside her to help her along." Joel reinserts his arm a couple of more times spreading the powder. "Okay, now pull!"

I get on the rope with Roger and with all three of us pulling, the calf slowly emerges; first the nose, then the head, and then the tips of the front feet. Eventually its head and neck come out and then

its shoulders. After the front legs are out and the shoulders are clear, the back half of the calf slips out rather easily. Not happily, but easily.

The mother during all of this has not made a sound or so much as shifted her feet. About the only thing moving on mom are her jaws; she has not stopped eating this entire time. She has occasionally shot us a glance over her shoulder, but she has remained remarkably, even angelically, calm through all of this.

One last pull and the calf falls unceremoniously into Joel's arms and then onto the floor. The calf lies sprawled, a look of disbelieving shock on it slimy face. Joel reaches down and brushes away the last bits of the amniotic sac and runs his hands over the calf, getting it to wobble up to an unsteady sitting position. Then, with what looks like a pipe cleaner, he cleans the nostrils of fluid. A couple of coughs and several gurgling snorts, and the calf takes its first breath of barn-fresh air.

It looks enormous to me, but I have just seen where it came from, so anything bigger than a large muffin would seem enormous to me. "It's a bull, and a big one at that," Joel states. "I'll bet mom is relieved to get him out of her." Roger is relieved too. Without the help of the vet this calf would have died inside the mother and she would have then died as well.

"She's a good cow, had her six years; I'm glad she'll be okay. I would've loved to have a heifer calf out of her but I'll take a bull. We have plenty of young heifers."

Roger picks up the new, still slimy calf and carries it around in front of mom. There, on some old hay for bedding, mom and calf get acquainted through the strong licking of mother's tongue.

There is nothing cute about a calf at this point in its life—cuteness takes about twenty-four hours to arrive on the scene. Right now the calf looks textbook pathetic—wet, slimy, blood-flecked—and its attitude can best be described as stunningly perplexed.

Roger and I stop fussing around the cow and calf and watch the scene at our feet. Licking comes as naturally and spontaneously to a mother cow

as blushing comes to a bride. The calf lies silently, enduring the rough massage. Its legs are splayed, beyond the calf's control at this moment. Perhaps not grudgingly but also not enthusiastically, the calf is licked and stimulated and massaged into his new life.

Licking from mom's perspective is important for bonding, but it also serves other purposes. It may be a way to regain needed nutrients or replenish some lost fluids. Perhaps the amniotic fluid is salty or perhaps it contains calcium. Whatever the reason, the licking is insistent. In an hour the mom will still be licking the calf in between breaks for food, and the calf will be dry, fluffy, and mostly in control of its legs.

"It's really something that that could've come out of that," I say with my usual barn eloquence, nodding at the calf and then the mother.

"Yes it is," Roger replies, quietly looking at the calf. "Yes it is." ◠

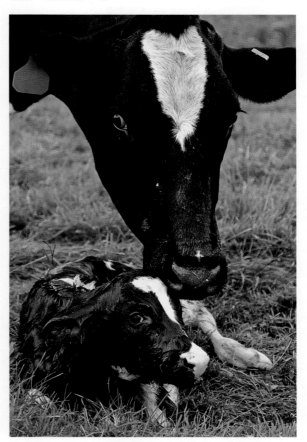

Fresh out of the chute, a calf just moments old.

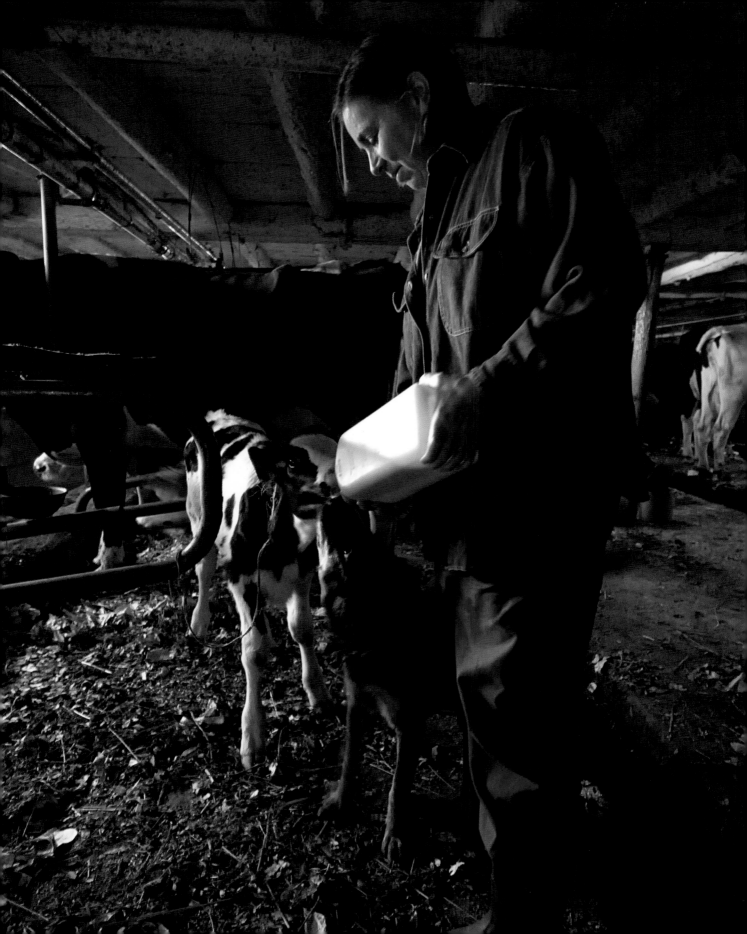

16

Milk wars

It's late August and I am walking into the milk barn a little later than usual, seven in the morning. I get out of bed at the same time in the summer as I do in the winter, but between the pillow and the car I seem to lose my way to the farm more easily when it is light outside. Curious how I find my way in the dark yet go astray in the light.

"Morning, Hugh!" I call out as I enter the barn and see him sitting on the stacks of newspapers to my left. He has been in the barn since five-thirty this morning (so I am told), and since his morning feeding chores are long finished, he is now simply sitting with the cows, watching.

"Morning, sir," he says, looking up at me, a small smile clinging to his stubbly face. I never really know if he can see well enough in the early-morning gloom of the barn to know who it is. I usually have to walk toward him and get into better light for him to change his expression from "who the hell is that?" to "by gawd, it's David." He recognizes my voice, though. Usually.

"What's new?" I ask, giving him the remaining part of my normal morning greeting.

"Oh, not much," Hugh replies through a soft chuckle. We tend to be not very imaginative first thing in the morning.

"Morning, Roger!" I say as I walk into the center aisle, grabbing the old hoe to start scraping out the stalls. "A tad noisy in here." It is actually very noisy, unusually so. "And a tad more crowded than how I remember the barn yesterday."

"Is it still morning?" Roger says, stepping out between two cows and playfully looking at his watch and ignoring my observations. He's been in the barn for at least an hour and he doesn't mind kidding me that I have not.

"Noisy, you say? Noisy? Is that what you said? Not sure I heard you with all this blatting. We have a few new calves in the barn."

"Yes, I can tell," looking down to the far end of the barn and seeing three new calves hitched to posts where yesterday morning there were none. "How many and when did they come into the barn?"

"Five, there are two more wandering around somewhere. I got them yesterday afternoon, brought 'em down from the heifer barn. They're not happy to be here and they're hungry."

"Yes, I can tell." The din gave away their emotions and the state of their stomachs. "Have they gotten any milk this morning?"

"Not yet," Roger says as he turns back to the cows. "Good luck!"

"Thanks, Roger. You know how I love a challenge!"

I head back toward the milkroom after leaning

Trish giving a calf (and her dog Quicksilver) a bottle of milk.

the hoe back against a center post. Scraping up will have to wait. I've got new calves to teach.

When a calf comes into the barn for the first time with its mother it can be either gentle, sweet, and quick to learn its lessons or stubborn, loud, and slow to figure things out. Most are the former; the memorable ones are the latter.

The lessons a calf must learn and will learn eventually if it expects to stick around are, first, sucking milk from a bottle, then drinking milk from a pail, graduating to drinking water from a bowl and eating hay or silage from the manger. In other words, a calf has to learn to suck, drink, and chew, not an unreasonable list of goals for a cow, in my mind.

Teaching a calf to suck milk from a bottle should be about as hard as teaching a snake to slither, but it is not. Most calves have to be taught to suck from a bottle. They'll suck expertly on mom right away, although mom might have a different opinion of their expertise, but sucking from a two-quart bottle with a nice, soft rubber nipple that is otherwise the same as mom's teat appears to be the cow equivalent of rocket science. The struggle to get the stubborn ones to suck from the bottle and drink from a pail is nothing less than a major battle: spilled milk is the ammunition, loud blatting is the artillery, and milk-soaked pants and socks are the casualties.

The one thing that a calf can do and do well without any instruction is to blat (blat is onomatopoetic—the word is the sound). Blatting is the calf's version of mooing, sort of a beta-moo or Moo 1.0. But there is a difference. A moo is sonorous—mellow, hollow, and deep, often with a faraway quality to it even when the mooer is close. A blat is none of that. A blat sounds like an old man blowing his large nose through a paper towel tube attached to a microphone with the volume cranked up. When you are standing next to a blatting calf, it is impossible to hold a conversation; when standing near five, it is impossible to hear yourself think.

Calves blat for two reasons. One is because their world has changed and they're not happy about it. They have gone from a quiet, comfy womb without a view to the wide-open world full of strange things, none of which is particularly comfy. To show their displeasure with the change they blat and blat and blat. Human babies bawl, cow babies blat. Why? Because they feel like it and they have no other alternatives. To be a calf is to blat, it is as simple as that.

The other reason calves blat is because they are hungry and mom is gone. It turns out mom doesn't much care about junior and junior doesn't much care about mom. To most moms a calf is a calf is a calf and to most calves the barn is full of fifty moms. The calf just wants a mouthful of milk, so any teat in a storm, or barn, will do. But if Roger lets the little gals and guys roam freely like a bunch of adorable, milk-crazed delinquents, he would get much less milk and the calves would rule the asylum. So after a day or two of wobbly wandering, a calf is hitched and a bottle and pail take the place of mom.

With bottle in hand I approach the calf at the first post. She immediately backs away from me, going to the end of her line. "It's okay, just a little milk," I coo, trying to comfort her as I step closer. To give her milk, I have to catch her and hold her because it is impossible to get a rubber nipple into a moving mouth. This is something you are just going to have to take my word for. Since I am holding the bottle with one hand, I have to hold the calf with the other hand or arm or any other body part that is available.

To hold and control but not scare or upset the calf, I usually bend over and catch her neck between my left arm and my side, my left leg diagonally splayed in front of her creating a human origami figure. I do this with the calf on my left side to allow my right hand to operate the bottle. I then use the fingers of my left hand to pry open the calf's mouth, gently inserting them into the toothless gap in her jaw between her finger-nipping incisors and her finger-pinching back teeth. This gap, this wonderful gap, is one of the few design innovations in a cow that I strongly support.

Once the mouth opens it is just a matter of inserting the rubber nipple into the mouth and letting the sucking instinct take over. Oh, how I wish that

were true! Calves don't automatically suck. They will eventually, but first they chew. Chewing a nipple is about as effective as peddling a car—lots of activity but very little to show for it. Chewing, though, is an effective way to get milk all over my sleeve, my pants leg, and, with a bit of effort, my socks. And when calves chew, their heads move, bobbing around like a prizefighter's avoiding a jab. Now picture yourself holding a large bottle of milk up to the fighter's mouth, trying to get it into his mouth. Okay, a disturbing image but accurate nonetheless. Still, I have to be patient and keep the bottle in the calf's mouth as I wait for sucking to start. Chew, chew, chew, chew, suck, chew, chew, chew, suck, suck, chew, chew, suck, suck, suck, bingo! We have sucking!

Some calves will start sucking when they feel the nipple at their lips, not very efficiently at first, but they get the idea and get milk into their empty stomachs. These calves are a treat to feed. It's a delight when a calf enthusiastically sucks on a bottle, its head cradled by my side and its beautiful, big doll eyes blinking in the milk. To be so close and so involved with a brand-new, soft, clean calf is magical.

But some calves will battle the bottle and me despite their hunger. Roger always says that "there is no better motivation than being hungry," and I agree; but sometimes the shear stubbornness of a calf is frustratingly maddening. Today the biggest calf, a bull calf who spent his first two weeks with his mother unsupervised in the high pasture before coming into the barn and who now weighs close to 150 pounds, is chew, chew, chewing and not learn, learn, learning to suck.

"He didn't take the bottle last night either," Roger says as he walks up to me.

"Well, at least he is being consistent, 'cause he's not taking it now either."

"Maybe you should try him with a pail," Roger suggests without conviction. Both of us know that getting a calf to drink from a pail is even harder than from a bottle. There's nothing even remotely natural about a pail. And the pail is down on the floor so a calf is drinking up, whereas a nipple is up in the air, where milk is supposed to come from, and the calf is drinking down. This may seem trivial to you but try eating cereal lying on your back and then talk to me.

I go back to the milkroom and get a one-gallon pail and pour in the milk from the bottle. With two milk-soaked fingers I approach the calf and touch my fingers to his lips. He begins sucking on them immediately. The pull on my fingers is strong but not uncomfortable, the soft roughness of the calf's tongue trying to squeeze milk from my hand. This is an old trick used to preoccupy or distract a calf or to get it to move along. Any calf will move forward to keep receding fingers in its mouth, but no calf will figure out that there will never be milk produced from all that finger sucking. Such is the little bovine brain.

Now the trick is to get him to follow my fingers down into the pail of milk. The thought is that if he is sucking on my fingers and my fingers are in the milk he will make the connection and simply suck the milk without the fingers. Unfortunately, that connection is often busy.

I put my fingers into his mouth and he sucks eagerly. As I slowly lower my hand toward the pail, the calf slowly lowers his head. As my hand sinks into the milk his nose follows and . . . nope, so sorry. Up comes the head, out come the fingers, and we start again. Since I've got nothing else to do, I get to repeat this process until the milk to mouth connection is forged. Over and over the pattern repeats—fingers in, head down, fingers in milk, nose in milk, oops, head up, fingers out; fingers in, head down, fingers in milk, nose in milk, oops, head up, fingers out; fingers in, head down, head up, arggh!

To add some variation to this useless routine, the calf every so often violently throws its head forward, butting whatever is in front of it—my head, my leg, the pail, or the post. Many calves butt, a natural behavior evolved to stimulate the udder to drop more milk, but this one tosses the pail across the barn when it throws its head. Every time it sends the pail sailing I have to retrieve it, clean it, refill it and start anew.

After thirty minutes the calf has learned to blow bubbles in the milk. Though this may seem

disrespectful and certainly frivolous, it is actually a good sign. Bubbles mean the calf isn't sucking but it is keeping its head down in the pail with my fingers in its mouth long enough to blow bubbles when it exhales. Bubbles are a short snort to drinking, so I keep my fingers immersed and my head away from sudden head butts, and within minutes the calf is, finally, drinking all by itself. I will have to go through this finger routine again to reinforce this new behavior, but most of the battles are over now and the calf is on its way to being a bull.

Walking back to the milkroom, empty pail in hand, I stop behind two cows and one farmer.

"Howja do?" Roger asks, admiring my milky battle scars.

"The big bull calf is drinking now but it was a struggle. He kept on tossing the pail around," I say wearily. "And he is just a tad stubborn."

"I did see the pail go flying but I figured you had it under control. He'll be going down the road to another farm now that he has learned to drink, so you won't have to struggle with him too much more."

"I can't tell you how happy that makes me," I say wearily.

"So are you a suckee or a sucker?" Roger asks, enjoying his word play.

I turn, smiling, and start to shuffle off to the milk room. "I feel like both, Roger," I tell him over my shoulder. "I feel like both." ✑

A calf thinking deep cow thoughts.

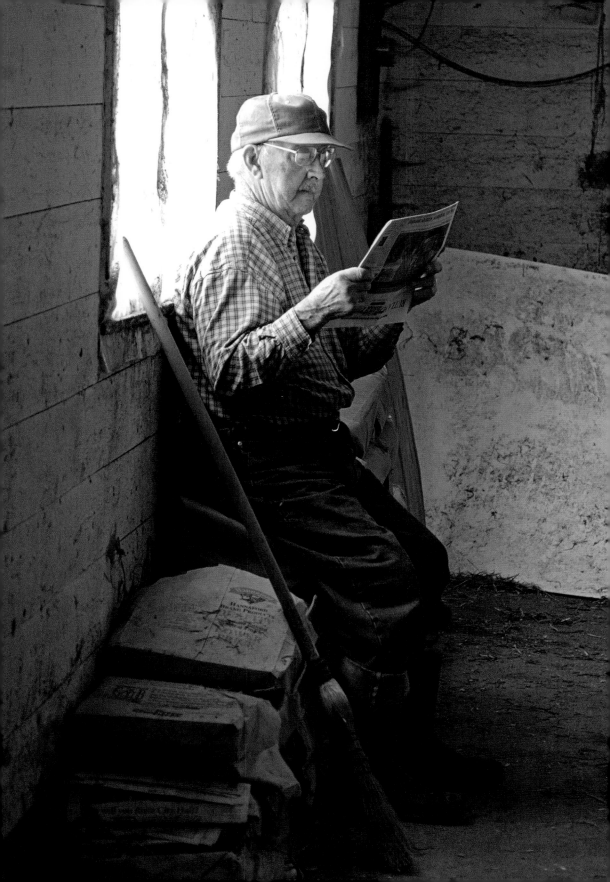

17

A good ol' girl

Hugh spends lollygag time—the time after we finish our chores and Roger finishes milking—sitting on the stacks of bagged newspapers that are piled along the wall under the big windows by the main barn door. Much of the time I'll see him just sitting there, with his back straight and his hands on his knees or leaning forward, Yoda-like, his hands resting on top of his old ski pole cane. When I can I will sit with him, and he'll tell me a story or two or start a rant about the town road crew or how the schools are being run or what's gotten into young folks these days. Sometimes he'll pick up a nearby months-old newspaper and take a look at it, but most of the time he'll just sit watching the cows in front of him as they watch him back.

"She's a good ol' girl, this one is," Hugh will say staring at the cow in front of him. "She hasn't a care in the world."

"She's not getting any smaller, Hugh," I add.

"No, by gawd, she isn't. That's a big cow. I'm looking forward to seeing her freshen—she'll have a good calf, maybe a heifer. She's a good ol' girl."

The cow lies in front of Hugh, resting after eating her fill of haylage. Her belly is huge, cartoonishly so, yet she is still a couple of weeks away from giving birth. I look into her big chocolate eyes, but I don't see much inside. To Hugh it is a different story. He sees a steady milker and a cooperative animal that has been a good provider of milk and calves for several years. And she is a gentle cow, tolerant of distractions, unlikely to toss her head around, lean on you, or give you a stray kick if she disapproves. When Hugh gets up to resume his chores, he always stands next to her for a moment and rubs her ears, mumbling sweet cow nothings only she can understand. 🐄

Hugh reading during lollygag time.

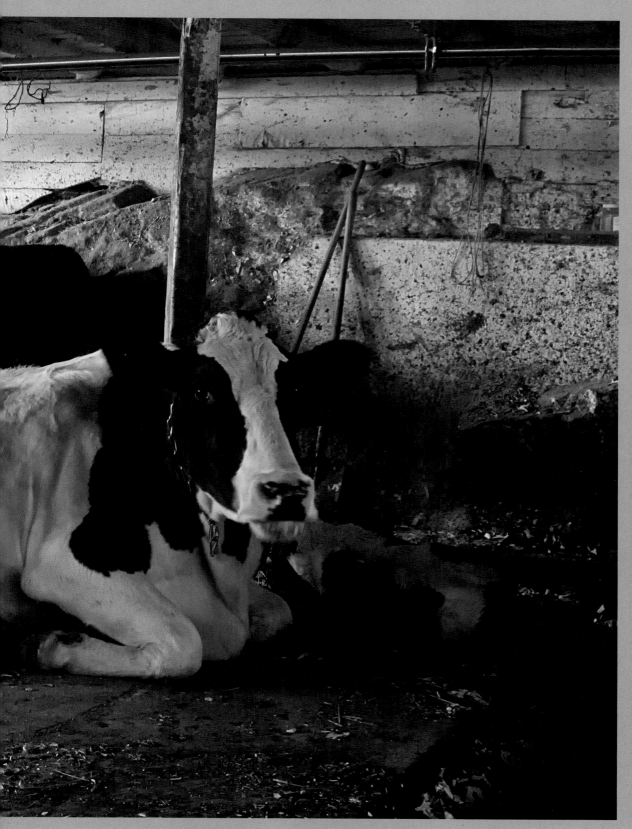

Not wanting to go too far, Mom lies down with her new calf.

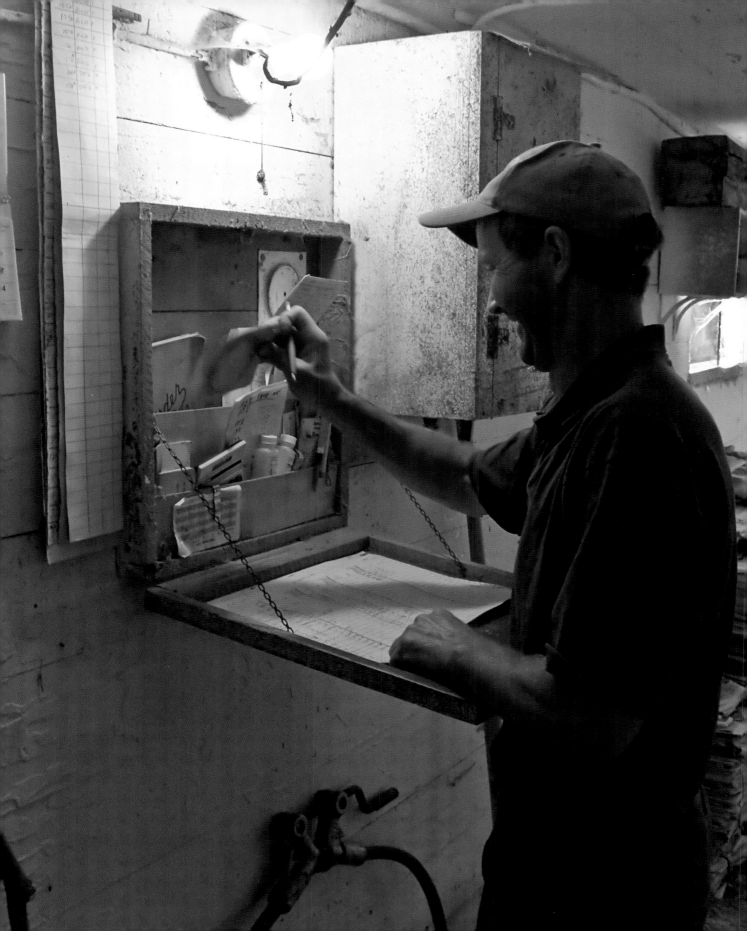

Running late

The other day Roger was invited to a luncheon in Rutland by his banker to find out about trusts and estates. The next morning I asked him how his big day in the city went.

"The affair started at noon," Roger tells me. "I was planning to leave the farm around eleven-fifteen to be sure I was early, but then the sperm salesmen showed up and Trish's sister brought some stuff up, and I didn't get out of here until twelve-ten."

"Well, at least you got there. Did you learn anything?" I ask.

"Oh, yeah. I learned that you miss the salad if you're late." ✎

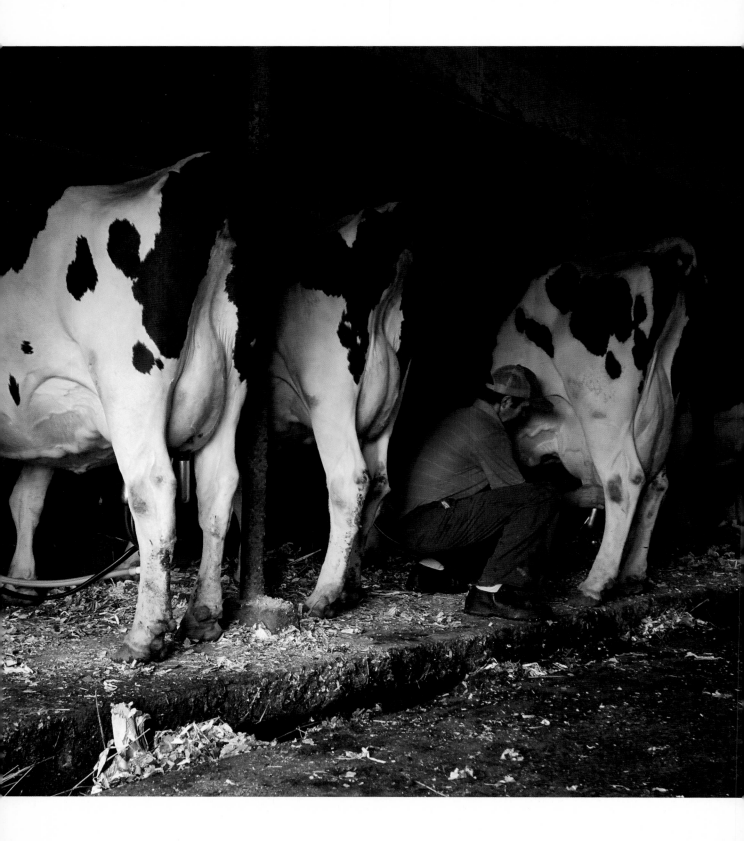

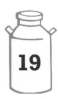

Milking

It has taken me two and a half years to figure out Roger's milking routine. This is a tribute to the outward complexity of what he does and my inward farm dim-wittedness.

When I first was learning to help in the barn I used to try to lend a hand with the milking, or, I should say, I used to try to figure out how I could lend a hand with the milking. But I could never figure it out, a fact for which Roger's cash flow and sanity are both thankful.

It's not that milking a cow is difficult; it is not. But Roger milks pairs of cows, actually four pairs of cows, all at the same time and something different is happening to each cow at any one time. Trying to figure out the pattern of what is going on is like trying to learn the steps of four pairs of out-of-sync square dancers, each one doing different steps to different parts of the same dance at the same time. Picture that and now imagine cutting in and not boggling it all up.

Here are the five steps in the dance that is milking: prepping the cow, attaching the milking claw, checking on the cow, detaching the milking claw, and, finally, sterilizing the teats. If Roger milked just one cow at a time, the routine would be very straightforward. It would also take much longer than the two hours it takes him now to milk all fifty cows. A cow takes about five or six minutes to milk, and each one will give about three or four gallons of milk. It may

take eight to ten minutes, though, and Roger may get only a gallon or he may get six gallons out of a cow. With fifty cows to milk and all the time to get ready to milk and then get cleaned up after milking, doing one or even two cows at a time would make it impossible for him to do anything else on the farm.

All the waiting on one cow is why Roger milks three other cows at the same time. But because every cow takes her own sweet bovine time, and that time is never the same, no part of the milking is synchronized. It's like watching four games of three-card monte all at once.

Okay, here is the basic technique. I don't suggest you try this at home. The first thing you need to do is introduce yourself to the cow. You are about to get pretty intimate with her so some preliminary pleasantries are always helpful. Don't go overboard, because you have fifty preliminary pleasantries ahead of you and every cow expects the same level of emotional commitment you have expressed to the first. If you feed one a treat, you'll be feeding them all. If you compliment one, you had better have compliments ready for the rest. What is heard in the herd is heard by all the herd.

Roger's pleasantries consist of a light touch on the rump to let the cow know he's there and then a crisp "tck-tck" to let her know he's coming in, claw in hand. With a properly trained animal this is usually sufficient to get her to move and be compliant.

When Hugh is helping with the milking, compliance is achieved with a loving "Come on, you old bitch, get over."

Interestingly, the above technique seems to be species-specific despite its obvious universal appeal, at least to males, that is. Hugh claims that his technique might have worked with the ladies, although he says he never tried it. The fact that he didn't die an early death seems to prove that point. In trials of my own, I can confidently report that a "tck-tck," no matter how crisply delivered, even with the addition of Hugh's endearing words, has never produced compliance or movement for me. And even with the sure-bet light slap on the rump, the results are the same.

After introductions, Roger leans over and rubs the udder and squeezes each teat, quickly and clinically. In doing so he stimulates the cow to "drop her milk" into the lower part of each quarter of the udder and thus into each teat. He also checks by touch for cuts or scraps or any other of a number of potential problems with the teats. Teats are, not surprisingly, both very delicate and astonishingly resilient. On a cow with a big udder the teats are tossed around like promises by a politician; between hooves, fences, brush piles, and brambles, teats can take a beating.

The milking claw is a four-pronged apparatus that looks like a four-legged spider with six-inch-long suction collars for feet. Each collar leads to four tubes, the legs of the spider, and each tube leads to a central cup, the body of the spider. Two bigger tubes lead out of the cup—one is a vacuum and controls the pulsed suction in each collar, and one is a sterile plastic tube that carries the milk. The milk from each cow goes up to a sterile stainless steel pipe that circles the barn and eventually is dumped into a sterile 800-gallon stainless steel tank in the milkroom.

When most of the milk has been collected, Roger removes the claw and either turns around to the neighboring cow, which he has already prepped, or moves to a new pair of cows down the barn. When he has finished a number of cows in a row, he takes a dipper full of iodine and dips each teat into the antiseptic solution. The entire process for one cow takes about ten minutes.

The complicating part of the process comes from milking four cows at once, while prepping, checking, finishing, and cleaning four others. At any one time while Roger is milking he will be milking one cow, prepping two others, monitoring two, and taking the claw from another. This is why from the sidelines what is in fact a studied, efficient routine looks like nothing more than random improv.

"Four claws going at once is the right number," Roger tells me. "Any more and I'm rushed and too busy to get anything else done. Any less and it takes too long. With four going I have thirty seconds here, a minute there to do the other chores I need to do—fill the feed cart, scrape up, collect milk for the calves, feed the calves, all the things you do around here. The big operations will have six milkers going at once but they usually have a milking parlor and lots of help. For me, four is just right."

With fifty milking cows, four claws and two hours twice a day, every day Roger collects a ton of milk. That is about 5 gallons of milk per cow, per milking, or 250 gallons a day. Miss a day and you will have a bovine rebellion in your barnyard.

As you might expect, this is the old-fashioned way of milking cows. Not the really old-fashioned way of hand-milking on a three-legged wooden stool, but old-fashioned nonetheless when compared to the mega-dairies with hundreds of cows. Those operations all have milking parlors—separate rooms where all the milking takes place. Cows come in six at a time, are attached to fancy machines by white-coated technicians standing in pits below the cows and are then let out into the barn for a smoke and a bite to eat. It is all very modern, very machine-oriented, and very efficient. Imagine a quick-lube car place and switch the cars to cows and the oil to milk.

"I can remember milking by hand," Hugh tells me one morning. "We didn't get a fancy milking system in here until 1926, but it didn't work well until we got a better one in 1933. We milked by hand from '26 to '33."

"If you had a new milking system, why did you milk by hand?" I ask.

"Well, that's a good question. I don't know why we still milked by hand. I do know why I milked by hand . . . I was told to!"

I find Roger in the barn removing a milking claw and ask him the same question.

"It was because the first automatic milkers weren't very good. They had good suction but it wasn't until they figured out the suction had to pulse did the automatic machines work worth a darn.

"We used to milk into big metal buckets and then carry the buckets to a holding tank. Before that they filled metal milk pails like you see now in antique stores and hauled them by horse down to the railroad tracks. The milk line system we have now eliminated all the pails. Now the milk goes from the cow directly to the holding tank. But we were pretty late updating; we didn't get the milk line until 1993. Most of the other dairies around here had already got the new system years earlier."

I go back to Hugh to ask about the really old days milking on the farm.

"When did you start milking cows, Hugh?"

"Five, started when I was five," Hugh tells me, the pride obvious in his voice. "We used to milk out there," he says pointing out the barn door to the old back barn in the barnyard. "I remember my father and a hired man and my brother Mott and me all milking cows. We only had fifteen cows then. We had one that used to kick. What was her name? Tom, it was Tom. Tom Shooter. Ol' Tom Shooter."

"You had a cow named Tom? Tom Shooter? Why Tom Shooter?"

"I don't remember why we called her Tom," Hugh says laughing. "But she could kick, all right. When I was five, I was milking her and she gave me a kick, sent me right out the barn and into the dirt yard."

Hugh is chuckling as he tells me this, his arms raised and his feet up showing me how he went flying out of the barn and landing on his bottom. "Right out the barn! Someone picked me right up and put me right back to milking. I don't know how I did it, put me right back to the cow."

"But why Shooter?" I ask feeling like I missed something.

"Why, she shot me right out of the barn. She was Tom Shooter after that."

He is shaking his head now, a mixture of amazement and pride. Even now, eighty-five years later, he can see himself flying backward out of the barn like a kid in a cartoon. I'm sure he wasn't laughing then. But I am also sure he got his milking done. ✍

Roger putting on the milking claw.

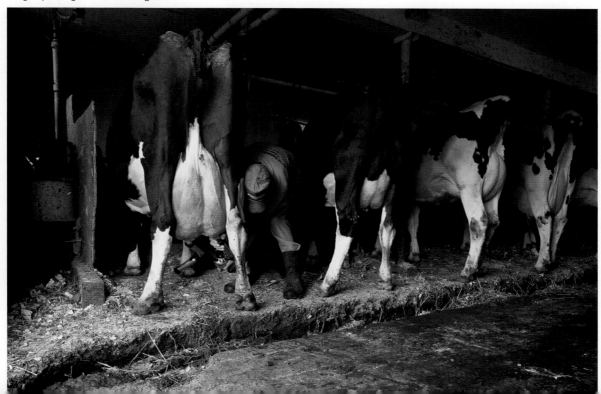

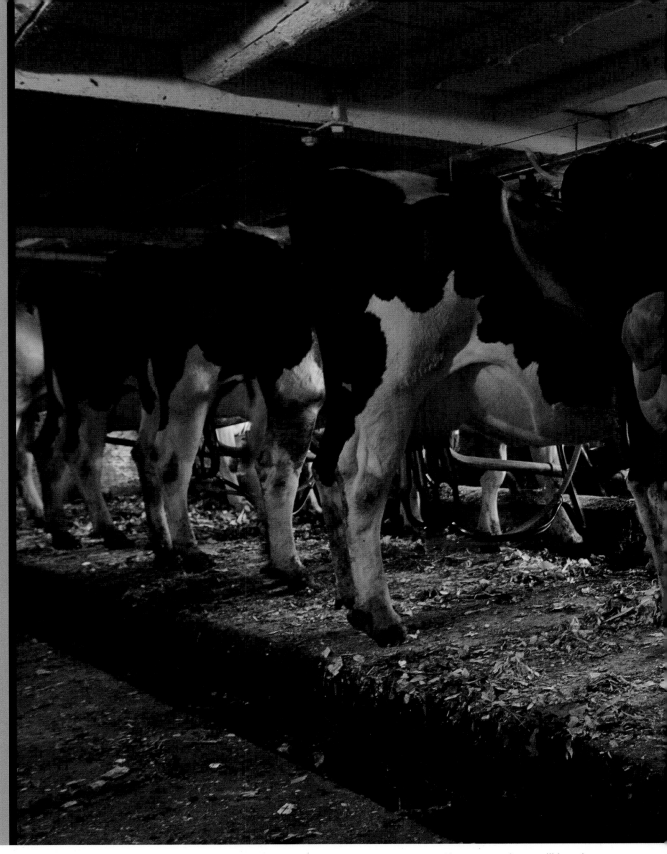

Roger removing a milking claw.

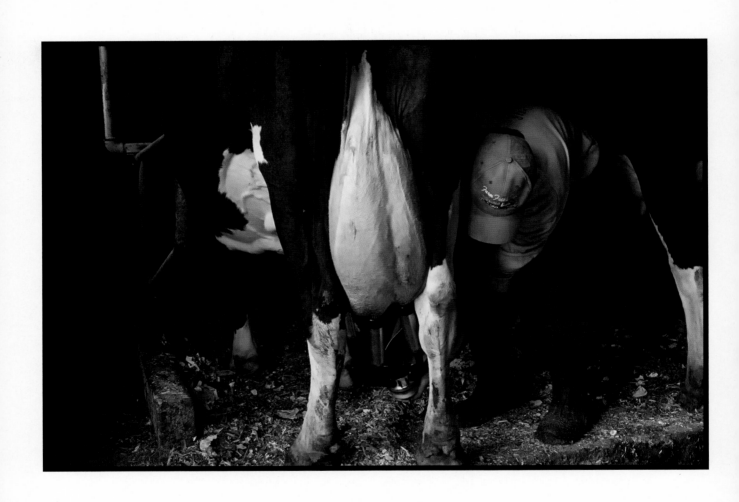

Milking by ear

It wasn't until I used the wrong shovel in the wrong place doing the wrong thing that I realized that Roger keeps track of what is going on in the barn when he is milking mostly by ear. He listens for the pump in the milkroom to make sure it is still running. He listens to the silage unloader to make sure it is throwing food down the chute, and he listens to the manure pump to tell when it's done. He listens for cars coming up the road and for Trish leaving to go to work. He listens for his dog Silver when she barks and for how the feed cart is running. He also listens for soft aluminum shovels scraping along hard cement floors. That was my mistake.

Most of the time he listens to the milkers. He can tell how each teat cup is sucking by the sound it makes. If a cup has slipped it makes a different sound from a cup that has a good hold. The milkers are my favorite sounds in the barn. If I get to the barn before Roger starts to milk, not an easy thing for me to do, I can monitor his progress by listening to the growing rhythmic symphony.

A single milking claw makes a pah-took, pah-took, pah-took, pah-took sound, the double rhythm of two pairs of teat cups alternating suction on four teats. But all milkers make a slightly different sound

because all teats and udders are slightly different shapes. When Roger adds a second milking claw the rhythm picks up—took-a-pah, took-a-pah, took-a-pah, took-a-pah—like a horse galloping on rubber cobblestones. A third and fourth milker add a high note to the milking symphony—tuckity, tuckity, tuckity, tuckity. And when Roger removes a milker and moves to the next cow the cups now sucking air produce a low base line—tock, tock, tock, tock—like a clock that has lost its tick.

Because the cows being milked are all in different stages—some just starting, some running dry, some mid-milkng—and because there are other sounds in the barn—the compressor, whrrrrrr; the milk pump, nummmmm; the silage unloader, chik, chikchik, chikchik, chik; the manure pump, uhm pfff, uhm pfff—when Roger is fully involved with morning milking and chores the barn sounds like a room of toy trains all chugging and tooting at once—tuckachik, tuckachik, tuckapfff, tuckanummm, tuckachik, tuckachik, tuckawhrrrr. Tuckachik, tuckachik, tuckapfff, tuckanummm, tuckachik, tuckachik, tuckamooooo.

If you are reaching for something to tap on a table right now you should head for the barn. We'll find something for you to do. ☜

Roger milking (he's the one in the hat).

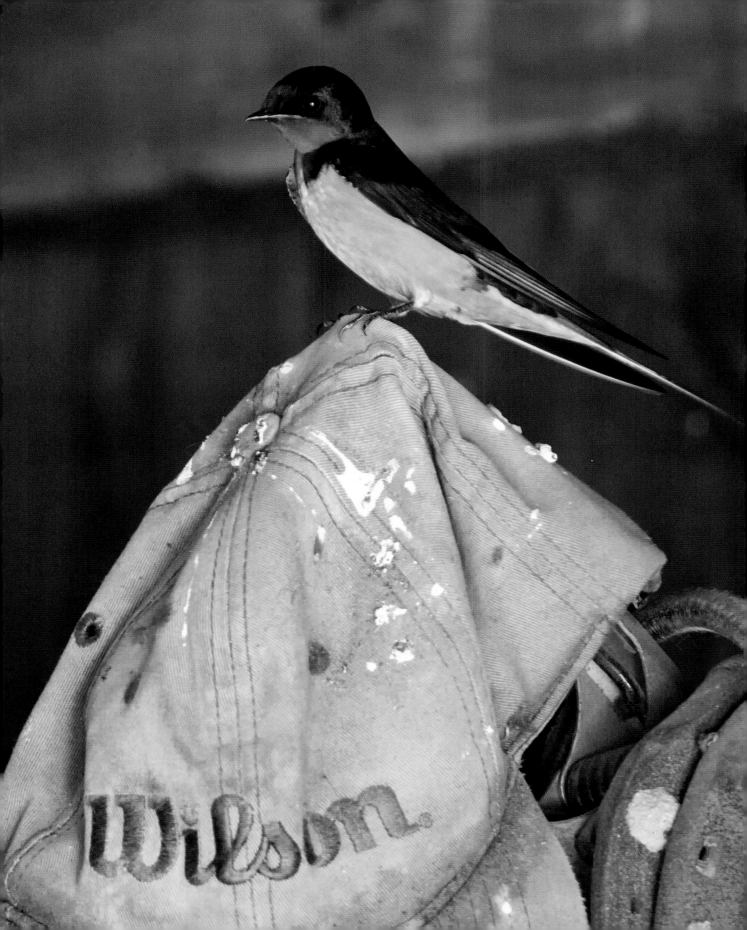

21

Leaving the farm

Death is a natural part of life on a farm. Between the cows, calves, chickens, cats, friends, and family, death is as common on the farm as birth. But the experience of death is ever different. Cows seldom die on the farm; if a calf lives to be ten minutes old, chances are it will live to be ten years old—it just may not spend all ten years on the Bromley farm. Roger will keep all the good producers that are well behaved, but with a new class of three-year old heifers coming into the milking barn each year, space has to be made. That is when the difficult and the disappointing ones are shipped off to the auction house. Where they go after that, Roger doesn't want to know and I don't want to ask.

The chickens and cats are free roamers on the farm, so they don't die as much as disappear from the farm forever. Coyotes, foxes, and owls are the likely culprits, but so too is a wandering spirit. One never knows.

"Have you seen Gracie?" Roger once asked, and we realized that days had passed since anyone had last seen the little gray barn cat.

"I haven't, Roger, come to think of it. It's been days."

"Well, she might have gone down the hill or she might have just gone, hard to tell. I'll keep an eye out for her."

Sometimes cats will change barns or switch houses on the farm, adopting new digs, and sometimes they switch farms; but sometimes they just vanish. In the four years since I first came to the farm, two family dogs have died and three barn cats have disappeared.

But as unexceptional as death is on a farm, life is cherished. No one will ever get them to admit it, but both Roger and Hugh are quietly, almost secretively, sweet toward the cows. They don't loudly announce their affection as they do their consternation, but it is there. And even when Roger has his hands full doing chores, I will catch him taking time to cuddle Piper, the current barn cat, or throw a toy for Silver. Perhaps they hold life so close because death is never far.

Roger and I are leaning on the old yellow front-end loader, its raised bucket above us with a large metal "X" hanging by chains underneath. The X, welded together out of rugged old machinery parts, is used to hook half-ton bags of fertilizer off a pallet and into the bed of Hugh's old blue pickup. Today talking has gotten in the way of working, and now the heavy contraption idly swings above our heads, slowly spinning.

"Joan wants to go to a nursing home," Roger tells me, picking up a conversation we've had in the barn over the last several weeks. "She says she's tired and just can't keep the house anymore. The catch is that she won't go unless the old man goes too, and you

Barn swallow in the horse barn.

Stormy the cat on the windowsill of the big house.

Chickens.

know as well as I do that there is no chance of Hugh going to a nursing home. Hell, what is he going to do in a nursing home? He's a farmer. He was born here on this farm and he will die here on this farm." Roger says this last part with resignation, pride, and personal defiance. It's a complicated emotional issue. A nursing home, away in a city, is the last place any farmer would like to end up, and it's disturbing just to think about it.

Roger stops and looks away over the fields and then back to the four bags of fertilizer that still need to be loaded and moved. The comfort of his ninety-year-old parents has been heavy on his mind of late, and variations of this topic have become a common theme in our early-morning barn talks. He remembers when two of his grandparents went off to nursing homes and how it made no one happy. And he remembers that neither one of them ever came back to the farm.

"I've been talking to a lot of the medical home care people that come up here to take care of Mom, and they say when someone begins to realize their time is getting short they worry about those they have been taking care of."

"That makes sense, Roger," I say. "Your mother has taken care of your father for sixty years. She wants to know that he will be all right."

I pause and watch the swallows darting in the barn. "Is this a clear thought or is the nursing home one of her recent imaginings?" I ask, knowing that of late Joan has been closely dueling with dementia.

"Well, there was the 'going upstairs to fetch her purse she left up there during the dance' story last week, and just the other day Hugh caught her talking with her parents. He had to gently bring her round to the present. No, I think she was thinking clear when she mentioned the nursing home. I think it's been on her mind. I talked to Stephen [his older brother] and he came down and we talked, but we didn't come up with any good answers."

"I don't think there are any good answers in these cases, Roger. I think there are only less bad ones."

"We decided to have someone come in the afternoon now as well as the mornings. They can clean up a bit and get supper ready, help Joan out.

My father might get up and do some of this himself, but he never has. And even if he tried, my mother wouldn't let him. That's her stove and she is not going to let anybody else touch it."

"I don't know, Roger, I guess you're just gonna have to see what happens, take it day by day."

"I don't see that I have much choice."

The next morning during milking I ask Roger about how he decides to keep a cow or not. It's not something I think much about, but it is on Roger's mind all the time. He needs to keep the best producers in the barn, producers of both milk and calves, so he is always evaluating individual cows to see if they pass muster.

"If they are not getting pregnant and they're not giving much milk, they're out of here . . . they are just costing me money. In winter I call those cows 'BTUs' because at least they will add some heat to the barn, but the rest of the year they don't even do that. See those four empty stalls? Those old cows weren't pregnant despite being with a bull for three months, and they stopped giving much milk—plus, I had been stepped on and kicked at and bothered by them enough. I was glad to see them go."

We don't talk about what "see them go" means. It's not something either one of us wants to think about, although we both know that once an old, unproductive cow goes off the farm, her days are numbered. Roger prefers the clinical, purely economic approach to these decisions, tempered by practicality. He is, after all, running a dairy farm, not a rehab center for difficult, unproductive cows.

"Any more you would be glad to see go?" I ask quietly. We are, after all, talking about these cows leaving the farm, and they are standing right here beside us.

"Oh, sure!" Roger says with unusual glee. Three or four years with an ill-tempered, low-producing cow is just about enough for Roger. "That big black one there and the one next to her, this one over here and the one in the corner just now stepping on the milker. Can a cow get much dumber? Those will all be gone come Tuesday when the truck comes for the auction house. I can't wait. Besides, I've got to make

room for the heifers to come into the barn. I've got sixteen new bodies to fit in eight empty stalls. We've got some work still to do."

A couple of weeks later Roger tells me that his mom got them all worried the previous day. "After you left in the morning the ambulance was here twice. First time she called it but she refused to go when it came, saying that she was fine. As soon as it left she wanted it back, so I called it back again. She was either unable to stand because of hip pain or perfectly able to stand, and she either wanted to go to the hospital or had no intention of going to the hospital. She settled on going. So off she goes to the hospital. She checks out fine, everyone is relieved and she gets a little trip out of the whole thing. Left around nine-thirty and was back by two!"

"That's a tough call, Roger but you did everything right. You can't ignore her pain because it may be legit, so you call the ambulance and off she goes. It's still better than her being in a home, I think."

"Yeah, I know, the old man moped around all the time she was gone. I tried to get him up on the tractor to spread manure, but he wouldn't leave the house. He just sat there and waited for her."

"It's a tough call, Roger. It's a bit of a gray area."

"It won't be the last call, I'm afraid."

The next day a cow had a miscarriage. That morning I had noticed a translucent, fluid-filled bag, perhaps

Roger and cat heading for morning chores.

Roger and Trish's dog Quicksilver in the cow barn.

the size of a golf ball, hanging on mucus strings from her back end. Puzzled, I asked Roger.

"Oh, boy," Roger said, with some dismay. "That means she just had a miscarriage or is about to have one. Can't say for sure which. She's a no-good cow really, always something going on with her. She's had calves before, but she has had a hard time coming full term with them. We'll have to keep an eye on her today."

Nothing happened the rest of the morning and she went out with the other cows after milking was finished. But that afternoon she didn't come back into the barn with the herd, so I went out looking for her in the ox pasture. I found her standing in the woods under an old maple tree, her stillborn calf at her feet. I got her to come into the barn to feed and be milked, but when she went out again she left the herd to be with her calf.

This morning she didn't come in with the cows and I found her again under the old maple up in the woods. She had spent the night by herself, lying by the tree next to her dead calf, two months shy of making it.

A week passes before Roger brings up his mother again. "At eleven o'clock last night my mom called the house. She asked me to tell her mom that she wasn't coming home tonight, that she'd stay at the house. I hung up and didn't think much of it; she's done this type of thing before. But she called again at two-thirty in the morning. This time Trish answered the phone. Mom said she was tired and that she had had enough. She wanted to go, go home now. Trish was very kind to her and said, 'Okay, we'll be right up, don't you worry,' and then said good-bye. I'm sure Mom fell right back to sleep but Trish was awake for another hour, thinking. It does make you wonder."

He walks across the aisle and rubs the udder of the next cow to be milked. I stand to the side, leaning on a hoe, thinking, but with nothing to say.

Roger comes back to me, his thoughts needing to be said. "You know, most times I decide what leaves the farm and what stays. This old bag of bones here I can't wait to get rid of. I've had enough of her. But there are also times when I have no say at all. Sometimes things happen and a cat disappears or a dog dies or a calf doesn't make it. With Mom, I don't know. Maybe she's getting ready to go, letting us know. Doesn't make it any easier, but I guess that's just the way it is."

He turns and heads up the center aisle, a bottle of warm milk in his hands for the new calf at the post. ☙

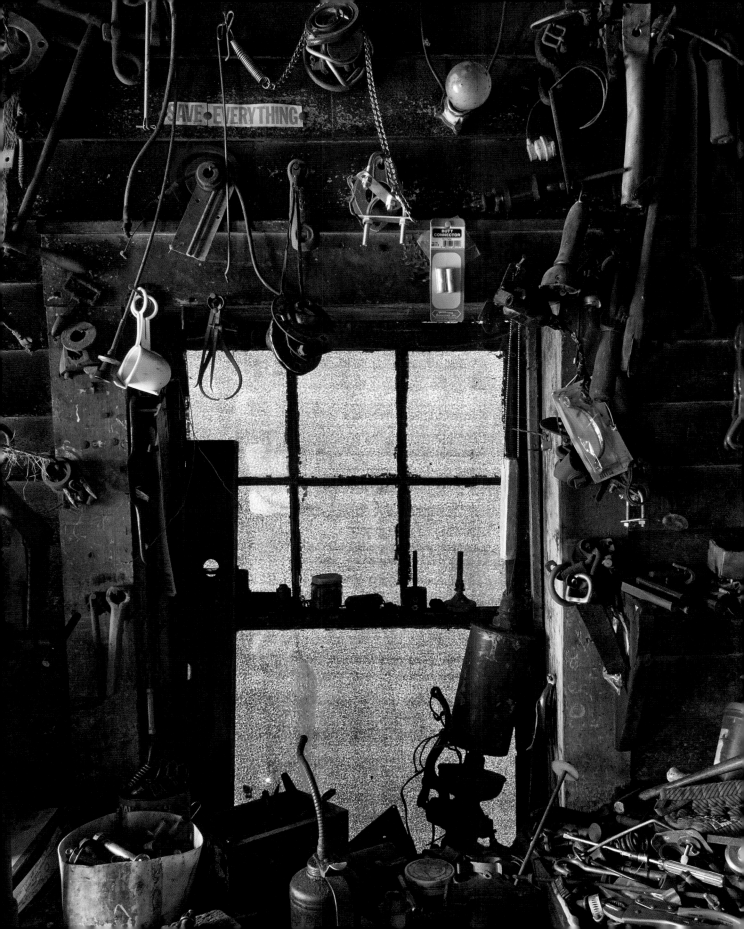

One at a time

On the wall of the old cheese house that became the old blacksmith shop that is now the metal parts and pieces shed is a small one-by-six-inch sign with bold red lettering that has been there for almost forty years. Despite the color and its large type, it is hard to notice and harder to read, being now obscured by hanging bits of tools, spare parts, and odd scraps. But if you look past the springs, washers, clasps, and clips, past all the memories of things that once worked, you can just make out what it says. Turns out this little sign in a now little-used shed spells out the central philosophy of the Bromley farm. Hold back the little oil can if you can't see it clearly. It says: SAVE EVERYTHING.

"Oh, no, Roger, tell me you didn't," I say with disbelief, anticipating what is coming as he recounts what he and Trish had done the Saturday before.

"Well, of course I did! They looked perfectly good."

"Roger, they were there for a reason. Besides, the recycling Dumpster is not a place to go shopping."

"I checked the tops and they all looked fine. Besides, it was hot and I was thirsty."

"So they are sitting in the sun on a hot summer's day . . . wait a minute, how did you see them? The sides of that Dumpster are seven feet high."

"I climbed up the side. You can't tell if there is anything good inside unless you get up there and look around."

"Let me make sure I understand. You and Trish decide to go for a drive and have a picnic. On the way out of town, you stop at the town Dumpsters to get rid of your trash and recyclables . . ."

"And to go shopping!" Roger chirps in.

". . . and to go shopping. As Trish is dumping the empty bottles and cans, you climb up the side of the bin to see what you might find inside."

"What valuable things I might find inside."

"What 'valuable' things you might find inside. Among all the dirty glass and crusty tin and flattened cardboard you see an open case of wine . . ."

"Homemade wine."

"Sorry, I forgot that important detail . . . homemade wine that you decide despite that it is in the bin, in the sun, thrown away, might somehow satisfy your thirst. You knew nothing about this 'wine,' how old it was, who made it, if it was even wine . . ."

"It was in wine bottles. Wouldn't you put wine in wine bottles?"

". . . if it was even drinkable. But not letting such silly concerns stop you, you grab the case and haul it out of the Dumpster, much to Trish's horror I'm sure, and put it in your car. Have I got it straight so far?"

"You forgot one important detail."

"You got a severe blow to your head right before you got to town?"

"No."

"You were going to use it as a weed killer?"

"No."

"Okay, what?"

"It was free!"

If you look up the word frugal in a dictionary, you will not find a picture of Roger Bromley. This is because frugal doesn't begin to describe the lengths to which Roger saves, reuses, and makes do. If you look up the word scavenge, though, you may find his likeness. This inherent frugality and love for all things scavenged combine to mean that anything with any potential use is saved if it's on the farm and picked up if it's not. "Don't think about what something can't do anymore; think instead about what it still can do" is the Bromley gospel, according to the middle son, Ike.

The best way I know to explain Roger's dedication to this gospel is with this example: the man eats M&Ms one at a time. Let me be clear about this—not one package at a time, or one handful at a time, or even one mouthful at a time. Roger eats M&Ms one piece—one little yellow, brown, blue, or red piece—at a time. The rest of the handful he puts in his shirt pocket for later.

This frugality seems perfectly reasonable to Roger, though I find it to be ethically, gastronomically, even biblically incomprehensible. I also find it just plain wrong. But Roger finds my gluttony in eating eight M&Ms at once to be bordering on barbaric. To Roger, not saving a little something for later, just in case, is, well, living on the edge of lunacy.

Roger explains: "What happens if in an hour I want another M&M? If I have eaten my entire handful I would have to go out and buy some more M&Ms, but if I have saved some of them I won't have to waste my time or spend my money on more M&Ms. I would have some stashed away so they'd be there when I needed one."

If you want to know how the Bromley farm has survived for more than a century and a half, this, the parable of the M&M, is a pretty good explanation. All the Bromleys think like this. Hugh once pulled out of the to-be-burned pile a very old straw broom whose handle was broken and whose bristles were worn past its stitching. He said it would be perfect for cleaning out the cobwebs in the hayloft. It's still there, in the hayloft, covered in cobwebs.

Ike once stopped me from using paper towels to wipe clean the milkroom white board because he said that paper towels were only for "amputations, messy births, or oil spills, and even then you must rinse them out and hang them up so they can be used again." The trick, he said, is to see how long the towels last, not how quickly you can use them up.

But Roger, despite Ike's considerable talent, is still the chief frugalarian. Like my friend whose mother has a box of string labeled "too short to use," Roger keeps old spark plugs in a box that is labeled "no good." "Do they ever regain their spark after you've put them into other motors and nothing happens?" I ask, trying to fathom the unfathomable.

"No, not yet, but they could!"

"They're dead, Roger. The box says so. No spark, not good for anything."

"Well, perhaps, but there is always a chance. Haven't given up on you, have I?"

Around the barn there is an old box-spring frame being used as a gate, a tool scraper made from a car's leaf spring, an oil tank that is now a feed trough, a ketchup bottle rain gauge, a barn step that is an old gravestone, gate closures fashioned from horseshoes, a grain cart made from the wheels of a baby carriage, a porcelain sink birdbath, and baling twine for just about everything else.

Baling twine is gold on the Bromley farm. Once a bale has been broken apart and fed to the cows, the three-foot-long red or green loop of twine is always saved. It is knotted together for temporary fencing and braided together as a gate to keep cows out of the manger. Single strands are used as collars for calves and to repair handles, water dishes, stanchions, doors, and feed carts. It is used to tie tools up and hold tarps down, keep gates and doors open and drawers and windows closed. It is tied around cows' feet as a reminder for special attention and around pants legs to keep out drafts or blowing chaff. In every barn or shed on the farm there is a hanging heap of string waiting to be used.

In addition to all this are the spare pieces of metal and wood that have been hammered and welded

Roger in the blacksmith shop.

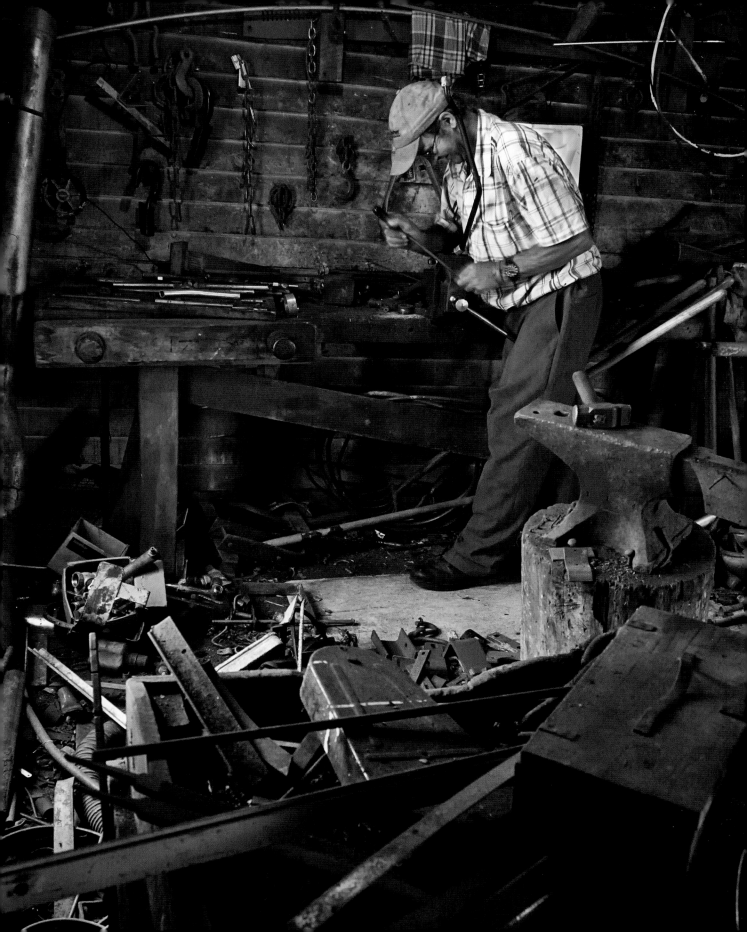

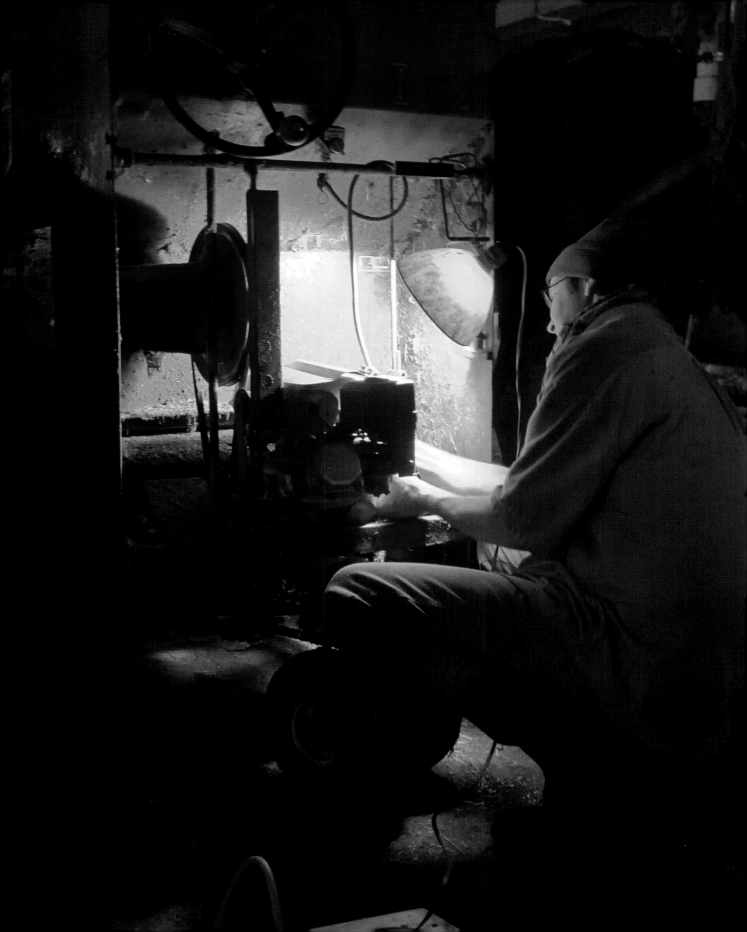

onto every working piece of equipment and structure on the farm. There are buckets of old nails, screws, bolts, and nuts, piles of scrap metal of every description, and sheds stacked high with planks, beams, struts, braces, and posts of all kinds.

The oddest reuse of something on the farm is what Roger uses for snowmobile trail markers. If you are ever out walking or riding around Danby, you will know you are on a trail marked by Roger if you find it blazed with neckties, a teakettle, and doorknobs.

"Why would you take doorknobs up to the top of the mountain to mark a trail junction?" I innocently asked Roger one evening over the back of a cow.

"Why not?" he replied.

But the most reused, make-do item on the farm is clothing. Pants and shirts have a very short life on a farm. If they are not ripped on some nail or piece of equipment or so badly stained by grass, grease, guts, or goo, many will simply wear out from rough use in only a few months. This is why Roger and Trish "go shopping" at the town's discarded clothing bins. Trish has found brand-new blouses with the price tag still attached, and Roger finds shoes, T-shirts, and pants there regularly. They don't really fit Roger— "That's what belts and baling twine are for!"—but they are worn for a few months and then turned to dust or oil rags.

All this is not to say that Roger and Trish and the rest of the Bromleys don't buy or have nice clothes; it's just that they don't see the point of wearing nice new clothes on the farm when they will quickly turn into not-so-new, not-so-nice work clothes. Why spend money on more when there is clothing that will do at the local "shopping" center, and it's free?

Ike once came back from a town "shopping" spree with a heavy wool peacoat, a deep navy with big button-and-loop closures. It was the middle of June.

"Look what I got in town!" Ike said with unusual excitement.

"It looks like a coat, Ike, a winter coat," I say, clearly not understanding his enthusiasm for this heavy coat on this hot day.

"It's not just a coat," he says, ignoring my seasonal comments, "it's a peacoat and it's like new! Look at it. It's like it has never been worn before."

"Or at least not worn in thirty years."

"Huh?" Ike replies, missing my fashion commentary as he goes through the pockets, looking for treasures.

"The last time I saw someone wearing a pea coat was Mary Tyler Moore on TV."

"Who is Mary Tyler Moore?"

"Who is Mary Tyler Moore? Dick Van Dyke, Mary Tyler Moore? TV?"

"Who is Dick Van Dyke?"

"You'll look great doing chores in that coat, Ike," I say, taking a different, more supportive approach.

"Doing chores in this coat? What, are you crazy? It is much too nice to wear. It is going in my closet. I might need it later for something."

If you think this is an unusual case, the same thing happened when I gave a brand-new winter farm coat to Hugh a few years back. The one he had been wearing was stained and worn and thin and kept him good and cold. The new one is quilted and clean and has been hanging in his closet for three winters now. "Too nice to wear outside," Hugh says. Who knew?

Doorknobs in pine trees and pants of all sizes. Ties on the wire and a pocket of candy. A barn full of string, a shed full of scraps. Save everything, reuse everything, make do with what you already have, get as much free stuff as you can. Add cows, stir in some nuttiness and repeat for 150 years. Welcome to the workings of the Bromley Farm.

"Wait. Whatever happened to the wine?"

"Well, we took it to some neighbors and shared it with them," Roger says shyly.

"You shared it with others? Are they still alive?"

"You know, come to think of it, we haven't seen them lately. The wine was pretty awful, although they seemed to like it. We left a few bottles with them."

"So what did you do with the rest of it?"

"We ended up putting it back in the Dumpster on our way out of town. We saved the box, though. Hard to find a good sturdy box like that." ✑

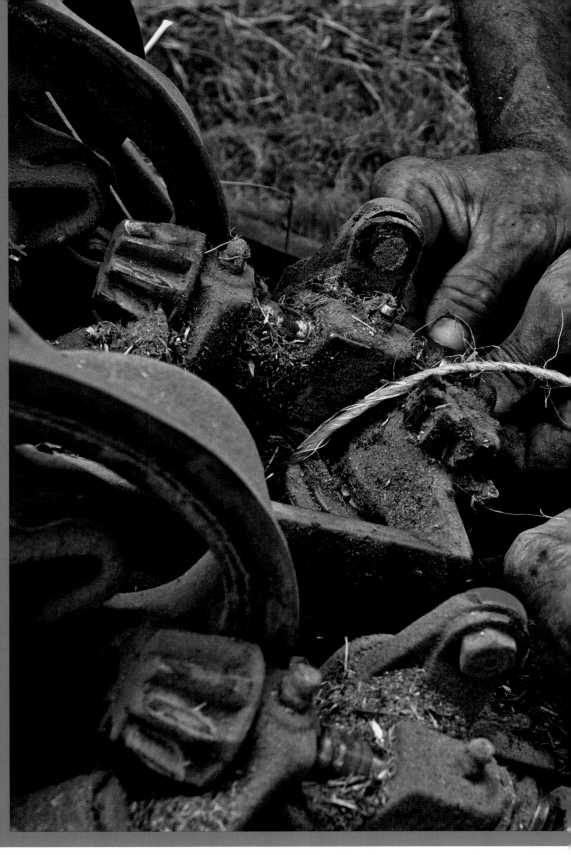

Roger's (top) and Hugh's hands fixing the knotter on the baler.

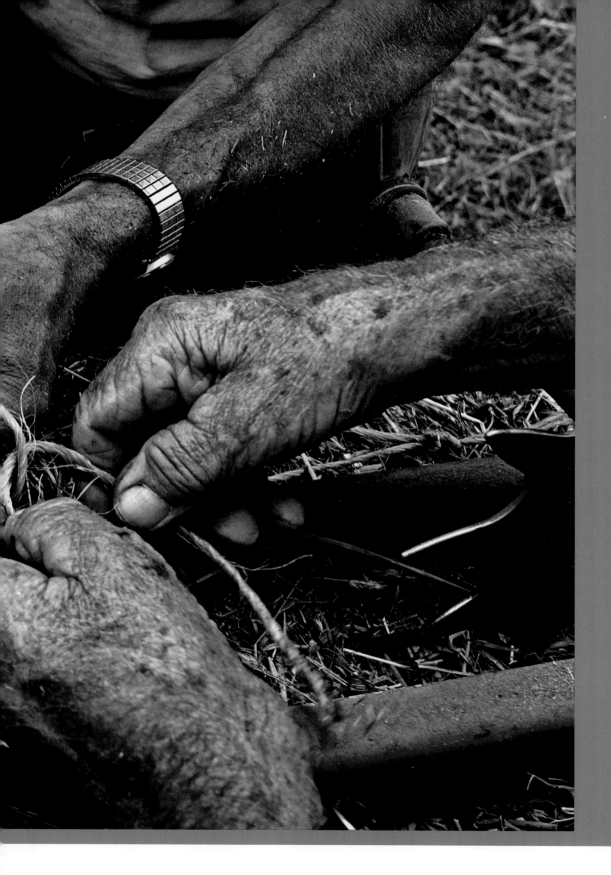

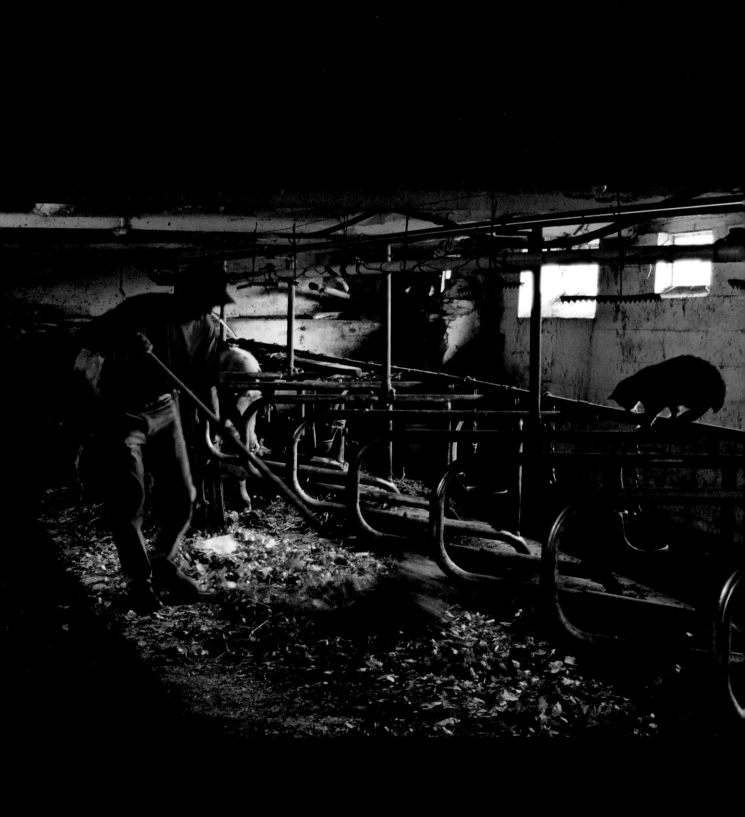

23

Sweeping clean

"What the hell is that?" I ask with a combination of surprise and horror, the kind of tone someone would use if he came across a severed head in a dimly lit dairy.

"It's a push broom. What did you think it was?" Roger replies, using his calm, good-morning voice.

"It's a brand-new push broom . . . brand-spanking-new!" I exclaim dramatically, clutching my chest and reeling back. "It's new, Roger. New! Do you know what you have done? You have brought something new into the barn. What were you thinking?"

"Well, I was in Granville yesterday and I saw it, and I figured it was time to replaced the old one we've been using."

"Replace the old one? Are you mad?" I cry, channeling Ike, the king of Frugalland. "Are you feeling all right, Roger? Fever? Chills? Blow to the head?"

"The old one did a crummy job. The bristles were every which way, and you couldn't do corners, so I figured what the hell and got us a new one. A new broom sweeps clean, you know."

"Does the old man know about it?"

"Not yet."

"Are we allowed to use it, or is it just for show?"

"For all the talking you're doing, you could've been done using it by now!"

"And the old one, the one that is no good anymore. Don't tell me you threw it in the burn pile."

"I did, but the old man saw it. He pulled it out and put it back in the barn."

"At least someone is thinking straight. Where is it now?"

"It's up in the hayloft. It'll probably be there for years."

"The hayloft?"

"Fewer corners up there." 🐾

Roger and Bob the cat fluffing up the bedding for the cows.

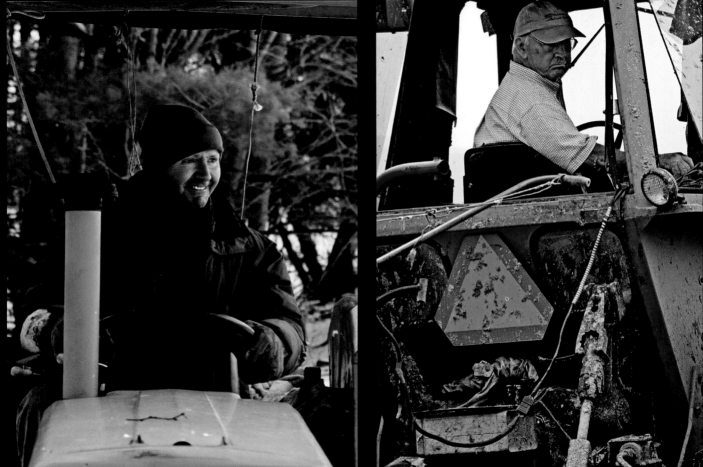

24

Fixin'

It's toward the end of May when I get back to the farm after being gone for a week. Seeing the tractor and manure spreader out, I ask Roger if he is done yet spreading manure on the fields. He starts spreading as soon as the fields are dry enough to drive tractors on them, but like everything else on the farm, his activities are at the mercy of Mother Nature. I know he thinks he is behind because he always thinks he is behind, and he usually is, but even I, who knows precious little about manure spreading, at least this kind, am getting the sense that it is pretty late in the month to be doing it.

This feeling was reinforced by my drive back from the Burlington airport a few days earlier, when I noticed farmers plowing fields and even mowing grass on the big farms in the Champlain Valley. Roger is nowhere near plowing or mowing.

"Mowing already?" Roger asks when I report to him what I saw.

"Yup. Two fields cut. Didn't look like much but they were cut."

"Why, that doesn't make sense. The grass is only a little bit high, hardly worth cutting. And the ground is still soft, so the machinery is sure to leave a mark. And with the cost of running a tractor—five dollars a gallon for fuel just about—it doesn't make sense to cut so soon. It only makes sense for bragging rights. I guess somebody has to try to be first."

We walk back up the road after putting the electric wire across the gate to the swamp pasture. The big red tractor and manure spreader are parked on the front lawn of the big house, where Hugh left them. It's not such a bad place to park when you're ninety-three. There really is no bad place for Hugh to park. If he is in the neighborhood and nothing is rolling downhill, he's doing just fine.

We walk over to the spreader, its red color obscured by layers of encrusted mud and manure.

"There's still manure in it, Roger. Why's that?" I ask, knowing that Hugh always works until the job is done, and a mostly full wagon is no way near done.

"The old man was spreading down at Hopper's and the thing broke. So now I've got to fix it to empty it."

The manure spreader is an open-topped wagon with a V-shaped floor and a large horizontal auger in the bottom that carries the manure forward to gear-driven paddles. The paddles fling the manure in great gooey gobs and small slimy spits onto the passing turf as it is towed around the hay fields. In April and in September the wagon is filled with manure from the milk barn that has been curing in the shit pit for five or six months and then is spread on the fields as fertilizer. The tractor and wagon combo is the mechanized version of how manure used to be spread on the fields here a hundred years ago—two

guys with shovels standing in a horse-drawn wagon full of manure.

"How did it break?" I ask, looking at the tangle of chains and gears and wheels. How didn't it break, is what I am thinking.

"Well, he filled it with the pile of manure from the barnyard—the pile with all the spilled hay in it. I told him it was too heavy and thick, but he was sure the spreader could handle it. There's no point arguing with him. He'll do prit' much as he pleases. He got down there, and as soon as he started spreading, the chain broke that moves the paddles. So he came back up here, took a nap, and quit for the day. Now I get to fix it and have the pleasure of telling him "I told you so.""

Roger will fix it but he won't say "I told you so." He'll think it, but he won't actually say it. It's too disrespectful.

Roger lifts up the metal lid covering the box with the main chains and gears and we see the broken chain hanging limply between the big gear wheel and two tension wheels.

"Hold this up for me," he says, nodding at the lid. "I want to see if he lost any of the chain."

I take hold of the lid and with my free hand hold various grease- and dirt-covered metal parts (identity and purpose completely hidden to me) out of the way of Roger's fiddling. By resetting the chain Roger can see that no links have been lost; one has just broken. The investigation, though, has made both of us dirty and greasy, hands to forearms.

"We might as well fix it right now, no sense cleaning up and coming back to get dirty again," he says as thoughts of my breakfast dance quickly into the shadows of my brain. He disappears for a few minutes to find a new link and grab the necessary tools as I continue to stare at the workings. It seems both straightforward and ingenious—the wheels move the chains that turn the gears that move more chains and turn more gears that move the auger and spin the paddles.

I would never attempt to become involved in any way with all this mechanical stuff, but Roger can't wait to wade right in and start figuring out how things are supposed to work and fixing them when

they don't. He also can't afford to call a mechanic every time something breaks on the farm; one would be here every day. In his lifetime Roger has taken apart and fixed every tractor and piece of machinery on the farm. Even if something is not broken, he'll tinker with it to understand how it works. The idle assembly of his brand-new four-wheeler was in pieces within an hour of arriving at the farm. "Seemed like it was running fast," he said a bit sheepishly when I caught him in mid-dismemberment in the horse barn.

Fifteen minutes later a new link has been found and inserted, the main drive chain fixed.

The lid is still up and Roger and I are admiring his work as Hugh comes over to see what is going on. This is a primary trait of Hugh's. He doesn't ever go far or fast, but he always shows up wherever something is happening.

"What happened?" Hugh asks, leaning in on his cane and squinting into the gloom of the greasy gears.

"The paddle got jammed so the chain broke," Roger tells Hugh. It is clear why the paddle jammed and the chain broke, but Hugh is not seeing it and Roger is not saying it.

"That shouldn't happen," Hugh says and spits to the side. "Maybe there's something else wrong."

"I don't think so," Roger says. This is as close as he is going to get to saying "I told you so." "I think it just jammed."

"Hmmph," Hugh replies and spits again. Discussion over.

The spreader back in working order, I head home to degrease, feed, and prepare myself for my day. Roger heads down the hill to his house for a bit of breakfast before he resumes his chores.

I return late in the afternoon to hunt for photos and see what's happening. I find Roger just coming out of the milkroom.

"Did you get down to Hopper's to spread the rest of the manure?" I ask hopefully.

"Oh, I got there but I didn't spread any manure."

"That doesn't sound good, Roger. What happened?"

"After breakfast I put a small weld on the new link so it wouldn't break again and then drove the

tractor back down to Hopper's with the same full load of manure. I started spreading and, doggone it, the chain broke again. This time it wasn't the welded link but a different one. There was nothing I could do down there to fix it so I came all the way back up to the house and fixed the chain all over again."

"So that's it?"

"Oh, no. I then cleaned out the chute that feeds the paddles. There was a thick glob of hay and manure that was jammed in the chute. It was rock-hard, so when the paddle hit it something had to give . . . the chain. It was a real mess.

"Once I cleaned the chute out I still had a full load of the same, unspreadable manure to spread. I figured that if I could lift up the main gear it would raise up the paddles, giving the manure more room. But in order to do that I had to attach the hydraulic lines. When I did that I found both the lines had leaks in them, so I had to find the leaks and repair them, reconnect the lines, and jimmy around with the wheel to get it high enough to spread the heavy

glop. Finally at three o'clock in the afternoon I drove back down to Hopper's and spread the manure until the wagon was empty. It took me five hours to do a thirty-minute job and three trips down there to empty it once."

"So I probably shouldn't ask if you went motorcycling today."

"No, you shouldn't ask. We didn't. Too chilly anyway, but it would've been nice to think about."

"Is all that thick manure gone now?"

"No, the old man still wanted to load more of the same stuff in the spreader! There's no way that is going to happen. I'm not going to go through that again."

"So what did you do? I almost am afraid to ask."

"I scooped up the rest of it with the backhoe and dumped it on the old compost pile down by the little meadow so he can't get near it. And I didn't tell him where I put it. Now all he can spread is nice soft shit."

"Nothing better than that, Roger."

"Tell me about it." ✍

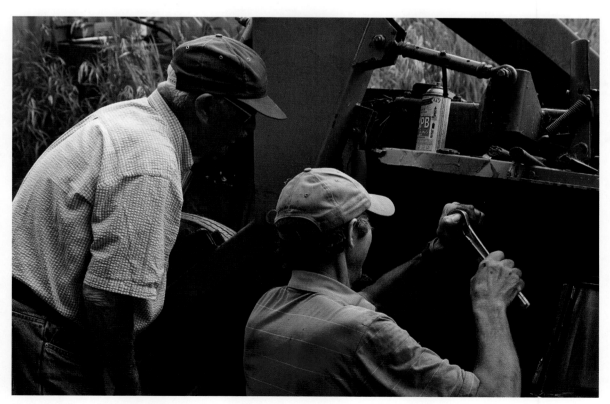

Hugh and Roger fixing the disc mower.

Pages 130–131: Roger and his brother Stephen (right) putting a tractor back together.

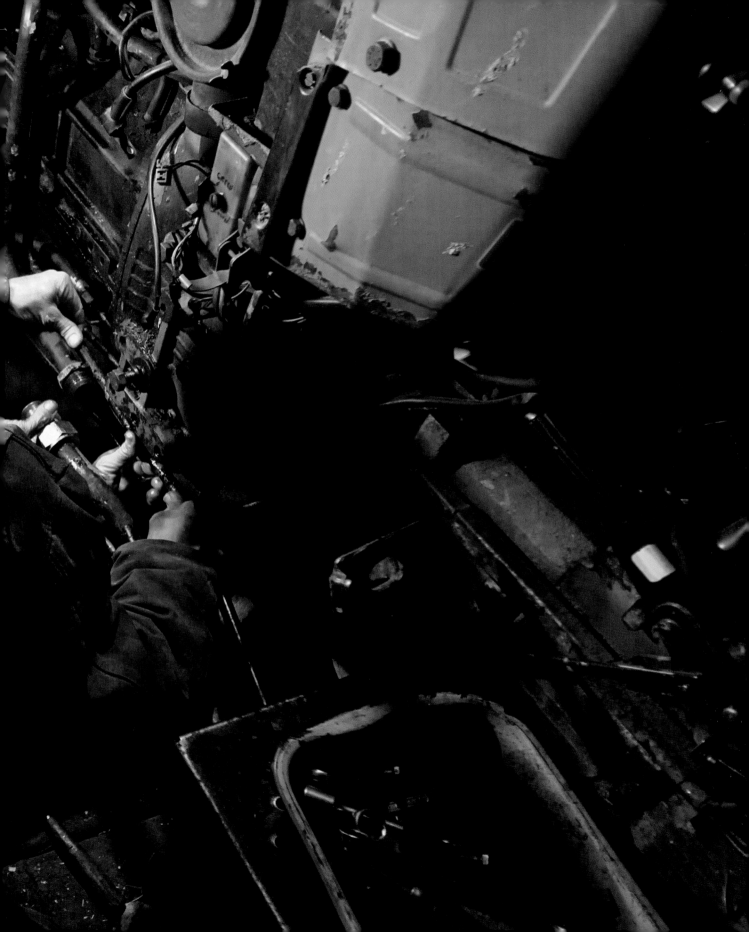

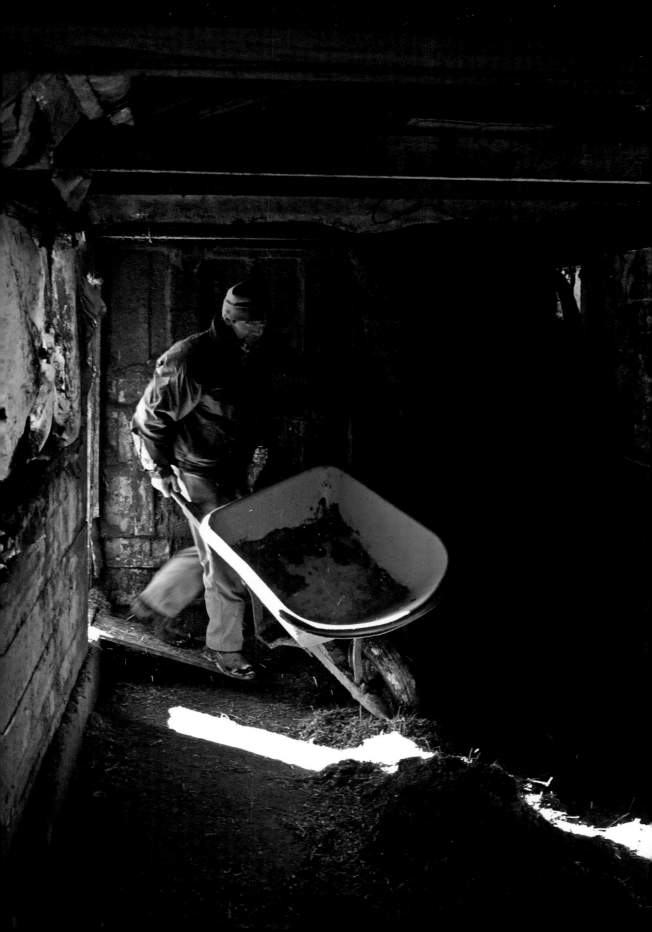

Do you smell anything?

"Do you smell anything?" Roger asks me as he leans over the swinging gate to the back manger.

"Do I smell anything?" I ask, mustering up all the normalcy I can, considering that we are, after all, in a barn with fifty cows, there are two large piles of fermenting haylage and corn silage not five feet away, and the gutter cleaner is running under our feet, stirring up all the wonderfully vivid aromas of fresh manure. I pause, take good, long, overly dramatic sniff, and reply, "No, not really. Can't say I smell much at all."

"Are you sure? Take another sniff and get closer," Roger says.

I lean into Roger, balancing on the blue feed shovel, and take another sniff. Roger cranes his neck to make sure I am getting the full effect.

"Nope, seems pretty normal to me. Is there something you want me to smell, Roger?" I say this with a combination of curiosity and concern.

"Well," Roger pauses. He tips his hat back and cocks his head to the side, looking around the barn. I look as well, though I am not sure for what.

"Yes?" I say.

"Do you smell perfume?" Roger says, smiling uncomfortably.

I look at him but say nothing. This actually seems to be a serious question he is asking me. Perfume? I think.

"Do you want me to smell perfume, Roger?" I ask, figuring that he had put some on and was hurt that I hadn't noticed the extra effort he had spent prettying himself up for me this morning. This is a turn I didn't see coming in our relationship.

"Hell, no, I don't want you to smell perfume. That's the point. I don't want to smell like perfume. I don't like strong smells."

He says this as a particularly sloppy and large pile of cowshit churns by us in the gutter and the two cows across the aisle simultaneously shower the floor at our feet with prodigious streams of urine.

"I agree, Roger. I don't like strong smells either. I don't know how people can work in a place with overwhelming smells. Can you imagine?"

The irony of all this is that farmers would never admit that their barns smelled or that they might be just a tad fragrant. They would never admit this because they don't realize it. To a farmer, the barn smells normal. Fresh air and non-farmers smell a bit off.

"Care to tell me why you are worried you smell like perfume, or do you just want to keep this part of your life really, really private?"

Roger is laughing now. The milkers need to be moved, there is food that should be pushed up, the grain cart is waiting, and the cows are getting impatient, but we've just got our teeth into a good story here, so we aren't moving until we come to the end.

Roger coming in from feeding the yearlings behind the cow barn.

"First thing this morning I went over to the big house to start their fire, and I couldn't find any paper to light. So I rummaged around in a box that was up on a shelf and I found an old bottle of perfume. Perfume has alcohol in it, doesn't it? So I grabbed the bottle and sprayed the wood with perfume, a lot of perfume, so it would light quick."

"Wait, you couldn't get the wood going, so you looked around the basement and found a bottle of perfume and decided to spray the perfume on the wood, thinking the alcohol would help ignite the fire. Is that what you just said?" I ask with part disbelief and part admiration. Roger's thinking process is so alien to mine that I find it fascinating. There is much wonder mixed in as well. I would've gone and found some paper, but Roger believes in making do with what you have. He had perfume, so he was making do. The problem was that he wasn't making fire.

"Yes, no paper, no fire, so perfume and hopefully fire."

"Well, McGiver, did it work?"

"No."

"After all that it didn't work?"

"No, didn't have any effect at all. But it made the basement smell like flowers along a spring brook."

"So you dabbed a little behind your ears and are now wondering if you dabbed enough? I know I have a heck of a time judging how much perfume to put on before I come to the barn."

"No, I don't want any on me. I don't want to smell like perfume. I am going down to town this afternoon, and the last thing I want is to smell like stinkin' flowers."

"I think you're okay, Roger. I am willing to bet you are not going to smell like stinking flowers this afternoon after spending the morning in the barn."

"Good!"

"So, how did you get the fire going?"

"I went upstairs and got some paper. Perfume is good for nothing." ✑

Pages 136–137: He actually knows where everything is: Roger inside the oil shed.

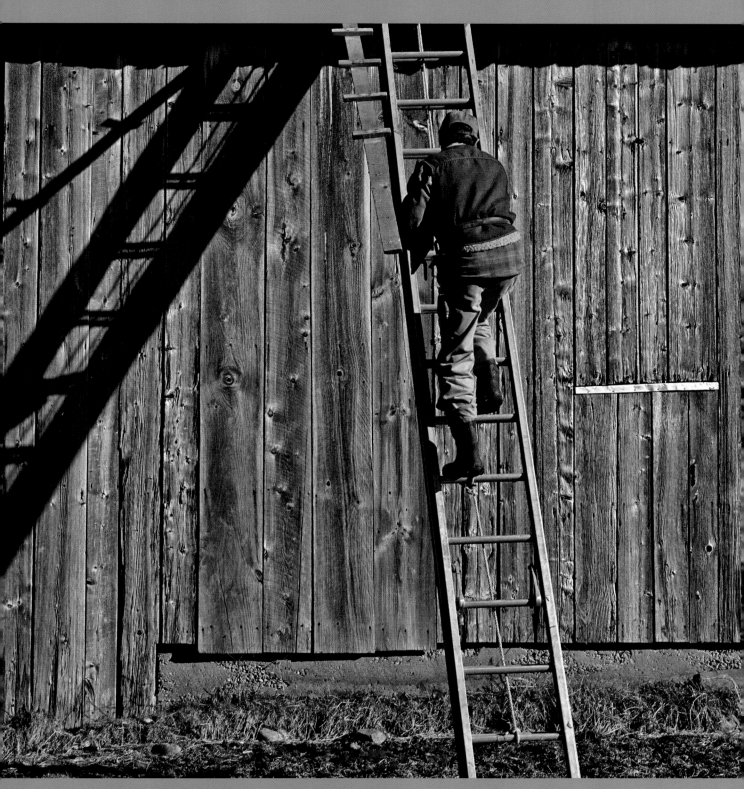

Roger going up to fix broken slates on the heifer barn.

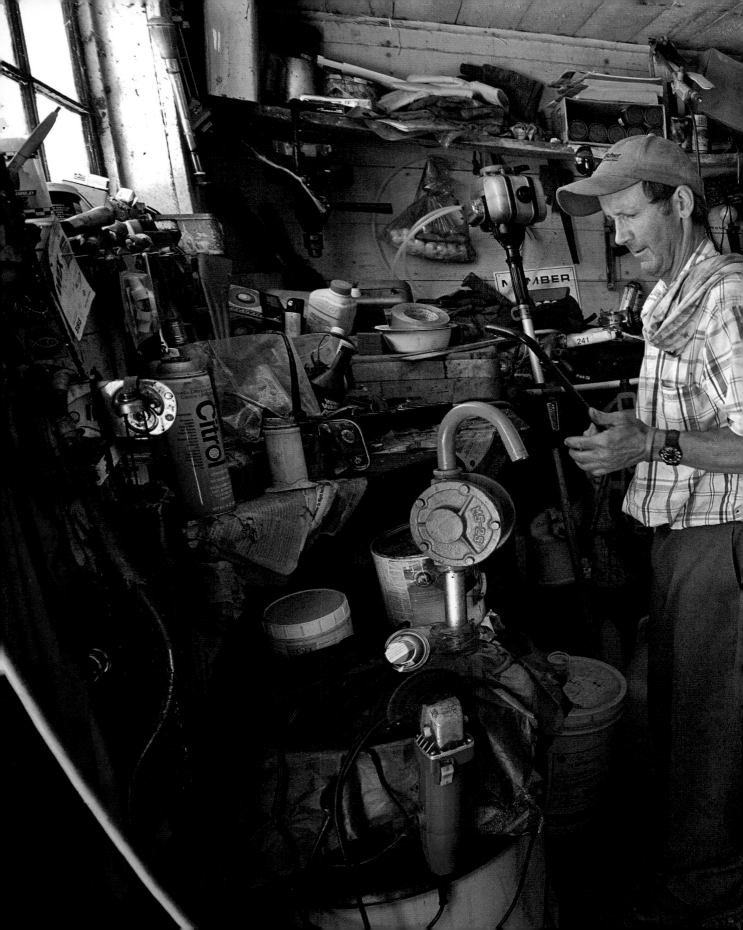

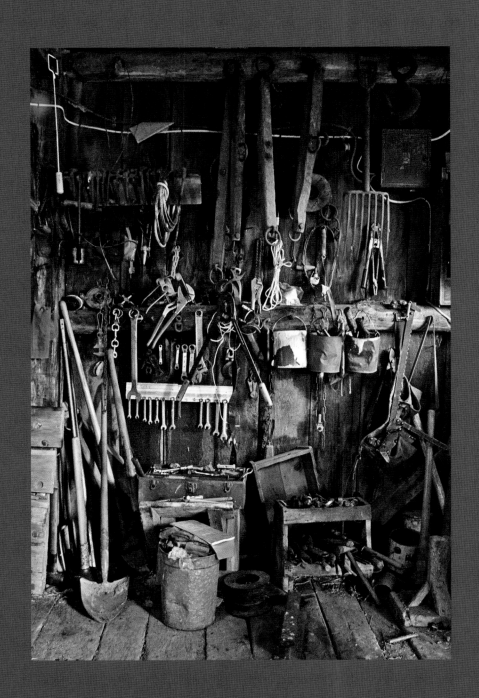

26

The dustman cometh

Every morning on her way to work, Trish comes into the barn to drop off Silver and say good-bye to Roger. This morning she also had some news. "The dustman called," she says to Roger. "He is coming today. Says he'll be here at nine."

"Okay, thanks. Have a good day."

"Thanks, see ya!" Trish yells as she heads out the door. She must be running late because she usually gives out treats before she goes—a biscuit to the dog and a kiss to Roger. Sometimes it is the other way around.

"Who is the dustman?" I ask Roger as he comes round from attaching a milker to a cow.

"He is a fellow that comes once a year and blows out the barn and then whitewashes everything. "

"Blows out the barn?"

"He brings in a big air compressor and lots of hoses and blows out all the dust and cobwebs on the walls and beams and ceiling. Then he goes through and puts on a coat of whitewash. This means that everything on the walls needs to be taken down and put in the manger and everything on the shelves needs to be put in the wheelbarrow or in boxes."

"Everything?"

"Everything we don't want whitewashed."

At eight-fifteen I have finished most of my chores and I begin to take things down and clear the walls.

I never realized there was so much stuff hanging on the walls of this old barn. I am sure some of it has been here, hanging around, for a hundred years. I find old ropes, cables, scrapers, hats and jackets, and various small tools. I grab two pitchforks, one hay fork, one silage fork, a hoe, two manure scrapers, a manure shovel, and three feed shovels. There are also plastic pails and metal barrels, a short wooden ladder, full bags of grain and empty ones too, rubber overboots and spare shoes, gloves and a light chain and pails full of clips and twine and papers.

On the shelves are all kinds of medicines and ointments and weird devices used to administer them to the afflicted. I pile boxes of syringes and tongs, gauze pads, and wraps into a large box. Any athletic trainer would feel perfectly at home in this barn. I also find things that Roger hasn't seen in a year—"Is that where that is. I was wondering where that went."

At eight-thirty the dustman cometh, bringing his hoses and tools into the barn where I am still trying to clean things up. Roger, seeing that I'm not yet finished, says to the dustman, "I thought you were going to be here at nine?"

"I am going to be here at nine," the dustman replies, straight-faced.

Roger and I look at each other.

"I'm going to be here at ten, too."

Tools and stuff in the horse barn—all kinds of stuff.

These kinds of moments are precious to Roger in a day that may be full of frustration and difficult work. It is a piece of mental chocolate that he savors all day, using it to sweeten his thoughts and outlook. If it is a particularly funny or odd moment he will enthusiastically share it with others. It is the currency he uses to get through the day. I, unfortunately, have made him a rich man.

As we are finally letting the cows out to clear the barn, I notice that one of them has a slight limp.

"The spotted one, Roger, the one near the back, seems to have a bad fright runt."

"Yeah, I noticed her yesterday."

We pause and look at each other.

"Did I just say 'fright runt'?"

"You did, but I knew exactly what you meant."

"You did?"

"Sure, she's got a sore bite rack as well."

No matter what happens today, or for that matter tomorrow or the next day, Roger's way will be easier, smoothed by a smile. ❧

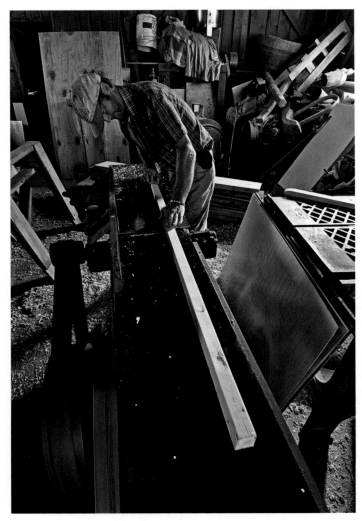

In the old wood shop Roger shapes a board to fix a door.

Roger and Stephen in the sawmill.

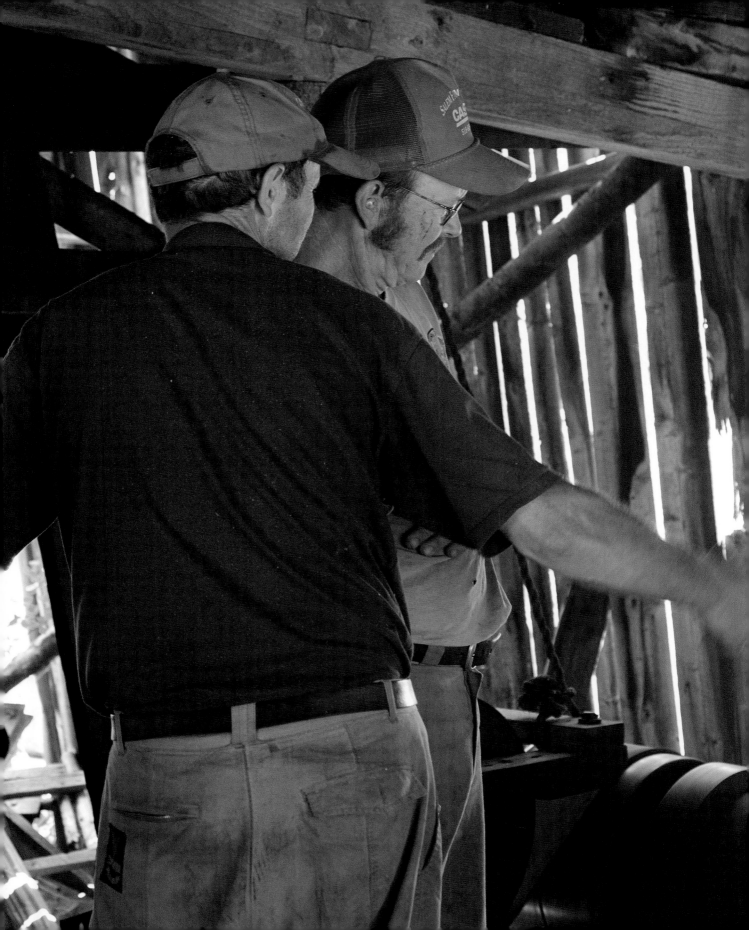

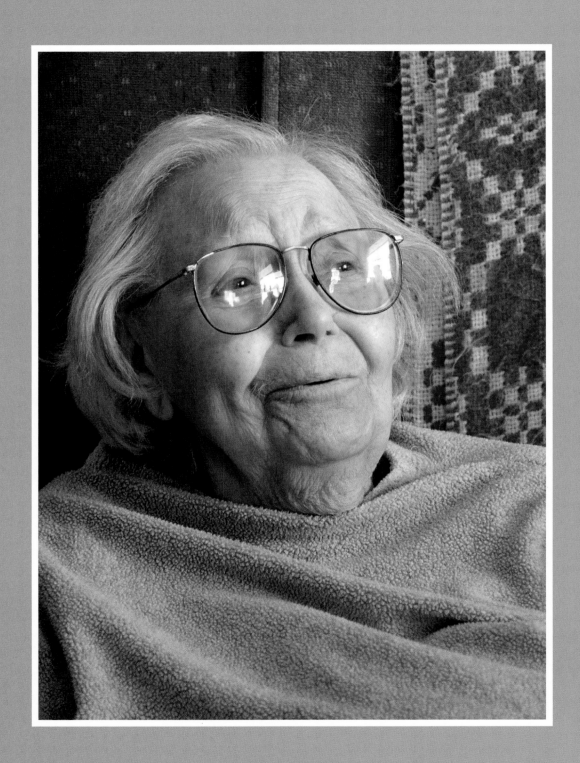

Joan

Joan Townsend met Hugh Bromley
in Brussels in 1944 during World War II. She was
a sergeant in the British army and a translator for
the Royal Corps of Signals, and he was a sergeant
in General Patton's Third Army. She grew up in
Wimbledon, England, a London city girl, and he
grew up in rural Vermont, never having seen a city. A
friend of Joan's, Madame Delcroix, who also worked
with Hugh, introduced them on a blind date at a
local restaurant. On the second date, dinner at Joan's
apartment, Hugh brought a kit bag full of contain-
ers of flour and sugar and tins of butter and sweets,
things that were in short supply at the time, and Joan
made them dinner. It was the first of sixty-four years'
worth of dinners she would make for him.

"I had a good friend, she was an American who
had married a Frenchman, and I couldn't understand
her at first," Joan tells me on a sullen winter's day as I
sit with her and Hugh in their kitchen. A woodstove
behind Joan keeps the room plenty warm and adds
a touch of smoke to the air. Rom, their old shaggy
spaniel, lies at Joan's feet, keeping watch in his sleep.

"She wasn't speaking my English at all! I asked
her where she came from and she said Pittsburgh.
Good heavens, Pittsburgh! It is a wonder I under-
stood her at all. After a while we got quite palsy
and friendly, you know, and she said she had a nice
young man working for her in the other office. So

she brought him around, and we all had dinner in a
restaurant we knew in the city, and it was jolly good.
I did all right. Hugo is honest and a hard worker, I'll
say, so I'd say we'd done all right, hadn't we, Hugo?"
She reaches across to hold Hugh's hand, giving a
gentle squeeze to carry them across the years.

"My folks were amazed I was getting married
but not so amazed as they might have been, as I
had had a French boyfriend before Hugo. His name
was André. André Revasso. He was a good boy but
I wasn't so interested in him because, I don't know,
anyone could marry a Frenchman, couldn't they?"
She laughs at this, and I can see the impish gleam in
her eye that she passed on to Roger.

"We didn't have a big wedding. Oh, no, no," Joan
says, shaking her head and smiling over at Hugh.
"There was no song and dance—I was trying to avoid
that. It always seemed to be so foolish to me. If you
are going to marry somebody, it is a lifelong thing you
are undertaking, and I don't want it all to center on
my frock," she says, laughing. "To some people that is
what it is all about, but to me—I was thinking about
the long road ahead." To a frugal young man from
Vermont this practical young lady from London was a
perfect match. Madame Delcroix had done well.

"So Hugo left Brussels in March of '45 and I followed
a few months later. He picked me up at the docks in

Joan and Hugh in their parlor, chatting.

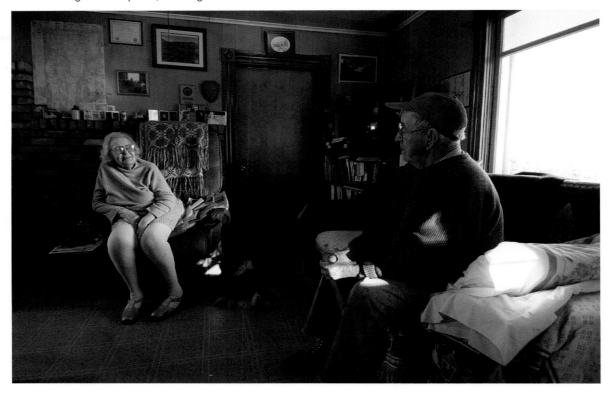

New York City on the first of May and brought me
by train and car up here to the farm. When we got
here I thought we were in the middle of the forest
somewhere. Sometimes I still do, but, you know, it
is beautiful country so you can't grumble. It was an
absolute change, of course, from what I was used
to. There were no trains, no trams, no trolley buses,
nothing. And, fortunately, no tube."

Hugh and Joan set up life together in the close
end of the big house, up on the second floor. There
was one big room with a gas cookstove and a big old
woodstove to heat water and warm the place, and
four small rooms that would soon enough be full.
Delos and Mame, Hugh's parents, lived on the first
floor directly below them. "Oh, I never called her
Mame. She was Mary Bromley, but I always called her
Mrs. Bromley. Still do, even though she's been dead
for thirty years."

It took a few years for Mame to accept Joan,
although from what Hugh has told me, she never
really ever did. "It was a bit tough around here at

first. I think Mrs. Bromley looked down her nose at
me, wondering, 'What is she good for around here?'
They never asked me to do anything. We were living
right above them but they never put much to me.
They probably thought I was so awkward, being a
city girl, I wouldn't know anything about anything
and certainly not about a cow from one end to the
other. But I pitched in and did my chores and learned
the program. Hugo was a good boy, always stand-
ing up for me. It was a bit of a challenge," Joan says
through a tight smile creased by understatement.

"But I was tickled to death to think there were
all of these beautiful animals to stroke, you know.
And horses too. They were very fine beasts and big,
and so beautiful with smooth, silky faces. They were
lovely. It was hard at times, oh, I'll say, but it was a
good life."

Joan was eighty-eight when I first met her. By then,
she mostly stayed inside, her body slowed and bent,
her mind battling the invasion of dementia. I had to

reintroduce myself to her each time I came in for a visit, but she was always gracious, even jovial in our conversations. She had scant knowledge of the present but her memory of her past was vivid, and I spent many hours listening to her and to Hugh's recollections. "Have you ever visited Paris?" she would say to me. "You really should, it is a lovely place. My mother and I always went during Easter. The flowers are so beautiful."

Joan never lost her English accent, nor did she ever lose her love of language. She spoke French to whoever she thought could understand and sang French songs so often that she would drive Hugh out of the house. "She's singing those songs again, those damn French songs. I can't understand a goddamn thing she's saying," Hugh would say as he returned to the barn for late morning chores.

In the summer of 2008 Joan's dementia deepened as her health became ever more fragile. Each morning

in the barn I would ask Hugh how Joan was doing, and the answer was always the same: "Not too well." As Joan's health declined, Hugh became increasingly quiet, his laugh lost, his eyes downcast.

By the end of July we all knew that Joan was ready to go. "There's not much I can do now," Hugh tells me one morning, "not much anyone can do now. I lie down with her and cuddle her but . . . " his words drifting off to the dark corners of the barn.

"It's okay, Hugh. She knows you're there."

"I stroke her hair and hold her hand . . . sometimes I talk to her but it seems she's not there."

"She's there, Hugh, and she knows you're there too. You're doing the right thing taking care of her at home, keeping her comfortable."

"Well, I don't know," his voice broken and shallow. "What is going to happen now? What am I going to do now? Where will she go?"

We sit in silence on bags of newspapers stacked

Hugh all alone

against the barn wall. It is the first time Hugh has seemed old to me, old and very sad.

"I suppose she'll go back to her mother," Hugh says now talking mostly to himself. "She's been talking 'bout that for some time now, and back to Martin. I guess it's time for her to go. I'm going to miss my Joanie."

We sit in silence again, my mind failing to find the words of solace I want to share. Hugh turns his head and says to me, "There's no one left anymore,

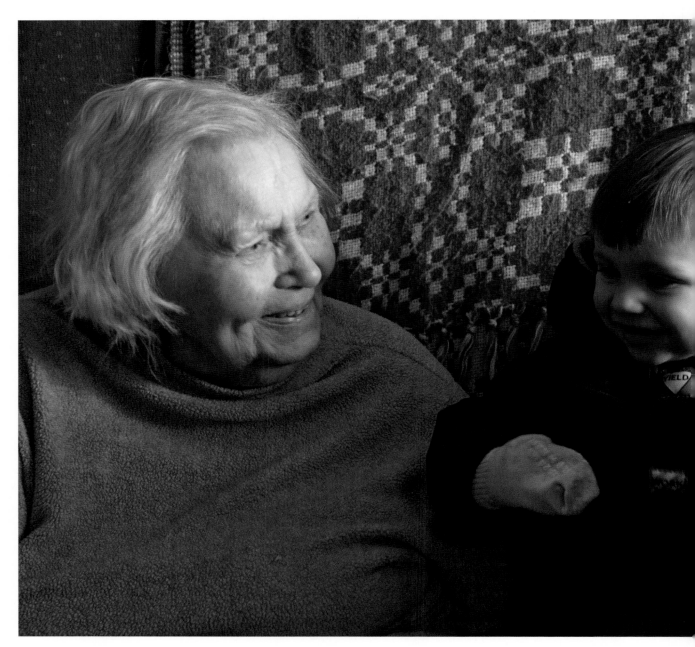

Joan, Macy, and Trish.

no one. I was thinking the other day, coming up out of Danby, the people we knew, we'd talk to and go visit'n', they're all gone now. The people she'd talk to, they're all passed, and now she's . . . " Hugh's voice is quiet, weak, his usual vigor and eagerness when telling "back then" stories gone. "And now she's going too, and I'll have no one to talk to, no one who knows my stories. It was just her and now it is just me."

We sit in silence again. As Hugh traces faint patterns in the silage dust at his feet with his cane he speaks again, his head bowed, his body slumped. "Last week, we were sittin' together in the kitchen, and all of a sudden she gets up and walks out the door and sits on the bench on the porch. She hadn't been able to get up by herself for a couple of weeks and she hadn't been outside in months. We sat there for an hour, talking. She said she had always loved the view over the barnyard, across the meadows to the high barn and the mountain. We came back in and she went straight to bed. She never got up again. She hadn't been on that porch in months, but she wanted to go out one more time, I guess. I wish I could take her out there again."

Joan died in her sleep early in the morning of August 4, Hugh sleeping fitfully on the couch in the room next door and Roger on the daybed in the parlor.

At dawn I walk into the barn and see Trish and Hugh hugging in the far manger. I go up to him and mumble, "I'm so sorry, Hugh," and he mumbles back a thin "Thank you," both of us unable to say how we really feel. I can see his eyes are red and teary, and his voice and his walk are unsteady, but he's in the barn, doing his chores, sorting and clipping in the cows. He doesn't know what else to do. After living through the sudden death of his youngest son, Martin, and now his wife, it is the one thing in his life he knows will not leave him.

I watch as he slowly crosses to the center aisle where several cows are standing, clogging up the middle and keeping the rest of the cows from their proper stalls. Leaning on an old pitchfork, he lifts his head and calls out to the cows, "Hee yah, get up to where you belong. Go on now. You don't belong here anymore. Get on up to where you go. This isn't your home anymore. Go on."

It is his final prayer to his sweet Joanie. ✎

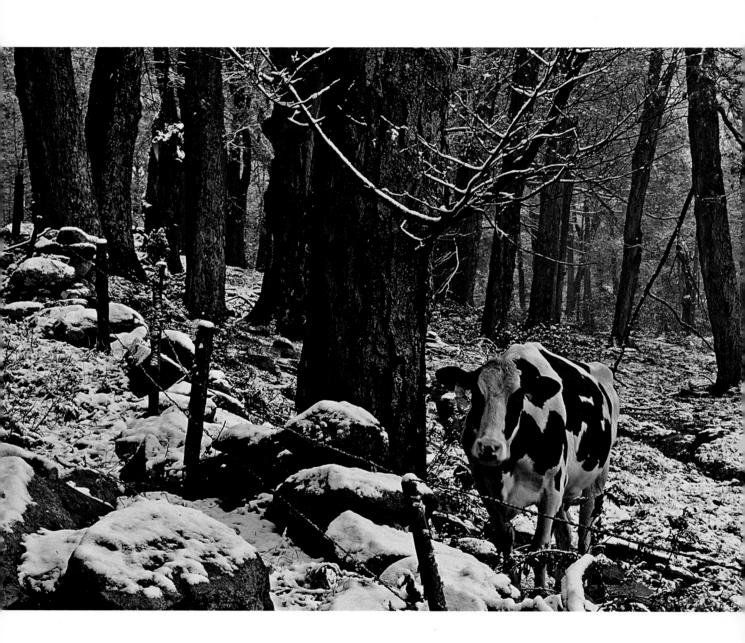

Cold

Winter, true winter: the ground is white and the wind is visible with kicked-up snow, and icy coldness becomes just another layer you put on in the morning and don't take off until your chores are finished at night. It is not something you can choose to wear one day and not another, like a gift tie or a frilly scarf. It is part of your daily ensemble, and you either figure out how to deal with it or you go back to bed and hide till spring, late spring.

If it is just cold, even mightily so, say minus 10 or 20 degrees, it is not so bad being outside. Adding another layer will keep you warm if you keep busy, unless you are sitting on a tractor. "If I stay busy, it's not so bad. My feet get cold and so do my hands, but after a while I don't notice them. If I have to sit on the tractor doing something, then I really get cold because I am not doing anything. Nothing is colder than a tractor seat." Of course, a tractor with a heated cab would solve this, but there is only one tractor with a cab on the Bromley farm and it's not heated and it is not used in the winter. Nice try.

When it is both windy and cold, being outside all day becomes nearly impossible. It is possible to wear enough clothing to stay warm, but it is impossible to actually do anything so dressed. When it's bitter outside, Roger will wear a couple of pairs of socks, long underwear, sweatpants, and baggy corduroys on his legs and a T-shirt, turtleneck, sweatshirt, insulated vest, and a down vest on top in the barn. A hat, neck gaiter, and gloves encase his head and hands, a parka for his torso.

If the wind is howling, sounding like a distant jet engine as it whips around Dorset Mountain, the barn can get uncomfortably cold—in the upper thirties where the cows are and in the twenties back in the haylage alcove. There the wind hurries through evil little cracks and down the haylage chute, making little drifts and menacing icicles inside. For weeks at a time inside the barn frost grows to be an inch thick on the cement block walls in the alcove, and the windows there are opaque with frost, looking like plush, icy velvet.

When Roger knows it is going to be especially cold at night—below zero—he will make an extra effort to button up the barn as best he can. The big barn door is snugged tight with a spring-held chain, and bedding is piled up around the base to cut out drafts. All the windows are shut and the fan turned off, and silage is piled around the back doors as insulation. In the milkroom a small electric heater will be pointed at the sink faucets, and a trickle of water will run all night to keep the floor drain from freezing.

When the barn is closed up this tight it won't get much below 40 degrees no matter how cold it gets outside at night. Fifty cows and half a dozen calves

Camo cow in an early snow in October.

Yes, it was that cold. A brisk day in January.

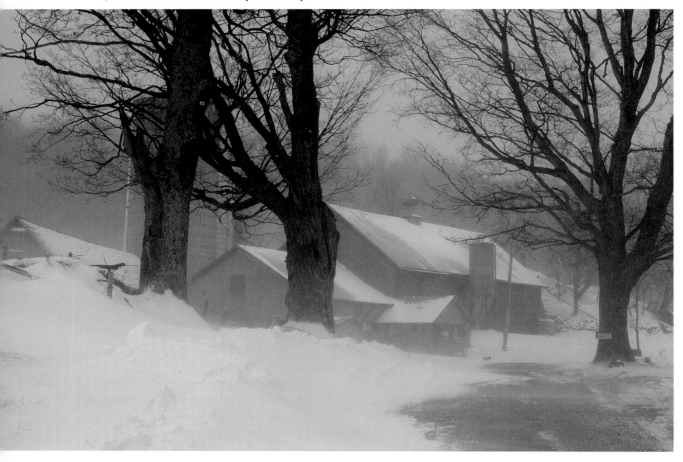

and yearlings make effective heaters. But if the wind is blowing from the north and the sky is clear, the barn will feel cold even if the thermometer says otherwise.

On these days you just have to be resigned to the fact that hands and toes are going to be more often cold than not. Rubber boots don't have much insulation in them, if any, and heavy gloves make some jobs impossible. Try clipping chains to fifty cows wearing heavy insulated gloves, and you'll quickly discard the gloves to get the job done. Once hands and toes and gloves get cold (and, heaven forbid, wet) there is very little chance of them ever getting really warm again. Roger will run a trickle of hot water over his boots to warm the rubber and thus the feet inside, but it is a very temporary solution. He'll rotate gloves—heavy,

lined ones for outside work and lighter, uninsulated ones for inside jobs—but these get cold as well. Rubbing a cow's back takes the ache out of really cold fingers, as does the heat from the bare overhead lightbulbs, but it is a net loss proposition: your fingers will warm up temporarily, but standing still chills your whole body.

The milking barn, though, is not the coldest barn on the farm. The coldest place is the heifer barn, a half mile uphill from the milking barn and fifty years removed. Every day, all winter long and into early spring, Roger goes up to this barn after he has finished his chores down below. If the snow is not too deep, he will take his four-wheeler to the barn; if it is more than a foot deep or if there are no good tracks, he will ride a snowmobile.

The yearlings chowing down around a feed bin.

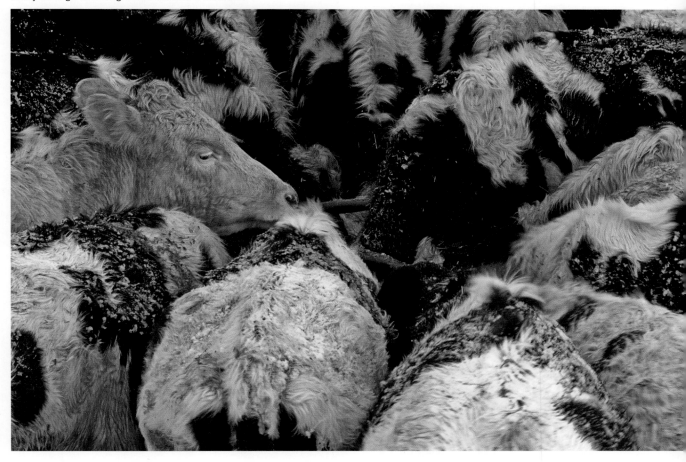

The heifer barn sits high on the north flank of Dorset Mountain. The views from up there will make your eyes pop but the weather will take your breath away, literally. It is always windy in these high meadows, but in winter, when the crown of the mountain cleaves the clouds like a big rocky plow, the wind roars down the pastures with bitter blasts of ice that will stop you dead in your tracks and make it hard to take a breath.

The only electricity in the heifer barn goes to two bare lightbulbs in the cow stalls. This is how it's been here since electricity came to the farm in 1934. Since then, little has changed. There is no mechanical gutter cleaner, no manure pump, no compressor to provide power. The power is supplied by Roger, the gutter cleaner is a shovel, and the manure pump

is a wheelbarrow. Add a strong back and you're good to go.

"I suppose we could put a gutter cleaner up here and we could put in some heat but it would only be used a few months each year and the heater only a few weeks, when it is really cold. This old barn is pretty snug down here; twenty heifers keep it warm enough, and they have plenty of food. The heifers don't seem to mind and neither do I. Besides, it gives me a good excuse to go for a ride."

Every winter there are days when the wind is nasty and cutting, armed with icy blades that sting your skin until it is numb and dulls your brain until you retreat inside. And then there are the really cold days. Chores anyone? 🐄

Pages 152–153: The heifer barn after a February storm.

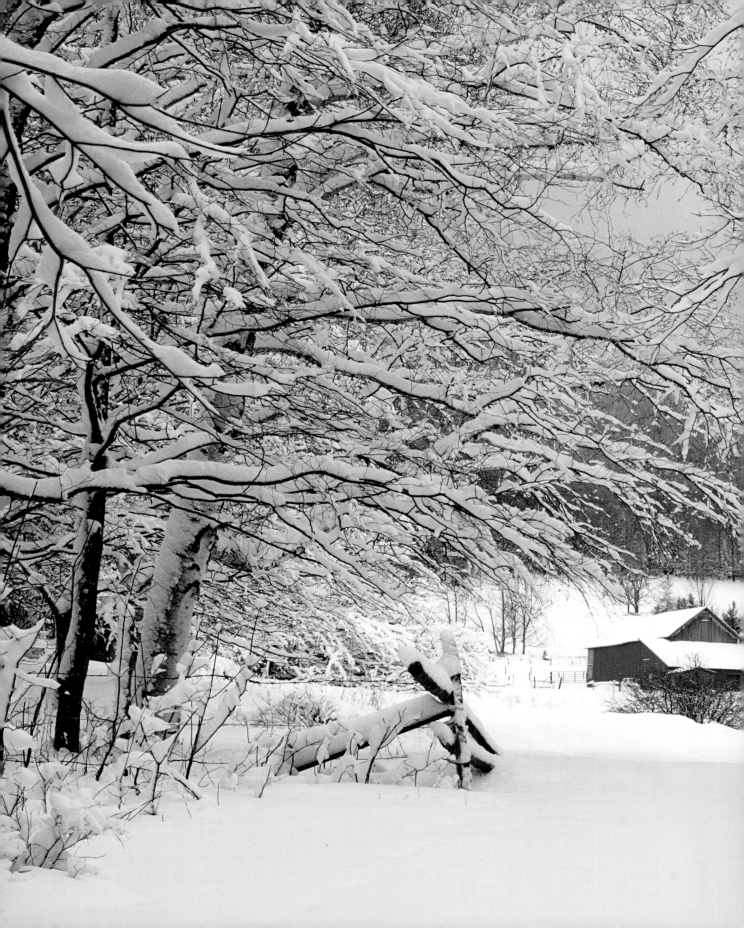

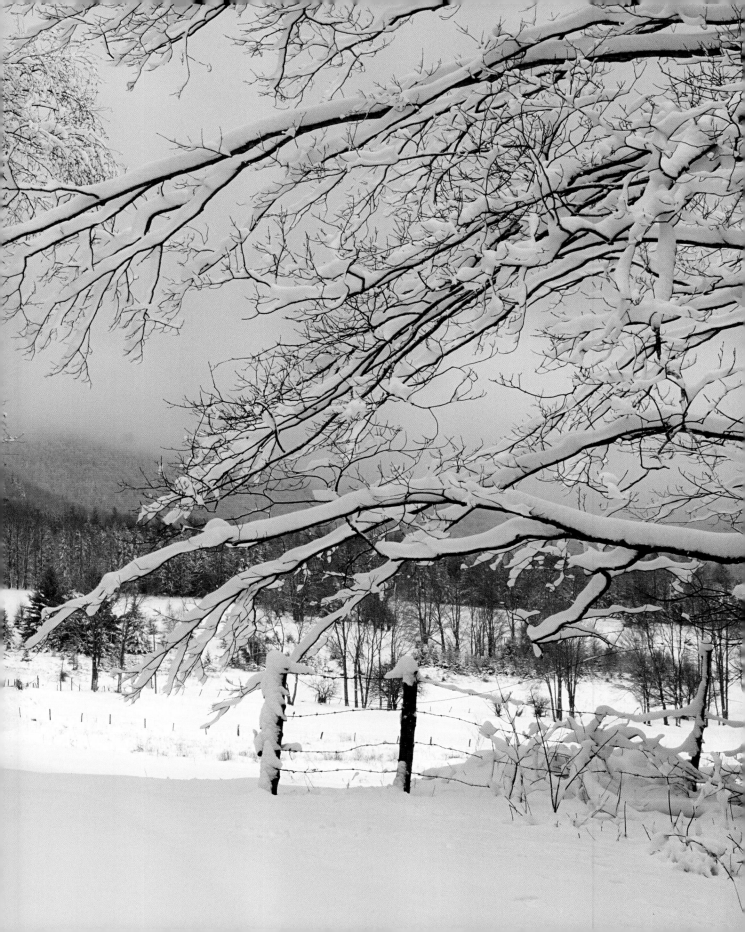

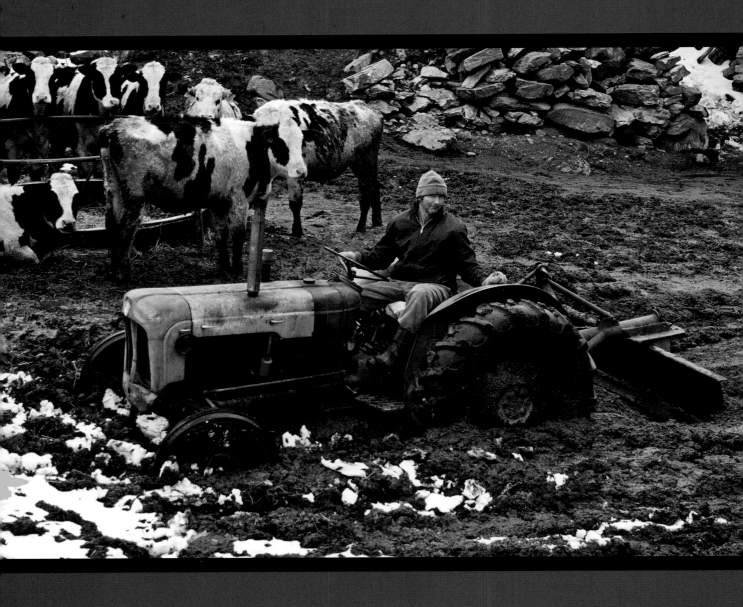

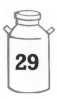

Piles

Piles—steaming, edible, baled, bundled, blown, frozen—and shovels—plastic, metal, short, wide, long, narrow—describe most of a winter's day on the farm. There are piles from cows and piles from calves, piles of silage and piles of hay, piles of grain and piles of newspaper and miles of piles of snow. There are piles in the barns, piles in the manger, piles by the silos, piles in the hayloft, and piles in the barnyard. There are piles that are cow-made, piles that are man-made, piles that are machine-made, and piles that ol' Ma Nature herself made.

And for every pile there is a shovel and a purpose for every shovel under Heaven. The wide blue one to push up food, the light metal one to spread sawdust, the old rusty ones to clean the gutters, the narrow blue one to spread the bedding, the ragged plastic one to fill the wheelbarrows, the short metal one for the calf's manger, and the brand-new one up in the hayloft that may never be used.

Shovel, scrape, spread. Pitch, push, plow. Fill, pack, dump. Repeat. From November to March, this is Roger's day. It is winter, a time of piles and the season to shovel.

"None of this would be necessary if we didn't feed 'em," Roger says, hunched over a wheelbarrow full of manure. This is not a serious complaint, even though this is the sixth time this morning he has filled, pushed, and dumped a full wheelbarrow of

manure. This doesn't include the four or five wheelbarrow loads of food he has taken out back to feed the yearlings, or the four times he has filled the feed cart and doled it out or the two times he has pushed the full grain cart around the barn, giving a scoop and a half to each round cow.

Except for the feed cart, all this work is powered by Roger. This is because when the barn was built, work was done either by hand or by horse or it wasn't done at all. Now, a hundred years later, the working spaces are too narrow and the configurations too contrary for modern farm machinery. Roger has nothing against a motor doing the work; it's just not practical or possible most of the time for most of the chores. So he supplies the power every day, twice a day, before, during, and after milking as long as there is nothing for the cows to eat outside.

"My life is crap," Roger says proudly, smiling at his wordplay. "There are times when my ass is grass but my life is always crap." Enjoying himself, he continues, "It's on my hands and it's on my clothes. It's on every tractor, wagon, and implement we've got. I sit in it, I walk in it, I breathe it. I see it every day, I smell it everywhere. I swear I taste it at times, and if it ever got quiet enough I could probably hear it call my name. It's a crappy life. Ain't it great?"

Roger wouldn't have it any other way. He would

Roger scraping up behind the barn, and that's not mud.

rather have a dirty boot than a dirty boss any day. He can always hose off a boot.

Not every pile is a pile of manure, but many are. Most of the manure from the milking cows falls into a shallow gutter and is carried away automatically by chain, scraper, pump, and pipe to the manure pit across the road. But the piles of poop in the calf barn, the heifer barn, and the back barn when it is full of the yearlings must all be cleaned out by hand using a shovel and a wheelbarrow. It takes two moderate loads to clean the calf barn, two heaping loads to clean the back barn, and three back breakers to clean the heifer barn.

When not shoveling manure, Roger is shoveling haylage and corn silage into a wheelbarrow to feed the cows the feed cart can't get to. Three or four loads in the morning, two or three in the afternoon, each load equal to eighteen or so full shovelfuls. Only twelve shovelfuls really fit in the big blue wheelbarrow, but if you get up on top of it, as Roger does, and stomp around a bit, you can fit a few more shovelfuls in the barrow.

Between shoveling, there are bales of hay to be fetched from the hayloft, paper to be chopped for bedding, mangers to be swept, cows to be let out and back in, sawdust to be spread, calves to be fed, and the feed cart to be driven around and food doled out. A lot of this he does while he is milking the fifty cows. With four milkers going at once but none on the same timing, Roger finds a minute here and thirty seconds there to start or continue or finish a chore. He is never rushed, but he also has no time to lolligag.

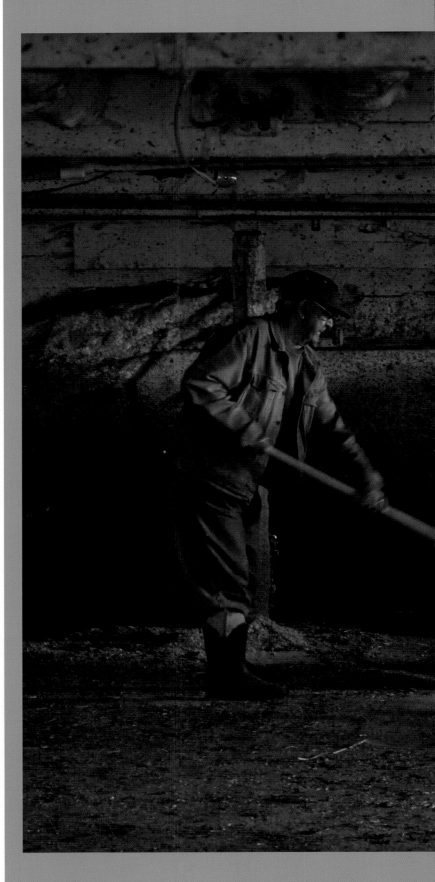

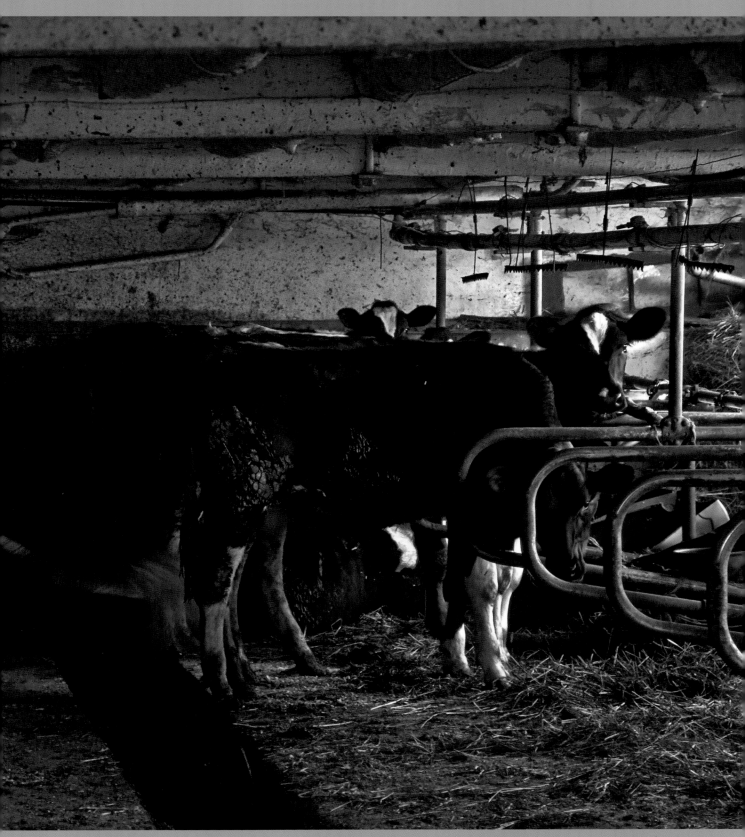

Hugh putting fresh bedding under the calves.

If Roger is by himself, it takes him three hours to milk the cows and do the early morning chores and about another three hours to do the cleanup of the milking barn and all the chores in the heifer barn and the calf barn. Add some time for a midmorning breakfast and an early afternoon lunch, and figure in some extra time for something to go wrong (or at least not quite right), and Roger has about an hour in the late afternoon to get something new accomplished before the evening chores and milking begin.

Trish and Hugh help in the barn when they can, but Trish has a full-time job during the day and Hugh is, well, Hugh is old. Trish comes up for the last hour of evening chores to clean up the mangers and spread food to the cows. Hugh is usually the first one in the barn in the morning, so he gives the cows their first food and then scrapes up as best he can. He then either goes over to the calf barn to give them their hay or shuffles back to his house to warm up and take a nap on the sofa. He comes back, though, after milking is over to let the cows out and help with the cleanup. He doesn't have to, but he has spent a majority of his ninety-two years in that barn, so it is more his home than his home is to him.

Winter is also the season to repair and maintain all the equipment on the farm. There is not a motor that Roger hasn't tinkered with, taken apart, or replaced something on. All kinds of people can be found on the farm, all kinds, but you will never see a mechanic or a tow truck. Roger does all this himself. He doesn't have to, but he likes to. And so he intimately knows every plug, gasket, and hose on every engine. I once saw him start a tractor by using an old railroad spike to connect two parts of the motor. He saw me looking at him as if he had just grown another arm, "It's just the way I've got it wired up. Don't ask," he said, so I didn't.

But all is not work on the farm in this season to shovel. If there is snow on the ground and Roger has a moment, he'll be on a snowmobile headed to one of the several winter trails that cut through the farm. He has many from which to choose—many snowmobiles, that is. The last count was fourteen, but it is a fluid number. There are enough so that when I was first opening doors and snooping about on the farm, I kept finding them in the strangest places. I found four stashed in the sugarhouse, five in the hayloft of the heifer barn (raised up there by a homemade derrick), two in his basement, and half a dozen in the old sheds up top.

Most of the snowmobiles are utilitarian, although Roger wouldn't turn up his nose to one that was orthodox or fundamental. They all have been tinkered with, parts swapped and individually modified to suit the needs of the farm. He needs one every day in winter to go up to the heifer barn, so he keeps three out to make sure one is running. And if there is a bargain at the end of the season, he'll get another one.

"There is a good deal on a snowmobile down in Bennington," Roger tells me one morning as I am scraping up. "Are you headed down that way?" he asks me.

I ignore him. I have learned it is best not to encourage this kind of behavior. Roger, hardly noticing my lack of hardly noticing, continues undeterred. "I could get rid of some," he says with mild conviction. "I did put an ad in the paper to sell one for $1,600. A woman called me up and asked if I would take $1,200 cash for it."

"What did you say?" I ask expectantly.

"I said, 'Sure, if there was also a $400 check included' . . . never heard back from her."

"It was a noble effort, Roger. Hollow, but noble."

"No, I really was going to sell it!" Roger says, pausing long enough to see if either one of us actually believes this.

"Ah, hell, what's one more snowmobile." ✦

Hugh cleaning up after a storm.

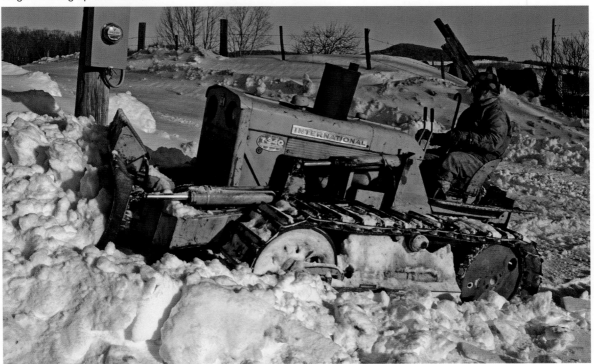

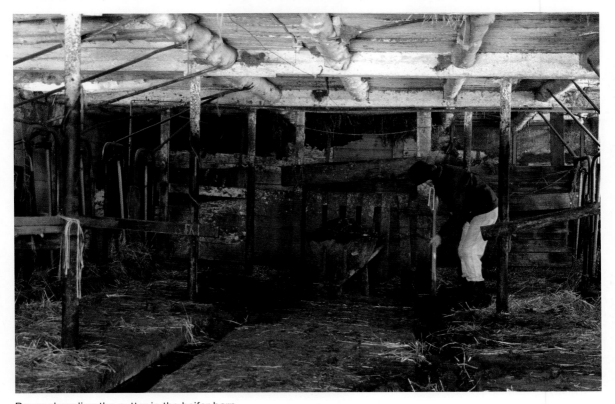

Roger shoveling the gutter in the heifer barn.

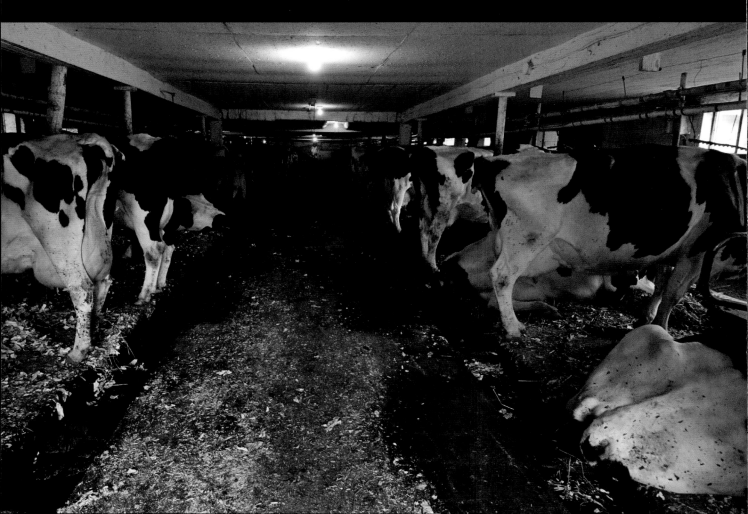

Isn't this something?

"I won't be long. I just need to drop something off for Roger and then I'll be right back. Won't take but a few minutes."

These innocent words represent an extreme level of delusion, equal to believing that the tooth fairy is a tyrant. It doesn't matter if I say it or Roger or Trish or anyone else, it is impossible to just stop by the barn.

This is because there is always something: always something to do, always something we forgot to do, and most likely always something that has gone wrong and needs to be fixed. But it's always something. This is why Roger has rarely been on time for anything in fifty years; something always comes up. A calf gets loose, the unloader freezes, a gate is out of whack, the grain chute is jammed, a tractor won't start, or a piece of equipment is broken. Considering that the farm is 150 years old and most of the buildings and mechanical workings aren't much younger, and that anything "new" on the farm is at least 10 years old, it is hardly surprising that the best-laid plans are never actually laid and seldom come off as intended.

Roger embraces this central aspect of farm life with all the gusto of a lush at a liquor store—he likes what he sees and can't wait to get his hands on it. There are times when, up against the weather, he will show a hint of frustration, but mostly he considers problems to be puzzles to be solved. Every day

there are new problems and thus new puzzles and new ways to solve them. This is how the seeming monotony of everyday routine is shattered. Roger would probably like a little monotony every so often, but if everything went just as planned and ran smoothly for too long, he would probably invent a problem he would have to solve or fix something that didn't need fixing.

On this night I am dropping off some newspaper articles pertaining to issues we were talking about during milking. These "Meet the Press" sessions we have over the gutter or leaning on a cow are generally low on fact but high on opinion, just like their TV counterparts, and though they don't last long, they allow us to vent and share and solve the world's problems.

It is seven in the evening when I walk into the barn, a time when Roger is usually halfway through milking and he is thinking about which TV show he is going to fall asleep in front of on the couch. But this time I notice the milkers are still in the milkroom sink and the compressor isn't running. Has he finished already? Stepping into the barn, I see right away that things are amiss. The cross aisle is soaking wet, as if it has just been hosed down and then covered in wet hay and sopping bits of newspaper. I then see that the first cow on the right is standing

The cow barn full of cows and full udders.

in four inches of water—as are the next six cows up the manger. One step more and the gutter comes into view. It is overflowing with water, a narrow little river clogged with cowshit, bedding, and hay that runs on both sides of the barn all the way down to the big barn door.

"Isn't this something?" It's Roger, down by the manure pump, scratching his head and admiring one hell of a mess.

"What happened?" I ask, dumbfounded, looking around the barn. When I left in the morning, the barn was all neat and tidy, and dry.

"Well, I was in Rutland all afternoon and I was running late as usual, so I just walked into the barn a few minutes ago. The hose to the water dish on the sixth cow up came loose and it has been pouring water into the stalls for hours. Helluva flood, huh?"

He says this without anger or disappointment or even a sense of frustration. He is closer to marveling at the flooded stalls and gutters than he is to getting mad. This is something he hasn't seen for a long time, if ever, so it is new and thus by definition interesting and, dare I say, fascinating.

"What are you doing here, anyway? Aren't you glad you came? Probably just wanted to stop over, didn't you?" He is laughing now, making jokes and taking it all in stride as I stand there slack-jawed.

"What are you going to do?" I ask, choosing to ignore his questions.

"Well I'm going to get that little electric pump we used the other day and try to dry this place out. Then I probably should do some milking and feeding and cleaning up. I called Trish and she is going to come up to help. And if you stand there much longer I'm going to put you to work."

He walks past me to retrieve the pump and I do a quick survey of the work that needs to be done: the gutter's got to be drained, the center aisle scraped, the six cows in the flooded stalls kicked back outside into the barnyard (better close the gate to the far barnyard or we'll never get them back to be milked), their sodden haylage shoveled up and tossed into the wheelbarrow, all the bedding in the stalls removed, the standing water swept out, and new bedding spread once the stalls are dry. Then the cows will need to come back in and reluctantly go back into their now different stalls (that will be fun), the feed cart will have to be filled with haylage and then refilled to feed them and the rest of their mates, and then after all that the regular evening chores will have to be done.

Roger comes back with the pump and a length of garden hose in hand.

"You still here?" Roger asks, grinning as he heads down to the manure pump and the deep end of the barn.

"I'll move my car," I answer, realizing that I had parked it in front of the milkroom door with the motor running. I was just going to be a moment.

When I return, Roger has the pump running in the gutter, and he has a stream of water gushing from the hose directed down onto the hard, frozen ground just outside the barn door.

"What are you doing?" I ask, perplexed.

"I think there's a hole in the foundation somewhere under all this ice and frozen muck here. I seem to remember blasting through the cement years ago just in case something like this happened. If I can find it and open it up, the gutter will drain much quicker."

"Has this happened before?"

"Everything has happened before. The trick is remembering."

"Do you remember where the hole is, if there is a hole?"

"Not exactly. It should be around here, though. It seems like a good spot to put a hole if you needed one, don't you think?"

I stare at the water hitting the frozen ground. It's going to hit 0 degrees tonight, and the barnyard is going to be a skating rink in the morning, but we'll deal with that then. Right now the water seems to be doing very little to improve the situation.

"But couldn't it be anywhere in the cement? How do you know it will be there?"

"It just seems like this is the place it would make most sense to put it if you were going to put a hole in the cement."

Before I can come up with another inane question, the hose sinks into the ground and water rushes into the gutter on the inside of the barn. He removes the hose and water starts to drain through the newly cleared hole.

"That should do it as long as it doesn't get all clogged up. I'll run the gutter cleaner as soon as the water goes down a bit. What?"

"You weren't sure there was a hole there but if there was that would've been the place for it to be. Is that right?"

"Where else would you put a hole? Wait—don't answer that. It worked, didn't it?"

Amazed, I turn to go up to the wet stalls. The logic of the practical man, I think to myself. Doesn't everyone drill holes in their foundations where they think it would be a good spot for a hole? I shake my head.

"Okay, ladies, surprise! Time to go back outside," I say to the six cows in the wet stalls. The cows look at me as if, well, as if nothing; there never really is any expression on a cow's face. But I do get their attention and unclip them all and send them back down the center aisle and out the barn door. It is not part of their normal routine to be put back out of the barn before they have been milked and given their grain. They shuffle out willingly, unable to muster enough rebellion to resist me.

It takes me an hour to clean up the stalls and replace the wet bedding and food. Trish arrives and starts in on the cleanup too, and Roger manages the lowering of the tide. He eventually starts up the gutter cleaner and the manure pump, and after thirty minutes or so the flood is half out.

But when he goes to start his normal milking he finds there is no vacuum pressure in the system. He comes up and fiddles with some air valves by the wet stalls where I am still working.

"What's up now?"

"Can't get any suction in the milk line," he states matter-of-factly. Without suction, the milking claws won't stay on the teats, and the milk won't

run through the pipes to the holding tank. In other words, without suction, he's got nothing.

"You're kidding," I say helpfully.

"Nope," he says and glances around. "Isn't this something?"

I look around at the barn now. Half the barn is still soaked, and the center aisle still hasn't been scraped, so long piles of cowshit have been left exactly where they were. I have piles of cowshit, chopped, wet newspaper—the bedding—and haylage in long piles by the gutter waiting to be slowly added to the muck so the gutter cleaner won't clog up the big pump. Several large rubber mats are drying in the aisle, there is a puddle the size of Lake Erie down by the barn door, and the six cows I put out have now decided to come back in, walking through everything and making a mess again. I have never seen the barn in such disarray. It is surely something.

But this is more Roger-speak. "Isn't this something" translates to "This is different. This is new. It'll be interesting." We all know what "It'll be interesting" means.

And there under a lightbulb, an island of tranquility in a messy sea, Roger is fiddling with a small plastic part of the milking line.

"This is the brains of the suction," he says as he pops off the top disc and exposes all kinds of little springs and clips and screws. My mind explodes with hideous thoughts; springs sprooning into the gutter, screws sinking into Lake Erie, clips vanishing in the wet piles. I can't watch, but I can't take my eyes away either. The potential for mishap is too great.

"I've never opened one of these up before, but this must be the problem. I'll just wash it out [oh, no, the sink, the drain!], it's probably sticking open." He says this without any trace of disappointment or frustration, nothing to betray the fact that on top of the current chaos of the barn, he has to deal with a completely different problem. If Roger is feeling any strong emotion now, it is curiosity. This is something new to take apart and examine. The barn and all its problems have temporarily been forgotten as he peers inside at the rings and springs and things.

This is too much for me to handle. I turn back to my piles and push some more into the gutter. This I can deal with. Push a pile, wait, push a pile. When there are no more piles I will start on the bedding. After the bedding, the food, after the food, the cows. I'm thinking about when I'm going to get to bed and Roger is thinking, "I wonder what that little spring does."

Ten minutes later he is back, and suction returns to the milk line. It is now eight-thirty and he still hasn't started milking yet. His outlook has gotten steadily rosier if anything. By nine o'clock my stall reclamation is finished and the six displaced cows are eating contentedly in dry stalls, on new, dry bedding. By nine-thirty Trish and I have gotten two loads of feed down in front of the cows, three bales of hay spread on each side of the barn, the mangers pushed up and swept, and the aisles scraped and clean.

Roger finishes his milking and cleanup of the milkroom around ten o'clock and comes back into the barn. Trish and I finished our chores twenty minutes earlier, so we wait, talking. He finds us leaning on brooms in the cross aisle, a late-night lolligag.

"Well, that was fun, wasn't it?" Trish and I cock our heads and smile, giving each other the same look. We are both thinking, "He's a nut, but he's your nut."

"Aw, come on," Roger says, "Let's do it again tomorrow!" ✍

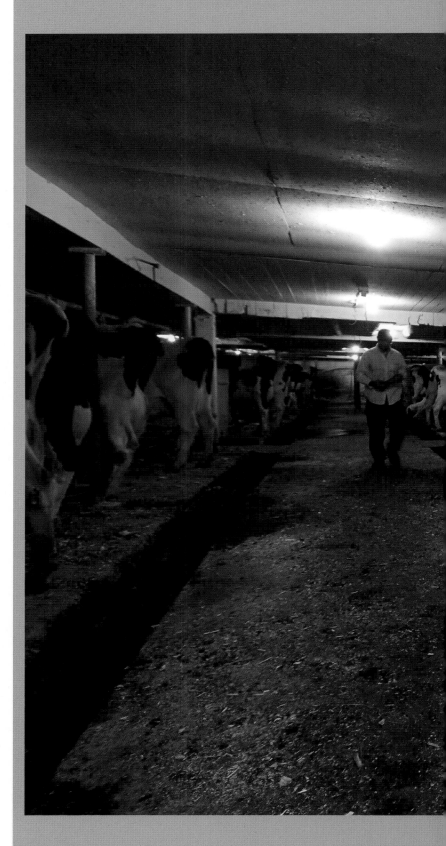

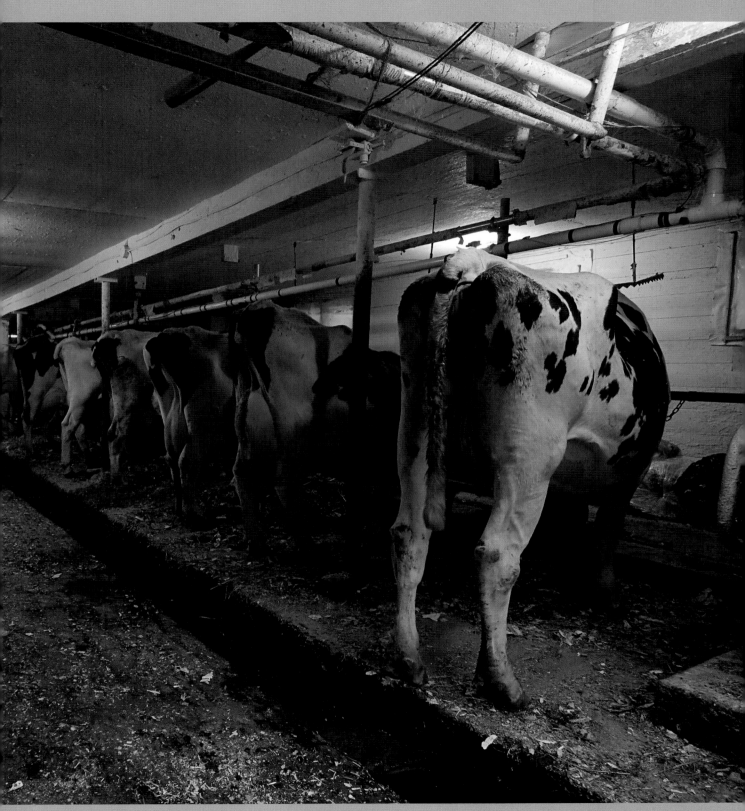

A full barn of fifty cows.

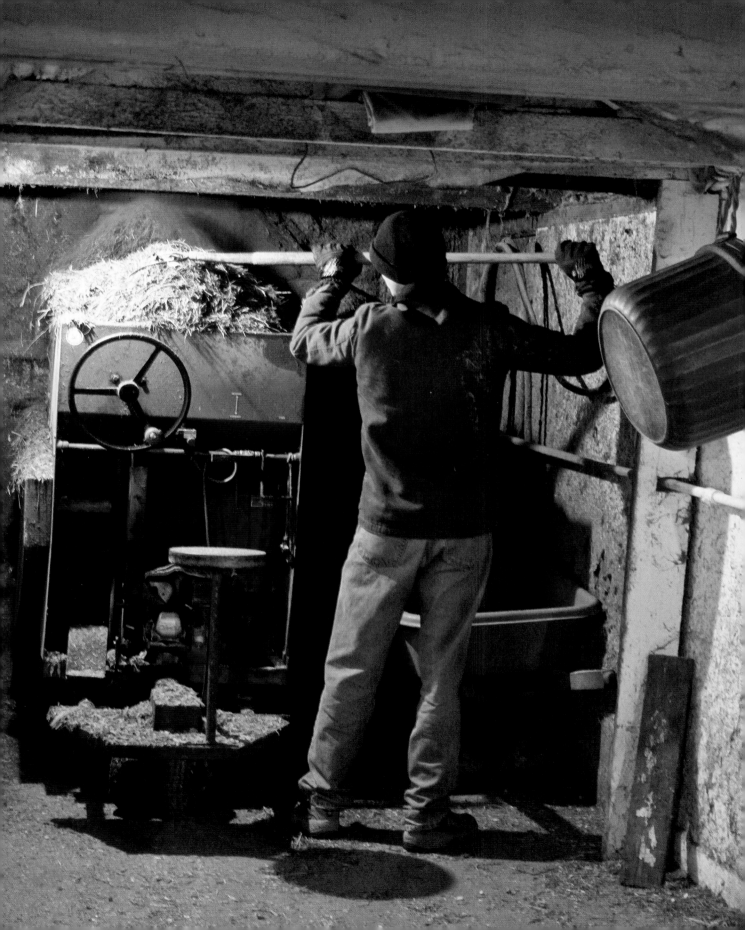

31

The cobacus

"We've gotta have a system!" Ike says with unusual vigor and exasperation. It is the middle of winter, and we are in the middle of the barn in the middle of morning chores. Time to meddle.

"A system for what?" I ask suspiciously, not being familiar with this sort of energy emanating from Ike this early in the morning.

"A system for keeping track of the number of times the wheelbarrow is emptied out back for the yearlings."

"We need a system for this?" I inquire, wondering if Ike is setting me up for a prank or to make some obscure point. The two possibilities are equally likely. He gets the pranks from his father, but he is responsible for all things obscure in his life.

"Yes, we need a system!" Ike says, pounding his fist into his palm with dramatic flare. "By lunchtime we don't know if the yearlings have had three loads or four or five, so we give them another just to be sure—but they are only supposed to get four loads."

Ike continues to pound his fist into his open palm as he says this. He is on one of his favorite soapboxes and he is gaining both speed and volume. I am not sure which soapbox this one happens to be quite yet, but I am enjoying the rising fervor in his voice. It could be the "we need to be more efficient" soapbox or the "waste not, want not" soapbox or, his current favorite, the "we are spoiling these cows" soapbox. It is a bit too early in the rant to tell.

"A system?" I ask with mock thoughtfulness.

"Here's an idea. How about we ask each other and then add up all the times and see if we come up with four? It's a difficult system, I realize, but with some effort I think we all could master the art of talking to each other and adding."

Unfortunately, this penetrating bit of sarcasm is lost on Ike. By the time I get to the end of my suggestion, Ike has moved on. This has all been a prelude to introduce his idea for the system. What I thought was just early morning crazy talk has been a calculated strategy for attention and action.

"We can't ask each other. We'll forget to ask, and even if we remember, we'll forget how many times we did or did not take a wheelbarrow out."

I am tempted to point out that the only choices each of us has are "none," "once," or "twice," and that even for us that shouldn't be too stressful. But Ike has a full head of steam now, so I decide to get off the tracks and let him barrel forward.

Roger has joined the conversation now, curious that his middle son is displaying excitement at seven o'clock in the morning. He is amazed that he is exhibiting anything at seven o'clock in the morning. Ike has mastered the difficult art of sleep-choring. Usually he is physically present in the barn and does do his chores, but he is mentally and spiritually back under the covers in his bed.

"What's goin' on?" Roger asks me while studying the person next to me to see if it really is his son.

"Ike says we need a system," I respond.

Ike filling the feed cart with haylage.

"A system? A system for what?"

"A system to count the wheelbarrow loads we take out back."

"Couldn't we use numbers? I hear they are really handy and easy to use once you get the hang of it," Roger suggests through a growing grin.

Ike has now gripped his hat and is shaking his hand in the air, once again exasperated with his fellow workers. Exasperation usually requires either the hat grab or the hand shake but seldom both. When he uses both, Roger and I know that we are getting to him and no matter what else happens this morning, it will have been a productive day. The fun is just beginning.

"No, it doesn't work! This is what we are going to do now." He says this so quickly and firmly that Roger and I are unable to sidetrack him. This is unusual for us, and it means that Ike has come prepared for our nonsense.

Ike holds up his right hand and shows us four particularly big pieces of corncob he has found on the floor of the manger. The biggest cob pieces, about an inch long, gain enough momentum blasting out of the silo chute above the feed cart that they often miss the cart and ricochet off the walls in their efforts to escape their cruel four-stomach death-by-digestion fate. Ike often finds these pieces and tosses them down the manger in front of one of the cats to get it to chase them, but today he is hoarding them. The cobs now have a higher purpose.

"Each one of these represents one wheelbarrow load. Every time you take out a load you will place a cob marker in this little cranny so we will be able to know exactly how much food we are giving the calves out back."

Roger and I are really suspicious now. This initiative is very much unlike Ike. He never shirks his work, but he seldom makes more of it for himself.

"Isn't this more work, Ike?" I ask.

"No, it will be less work. Now we won't be taking unnecessary loads out back. With this system we will only do just what we need to do."

Aha! The soapbox has finally revealed itself. It is the "do the work but don't do any more than is necessary so we can get out of here before Roger thinks of more that needs to be done" soapbox.

Roger pipes up now, "Oh, I like this idea. This will really work!" Roger generally likes any new idea because he knows that his father generally won't. But I think he actually believes Ike's idea has value beyond rattling a few shingles off the old man's roof.

Kidding, I add, "What would be really nice is one of those counters they have over pool tables, you know, where they reach up with their cues and slide some tabs over to indicate their score."

"Yes! Yes! That's it!" Ike is practically shouting now. "And we could make it out of baling twine! It would be authentic then and look like it fit in the barn, been here for a long time. Oh, this is going to be great!" he crows.

Before Roger or I can slow him down, Ike has turned and is making a beeline to the barrel where the extra twine is stashed. Ten minutes later he has strung his first cob-bead onto the twine and is excitedly stringing the next.

"This will be great. You'll see. They will be remembering this day for generations!"

In his mind he is storming the barricades, trying to bring down the tyranny of unnecessary work. As it is, he is standing in the center aisle digging with his pocketknife at the center of another large cob. When he finishes four he strings them up between an old nail and a switch box on one of the ceiling beams—the cobs caught in the space between the nail and the box.

He takes us both over when he is finished. "There, four cobs, all on one side. Every time a load is taken out back, a cob is moved. It is foolproof!!"

"Do we move it before we take the load out back or after we come back?" Roger asks teasingly, trying to cause a little trouble in Ike's newfound paradise.

"Doesn't matter as long as it is moved," Ike says firmly. "It is foolproof," he trumpets triumphantly. "Foolproof!"

"What does that make us?" Roger asks as he turns to me.

"I think it makes us fools." I respond with horror.

Ike is having nothing of this. He knows we are just trying to get his goat, or wheelbarrow in this case, and he will have none of it.

"Foolproof," he repeats. "Ah, what a great day."

Pages 170–171: On a lovely day in March, Roger dumps food for the yearlings.

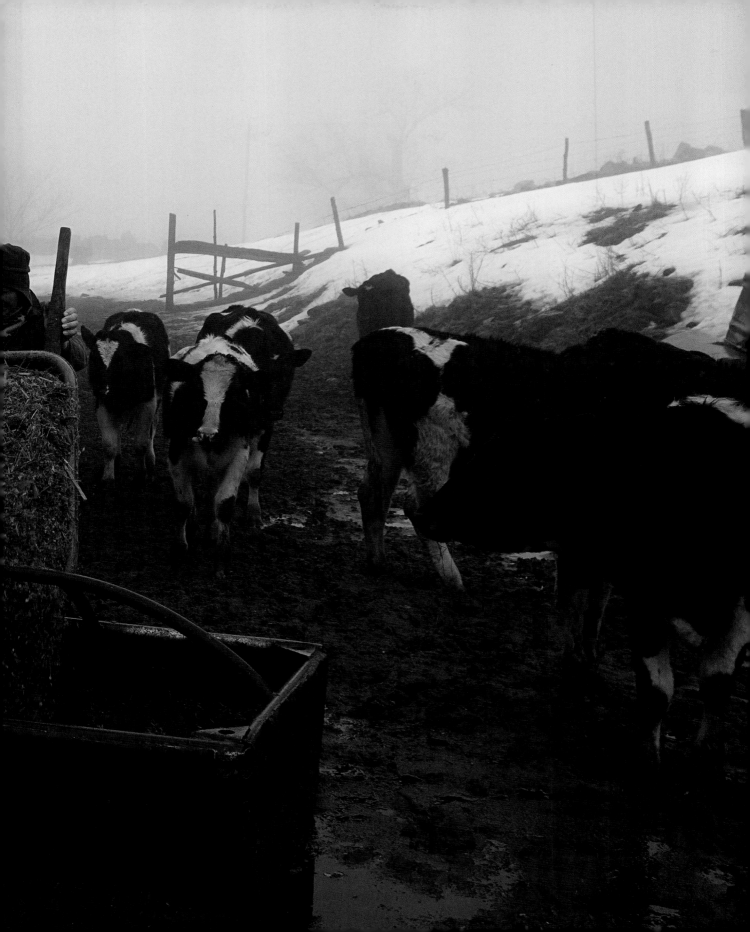

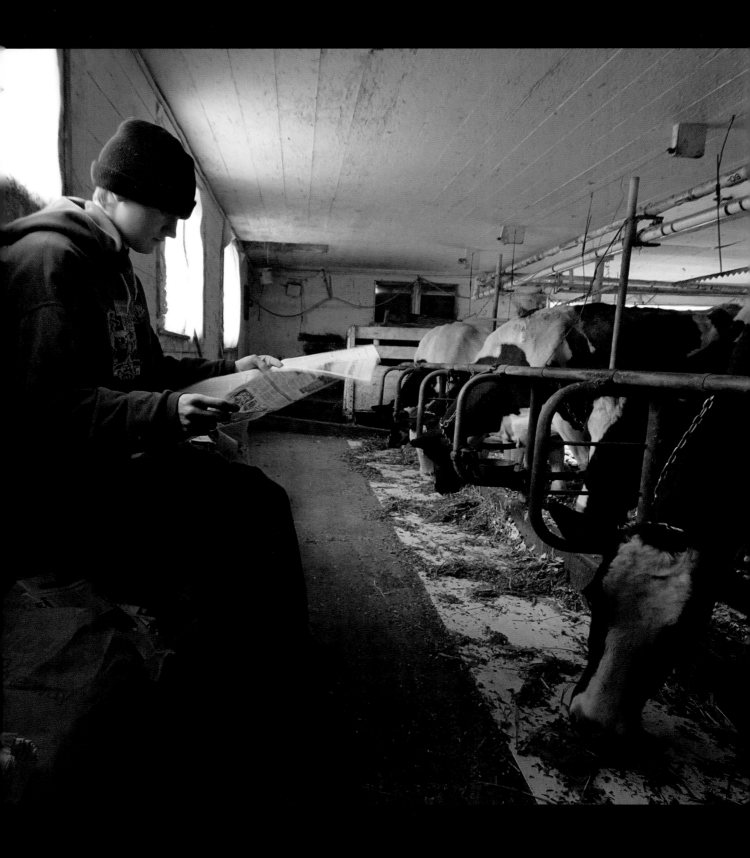

Trish in the barn

"So is this what it was like when I first started coming here?"

Roger straightens up between the two cows he is milking, pushes his cap back, and starts slowly shaking his head. His eyes, though, are in full glistening delight, and, with great drama, between not-so-quiet bursts of laughter, he places a hand on my shoulder, musters all the solemnity he can, which at the moment is precious little, and says in a voice thick with mock gravity, "Yes, yes it was."

We both laugh now, remembering the silly and unnecessary "chores" I did back when I first started coming to the barn. Back then, I did busywork in a working, busy barn. It wasn't that I didn't know any better. Well, okay, it was that I didn't know any better, but my ignorance was bolstered by my desire to be helpful or at least look helpful.

I suppose I could've just asked what needed to be done and then gone ahead and done it. But I didn't. I suppose I could've just watched quietly, or I could've amused myself exploring the old barn. But I didn't. I also couldn't just stand around taking pictures and watch Roger work.

I know photojournalists are supposed to keep their distance and not get involved in the story they are trying to tell, but I am not a photojournalist. I am a nature photographer, and nature photographers are not bright enough to know not to get involved. Besides, what better way to tell a story than to live the story?

So, I saw a broom and just started sweeping. Roger did give me a ten-second lecture on how to use the manure scraper ("It would've been five seconds if you hadn't been a college graduate!"), but I didn't have to attack so passionately every fresh pile of poop on impact. Nor did I have to push forward so enthusiastically whatever I had just pushed back and spread out what I had just piled up. I went around that barn like a toddler at a tea party—lots of commotion and nothing really getting done but with really stinky pants.

Ah, but those were heady days in the barn: heady, clean days. Sweeping and scraping were about the only things I was able to do that didn't involve constant monitoring by Roger, and so I did them with fervor. I swept corners that hadn't been swept in years, I swept behind tools that hadn't been swept behind in months, and I moved bags of I don't know what that hadn't ever been moved and swept behind them too. When I was done I swept again, and when I was done sweeping I scraped and then scraped again. With me around, this wasn't going to be just a cow barn!

No matter how remote the chance, the threat of burning the place down or getting myself killed prevented me from doing anything truly helpful. Still, the outside aisles have never been so free of chaff, and both cow pies and cobwebs trembled at my frequent, very frequent, passing. The barn hasn't been as spotless since.

Ike, the inventor of lollygag time, practicing his art.

Roger finds "help" like this quietly entertaining. He has good-naturedly suffered through many well-intentioned people coming to help him, from those who spend more time propped up on a shovel than pushing it to those who can't stop pushing it. Being a one-man dairy operation, Roger has honed his chore routine to such a fine, efficient edge that my earnestly eager antics in the barn didn't have a chance of being anything other than comical to him.

I also remember the quiet tolerance and patience with which my endeavors were received. Roger was always appreciative, even when my efforts made more work for him or got in the way of what he was trying to do. He never once wondered, at least out loud (or at least so I could hear), what it was that needed so much attention. For nine months Roger held in the fun of seeing me overly complicate the simplest tasks. It must have been a very long nine months for him.

As new skills were added to my repertoire, my chores slowly became useful and more involved and I had less time to fiddle away. Still, with each new task I always overdid the easily done, and each time Roger suffered in silence. I did eventually master the proper use of the broom and scraper, and today I am more judicious in my cleaning—sweeping and scraping just enough and no more. It is, after all, just a cow barn.

If I overdo jobs now—push up the feed more often than needed, reposition the wheelbarrow once again, respread the hay yet again—Roger will teasingly let me know it; "If you push that food around anymore, they'll never find it," he will say, or "If you sweep anymore, we are going to have to pour a new floor," or "If you walk down this aisle empty-handed anymore, someone is going to think you're getting married!"

Don't assume, though, that Roger is a tyrannical taskmaster when it comes to doing chores his way. He will show me how he does something and I will try to do it the same way, but I always miss the subtleties and end up with my own poor variation of his practiced technique. If my way is causing me more trouble than it should, he will come over and suggest a different approach, but he never demands it. "You could try it this way, but it is up to you. Do it however you want; it's your job," he will say. And he means it.

This is much different from how Roger was taught by his father and how Hugh was taught by his father and how Delos was taught by his father, Martin. There was no gentle guidance back then and no various ways to get something done. There was one way and one way only to do anything—the way it had always been done. "If my brothers and I didn't do it the right way we'd hear about it, all right. My father and grandfather were tough, no-nonsense men, but they had to be to survive. Something different was not something they were too interested in. If one way of doing something worked, there was no reason to do it any other way. Still is this way with the old man. He can be stiff as a board sometimes when it comes to new things."

Roger has tried hard to soften the grip of 150 years of doing things one way. In fact, he will deliberately do something different now just because it is different. He will tell you he does so to break up the routine, which I am sure is partly true. But he will also do things a new way because he knows his father is watching and he wants to give him something to think about. "See if I can bang a few boards loose on the old man!"

I'm not above this kind of gentle needling and Roger hasn't completely slipped the grasp of his rigid heritage.

"You might want to clean up the manger before you feed them their haylage," Roger tells me one morning as I am perched on the feed cart ready to feed. The manger is where fresh food is placed, and the uneaten hay is always cleaned up before any silage is fed the cows. Because. It is a direct line from Martin to Delos to Hugh to Roger.

"I was thinking that they would eat the leftovers up if I put some fresh food on top," I respond, and Roger, who may think or even know that this is the most foolish thing he has ever heard, will only say back to me, "Might work, why not? Give it a shot. You're not going to kill 'em . . . I don't think. We could use a few less cows around here, anyway." This is how I learn the right way to do my chores.

The one thing that never changes is that there are always more chores to do. You do a chore once, you finish it, and you move on to the next one. If you keep doing the same chore over again, the next one will never get done, and if it never gets done, you will never leave the barn. Pretty soon, you've burned up all the hours in a day and didn't get all your chores finished. A farmer who leaves chores unfinished is a farmer who eventually leaves farming.

When I started, Roger said nothing as I bumbled around, keeping his amusement to himself. Today, though, he has finally let the punch line out, and a laugh that has waited nine months to emerge is out and high-stepping around the barn.

What brought this all about was the presence of Trish, Roger's wife, in the barn.

"Good morning," Trish calls between snippets of a merry tune she is humming.

"Good morning, Trish. Do you have a day off today?"

"Yes, I do, and tomorrow too. Go ahead and ask me about Monday."

"Wha . . ." and before I can form a word Trish sings, "Monday too!"

"Today I am Ike. I gave him a day off. So I am here doing what Ike usually does. He said to just do what you say and I'll be fine."

Ike is Trish and Roger's middle son. He usually comes up to the barn around seven to help with the chores, but a day off and a chance to sleep in are not to be passed up.

"So what would you like me to do?"

Trish says this in such an enthusiastic voice that her attitude is infectious. This is remarkable because I seldom am awake enough at six o'clock to catch anything other than ten more minutes of sleep.

"Well, it will be a nice change to have a cheerful face in the barn for once," I say loudly enough for Roger to overhear. He obliges by coming over with a huge smile plastered across his stubbly face.

"If you are going to do what Ike usually does, you'll have to do it sitting on the pile of newspapers, reading," Roger teasingly responds.

"Don't you have some cows to milk?" I ask Roger.

"As a matter of fact, I do. Don't you have some chores to do?"

"We were just discussing that. We might go off and have some breakfast instead."

"Well, make me some too. I'll be right behind you."

Roger turns and heads back to his milking, satisfied he got to be a ham with a little ribbing on the side.

"Are you two always like this?" Trish asks through a fake scowl.

"Pretty much," I say.

"Well," her smile returning, "what do you want me to do?"

It is a bit silly for me to be telling Trish what needs to be done in the barn. Trish has worked in the barn for more than twenty years, and she is far more experienced and much more of an expert at chores than I will ever be. But she takes the tasks I give her gladly and goes about her jobs smiling and humming and happy not to be stuck in an office.

The catch is that as she does her jobs, she does other jobs she thinks also need to be done. Most of those jobs, though, are the ones I had just finished doing. The result is that Trish and I yo-yo around the barn repeating ourselves so many times it is as though the barn has suddenly developed a stutter.

This, of course, is not lost on Roger. Nothing in the barn is lost on Roger. He keeps an eye on everything in the barn, not obviously so but attentively so, and he tries to know what is up at all times. When Trish is there, he keeps an especially close eye out. He is not worried about her; he just likes to know where she is and what she is doing. This is partly because he wants to keep track of what he no longer needs to do, but also partly because he wants to be able to have fun with her whenever he can. Trish breaks up the everydayness of chores, and Roger welcomes the chance to play.

Trish also, unknowingly, breaks up the sequence of the chores that Roger and I have developed over all our early mornings. The timing of the chores is important because the start of one chore often depends on the finish of another. Our chores have become a three-hour dance routine of steps and

coinciding moves choreographed to get our jobs done and to stay out of each other's way.

Roger usually leads and I try not to get stepped on. The cows determine the flourishes and variations. The steps sometimes differ but the rhythms remain the same, set to the beat of an age-old way of life. I scrape the aisle while Roger takes bales out back. I spread hay while Roger starts milking. He cleans up in the milkroom while I feed haylage. I sweep up corn while he feeds grain. He finishes up while I read last month's paper.

Trish adds a syncopating beat to this rhythm, a welcome, cheerful diversion from the regular slow drumbeat of our morning routine. But she is playing jazz, improvising as she goes, and I can't figure out where she's heading. Every time I suggest a new chore to do, she has done it, at least once, already. "That's okay," she says, "it won't hurt if you do it again. I'm sure the cows won't mind."

The redundancy of it all is baffling but harmless, harmless but baffling, the redundancy of it all. I shake my head, befuddled but also amused, happy that Trish is dancing chores with us this morning.

Roger is peering through the legs of the cow he is milking, watching Trish give milk to the new calves, again.

I walk up to him and catch him grinning from ear to ear.

"What are you smiling about?" I ask him suspiciously.

"How many times do you think those calves are going to drink this morning?" Roger replies, knowing that "once" is the right answer, usually.

"At least twice, Roger, maybe more."

"And how many times are you guys going to push up the feed?"

"Well, at least twice, Roger, maybe more."

"When the old man gets here, it will probably be three times, maybe more!" Roger laughs, enjoying the happy chaos that our chores have become today.

Trish comes past carrying empty pails and smiles at us, happily doing her, and my, chores this morning.

"I'm going to the calf barn now," she proclaims, and we watch as she ducks out the milkroom door.

Roger turns back and asks, "Didn't you clean up the calf barn earlier this morning?" perfectly well knowing the answer.

"About twenty minutes ago. But I'm sure it needs it again by now."

"She'll be back soon, wanting to feed the calves some more."

"I think I'll push up, Roger, if that's okay."

"It's okay with me!" he says, chuckling, "and don't forget the calves!" ☙

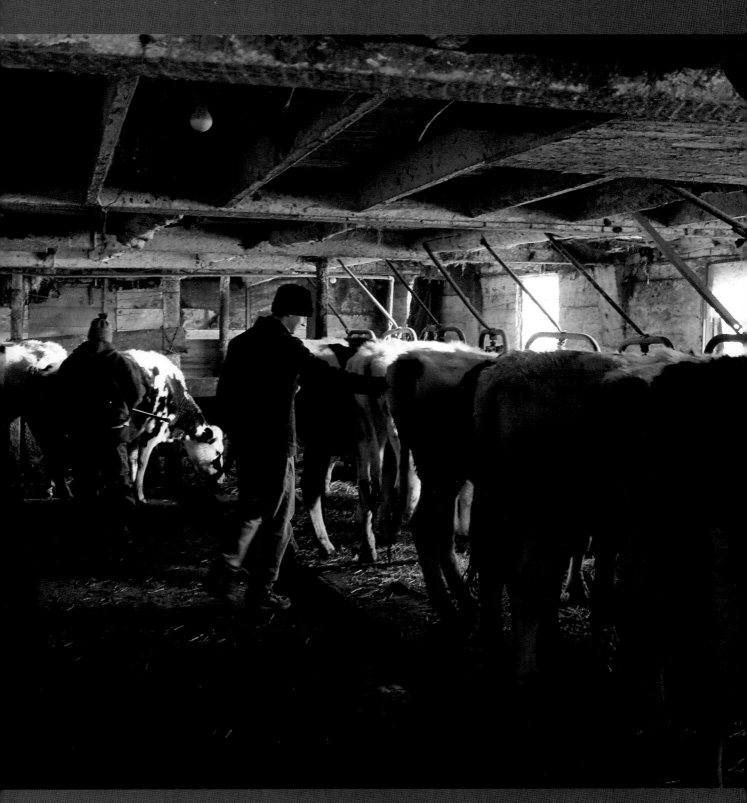

Trish and Ike sorting cows in the heifer barn.

Stepping out

"One of us is tired this morning, but one of us is really tired," I say to Roger as I walk into the milk barn at dawn. I find him standing in the manger leaning on a hayfork, oddly stationary for this time of the day, when there is so much to do.

"I know which one I am," Roger replies.

"When did you get back home?" I ask.

"Trish and I didn't get back until after midnight, but it was a good night, we really enjoyed ourselves."

"You worked all day and into the evening, you had a quick dinner and a clean up and then at nine-thirty you go out. I don't know how you do it."

"Oh, I'll be fine today and tonight, but tomorrow around midday, it'll hit me. I'll be good for nothing. When I'm moving it's not so bad, but as soon as I stop, that's when it hits me. I was moving last night though. It was fun."

There are only a few things that could get Roger out of the house at night. One is a calamity on the farm; that didn't happen. The other is dancing, contra dancing to be specific. It was the fourth Friday of the month, dance Friday, and Roger and Trish were out the door.

Contra dancing, also known as New England folk dancing, started in the seventeenth century in England as country dancing. It then migrated through France, where it picked up some steps from the dances of the French court—contredanse—and then sailed to the New World to settle in New England. Contra dancing became popular throughout the country in the mid-nineteenth century, but it soon lost favor to square dancing. Except, that is, in the stubborn states of northern New England where it has remained popular to this day. Vermont, New Hampshire, and Maine have never been good at following trends.

Contra dancing is like a folksy, overly friendly version of square dancing. In contra dancing couples face each other in two long lines and move through the line dancing with all the other couples until, at the end of the five- to ten-minute dance, each partner in a couple will have met every other dancer on the floor but ended up back with the one he or she started with. The music is live, usually Irish or Scottish or American jigs or reels, and the progression of each dance is "called" or choreographed by a dance caller. There are no costumes or stylized routines, single dancers are welcomed and encouraged, and laughter and gaiety are mandatory,

In Vermont folk dances have been as much a part of the fall, winter, and early spring seasons as harvest, splitting wood, and maple sugaring. And like these, dances are better done among the community with the help of others. In a time when darkness means the day is over and doors are locked, when families surrender to television or separate to their own

Behind the band at the Tinmouth Community Hall contra dance.

Roger and Trish contra dancing.

cyber companionship, dances bring people together. Perhaps it is the inherent isolation and hardness of winter, when roads are difficult and temperatures are forbidding, that force people to seek out the company of others to stay reasonably sane. Or perhaps it is just the dogged stubbornness of New Englanders who refuse to let a bit of a blizzard keep them from their pleasures. Whatever the reason, if it is the season, Roger will be dancing.

He comes by this honestly. "We used to go dancing all the time," Hugh tells me, his voice suddenly animated. "We'd dance in the basement of the church, at the Tinmouth dance hall on the pond, wherever we could. We used to walk a mile and a half down the road to the east and the people would clear out the bedrooms and we'd dance upstairs."

"When did you ever have time to dance? Your father was pretty strict, I hear."

"We'd leave the farm around eight-thirty after milking and start dancing around nine or nine-thirty. We'd finish at one and be back in the barn for milking at half past five. I was always here for milking."

"I bet you were. You still are."

"There was a German girl in town—Ooshee we called her—her real name was Ursula. She was a real nice woman and a helluva dancer. I'd meet her at the dance and soon enough her husband would get drunk. Then she and I would dance all night—we had a helluva good time."

Hugh doesn't dance anymore, at least not with his feet, but I am sure he still dances in his dreams, looking for Ooshee and space on the floor.

It's dance Friday and I go to out to see what this dancing is all about. I find Roger on the dance floor, washed, shaved, and beaming like a brand-new penny in a pocket full of old change. I can't remember if I have ever seen him without any hint of the farm on him. I daresay he looks normal, a dairy farmer in everyday camo.

The dance is held in the Tinmouth Community Center, a beautiful building with a hardwood gym floor and a portable stage at the far end for the caller and musicians. Two basketball rims and backboards hang from the walls, and there is a kitchen with iced tea, cider, cookies, and brownies clustered on the counter. There are no prices on any of the goodies, just the request for donations.

Most of the people seem to be locals dressed in blue jeans and baggy sweaters, the ladies in long, flowing skirts. Ages range from seven to seventy-five, and there are a surprising number of young folks, older teens who are doing something so uncool it is cool. Four musicians sit up front—a violin, a squeezebox, a mandolin, and a guitar—and the reels are rousing, the jigs joyous.

When I first watched a contra dance, it appeared more chaos than control, but with a little study it is not so hard to give focus to the blur of swirling bodies. If you watch the beginning of each dance, especially if there are lots of new dancers, the dance floor looks a bit like a demolition derby in socks and plaid shirts. But as the dancers learn the steps through the repetition of dances, the demolition aspect diminishes and a dazzling synchronicity rises so that the assembly appears to be more a single troupe than a gathering of individuals.

I take my first steps on the dance floor with Trish as my partner. I feel as out of place and conspicuous as I did my first morning in the milking barn. My steps are unsure, my apprehension extreme, my abilities diminished. I might as well be a linebacker at a quilting bee or a ballerina at a tractor pull. My partners, though, be they wary women now or cautious cows then, tolerate my missteps. In both cases I end up with my head spinning.

When done by experienced contra dancers, the matched movements of swings and passes of the ever-changing couples are mesmerizing. It is like watching many-colored human pinwheels of all shapes and sizes turning on the winds of reels. Some of the folks, especially the young ones, just follow their own muses—dancing dervishes—twisting and turning to a beat of their own making. But most are dedicated dancers, and they flow through the dances, the couples, the night with practiced ease.

Contra dancing is Roger's escape from the farm and his touchstone to the community. What I find interesting is that of all the outside groups he could've joined—snowmobile or motorcycle

clubs, Rotary, volunteer firemen—he chose not the familiar extension of his isolated existence but the opposite. And yet when I think about it, the ritualized patterns he traces on this hard gym floor are not that dissimilar from the ones he traces twice a day as he milks and goes about his chores. If you watch him milking—the shuffles, the turns, the working down the lines—it is a contra cow dance without the fiddle, squeezebox, and guitar. With age-old patterns he moves through the days, the seasons, the years—two steps, a twirl, a shuffle, and a glide.

Between dance sets, I head for the entrance on the way to my car and my bed. I am tired and I can think only of sleep. I stop at the door to look back at the dancers still on the floor. A slow waltz is being played, though most of the dancers are on the sidelines resting aching feet or getting a quick brownie or drink of cider. I see a half dozen couples out on the floor moving with patterned steps to an old squeezebox tune in the yellow light of the hall. Roger and Trish are among them, arms entwined, dancing to the music of times long ago.

I watch as they move around the floor, keeping time to their own rhythms, own ways, own love. It could be Hugh on the floor or even his father Delos—the tunes, the steps, the feelings the same. Soon enough a new dance will start and people will crowd back onto the floor, but for now I see only Roger and Trish alone, together. Two steps, a twirl, a shuffle, and a glide: turning together through the night, through the seasons, through the years. ❧

Two old sugar maples guarding the old corn field up top in late October.

34

The seasons

The beginning of a new season on the farm is so subtle and gradual that it is realized only when the previous one is long past. The old season is carried away on the receding waters of jobs completed as the new season is lifted and carried in on the rising waters of jobs now to be done. But where one seasonal tide ends and another begins is unmarked and unannounced. There is no ring of a bell or clap of thunder or mark on the calendar to declare a season's arrival. Nor is there one defining event that starts it off. The next season appears as an accumulation, a line of chores on a grassy shore that tells of a season once come and gone.

The first signs that late winter is fading and early spring has arrived are felt more than seen. One day, when the last cows are being milked in the morning, the barn door will be opened to let in the warming air, or in the middle of chores a jacket will come off and be hung by the door. Soon talk of yesterday's lows will be replaced by talk of tomorrow's highs, and a layer or two of clothing will be washed and put away for next year. This is early spring, or the Season to Prepare.

Late spring to early summer is marked by grass that greens and mud that dries, apples and plums and pears that blossom, and gardens that are cleaned, turned, and planted. Machines that mow and plow and plant are wheeled out and oiled, sharpened and examined; Roger mentally compiles a list of things

soon to go wrong and now to watch. This is the late spring to early summer, the Season to Grow.

Summer lives in the meadows where bobolinks dance and sing in the June sky, and the grassy empire rises thigh-high. Grass is everything now; it fills the days with endless cutting and baling, fills the mind with thoughts of barns to fill, and fills the shirts, socks, mouths, ears, and pockets with bits of green. Summer is circles, traced around and around every field, around and around from bale to barns, and around and around the endless days of baling. This is summer, the Season to Hay.

Autumn arrives with the bleat of a calf, but calves don't know calendars. They arrive when they are ready and mom has had enough. This is often in the middle of, well in the middle of everything—milking, supper, a pouring rain, the night, chopping corn. And then everything stops, or at least slows, until the calf is safe. Calves drink milk from the udder, then milk from a bottle, then milk from a pail, then milk from a bowl; and suddenly there are many. This is August and September. And probably October and November . . . and July . . . and December. This is the Season to Calve.

Winter arrives whether it is ignored or not. The ground freezes, the sky lowers, and wheelbarrows are filled with food and manure. There are piles to move inside and piles to plow outside. This is winter,

The main farm road in an April rain.

when both food and cows are inside and chores are done to keep warm. The barns are full; every space below full of cow, heifer, or calf and every space above towering with stacks and stacks of hay. This is the end of the year and the beginning of the year. This is the Season to Shovel.

In all, there are twenty-two months in a farming year; the seasons overlap so that many months contain two seasons at once. From year to year the days will change; the coming season waiting for fields to dry or corn to ripen or heifers to grow, but from year to year the seasons stay the same. It has been this way for lifetimes, for generations, for centuries. On the Bromley farm it will always be so. ✑

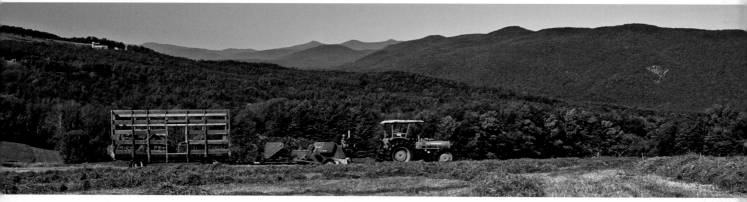

Haying the upper meadows, looking north over the Staples' farm.

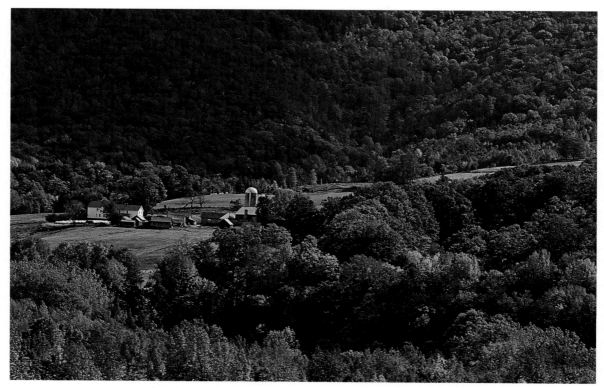

The view of the Bromleys' farm from the Staples' farm.

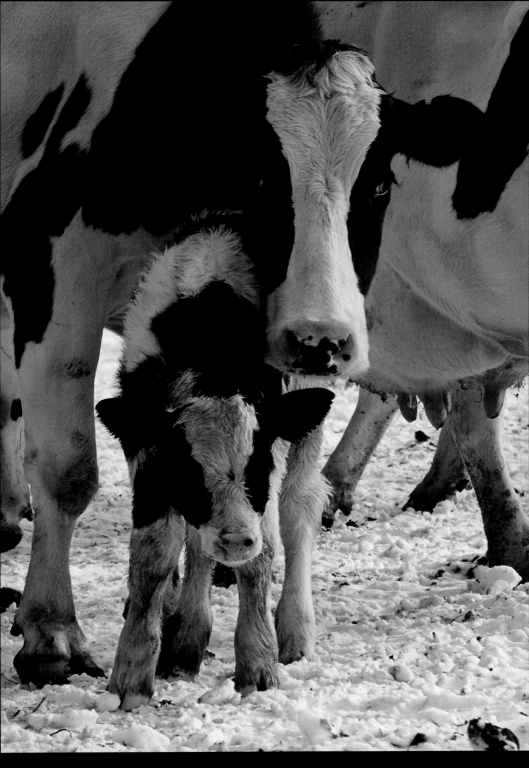

The first calf of the year, with Mom.

The se

Roger planting corn in his garden behind his house.

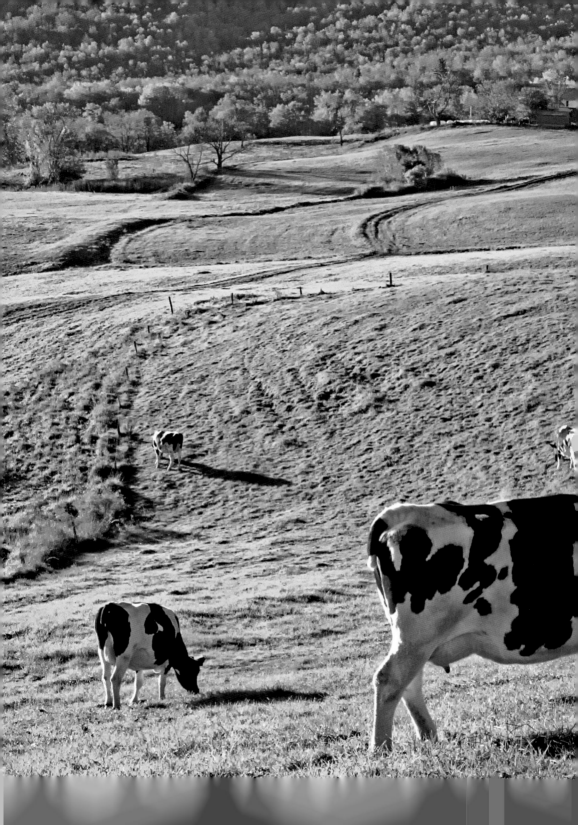

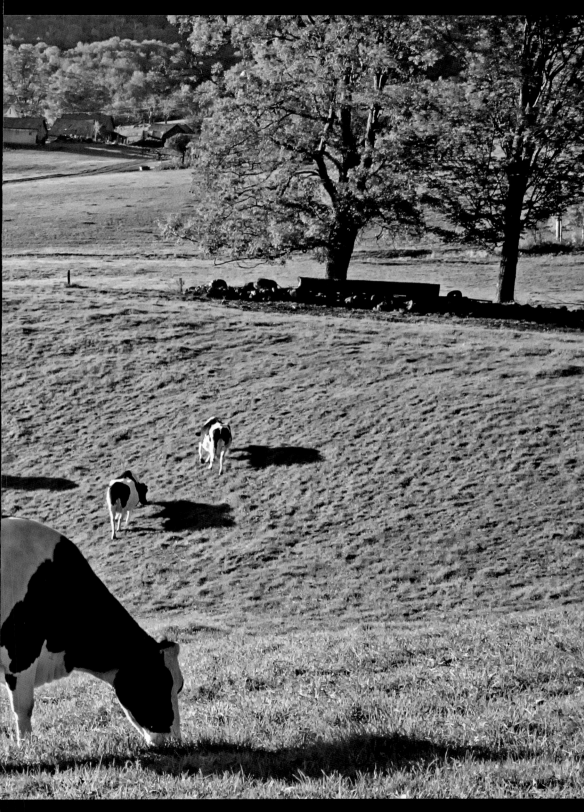

Looking up toward the barns on a fine October morning.

Afterword

Yes, the Bromley farm is still going strong, and, yes, I still go to the farm every day I am home. There is, just to be clear about it, no relation between the two.

The farm is doing well. Hugh is still going strong. He's ninety-four now, and he's still as set in his ways and as cantankerous as ever. But he is also still as generous and patient as he has ever been to me, thank God. He still cuts the first grass in June and spreads the last manure in November and lets the cows in the barn in the morning. He gets lonely at times in the big house now that Joan is gone, but there's a steady stream of people coming over for a visit and to help, so he is never alone for long.

Whenever I come back from being away, Hugh says the same two things to me when I first see him in the barn: "Where've you been?" and "I didn't think I'd be seeing you again, I've missed you." What a sweetie!

Roger is still doing most of the work on the farm and, as always, without a complaint. Help has a way of showing up whenever it is really needed, but most of the time it is Roger stepping through the seasons as he always has. Trish is ever smiling and singing little songs to herself; she remains indefatigably merry. She has a new granddaughter now, Mirabelle (Ben and Kim's second child), and she still comes up to the milking barn after supper to help finish the evening chores.

The boys come and go. Ben, the oldest, lives in Danby and comes up to do the milking whenever Roger is not going to be there and snowmobiles with his dad most weekends in winter. Ike is now in Utah with his steady girl, Jessica, taking classes and keeping busy while she completes a Ph.D. Rob came back from a tour of duty in Iraq and completed his nursing degree in Vermont. He is now in Los Angeles waiting for his steady girl, Ho, to complete her nursing degree. No one knows where the wind will blow Ike and Rob next, but no one is very worried either.

The farm is doing pretty well economically. Milk prices are down, as is the price of calves and heifers. The costs of grain and fuel remain high, but without any debt and New England thriftiness in the Bromley bones, the farm is surviving nicely. Lean times happen if you farm for 150 years, but better times always follow, according to Roger. I'm not going to argue with him.

I know you want to know what is going to happen to the farm in the future, and I will tell you what Roger tells everyone when he's asked: "Don't know." The entire farm is part of the Vermont Land Trust so it will never be developed and turned into houses and lawns, and it will remain a working farm for

as long as the Bromleys and the land trust survive. Roger doesn't talk about the future much because it is too speculative and too far down the road for him to think about. Roger and Trish want the boys to go out and find their own lives and have never put any pressure on any of them to come back to farm. Besides, Roger's got two or three decades of farming left in him. "Wouldn't know what else to do" is how he puts it.

Why do I still go to the farm? I tell people I go because there are still pictures to be found and stories to hear, and that is certainly the case. There will always be more pictures to find on the farm as the light and seasons conspire to present a kaleidoscope of images. And the stories will certainly never end, that I can assure you. Roger, Trish, and Hugh still surprise me with farm tales I have never heard, each one as crazy and delightful and, well . . . Bromleyesque as the last. And, yes, I am still right smack in the middle in many of them. Things have a way of being slow to change on the Bromley farm.

I also tell people that I go because I like getting up early and doing a few hours of honest work before most people have even had their coffee. The rest of my day may be a disaster, but at least I've gotten something accomplished and contributed in a small

way to the greater good of the farm. Now, Roger may have a different opinion, but that is his story and I am keeping to mine.

I also like, no, am proud to be associated with the farm. The fine folks of Danby often ask me how things are going "up on the hill"; Are there any new calves? How is Hugh feeling? Has Roger been snowmobiling yet? Have you started haying yet? It's this kind of question, when a person thinks of me as part of the farm operation, that makes me the proudest and happiest. I don't deserve such credit, but I accept it gladly.

All these reasons are true, but the real reason I still go to the farm is that I have fallen in love with the place—the fields, the barns, the views, everything about it—and I adore the Bromleys. Wonderfully, I have become part of their family; Roger is a brother to me, Trish a little sister, and Hugh a granddad. I am at a loss for words to describe how important and meaningful this is to me.

In truth, I can't not go to the farm. My life is so much richer, so much better with the Bromleys by my side, and the perfume of the farm, all parts, is intoxicating to me. My health has never been better, my heart never more full, and my soul never more content. I have found the farmer in me and I couldn't be happier. ✑

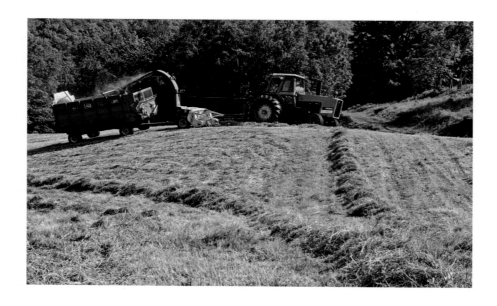

Afterword · 197

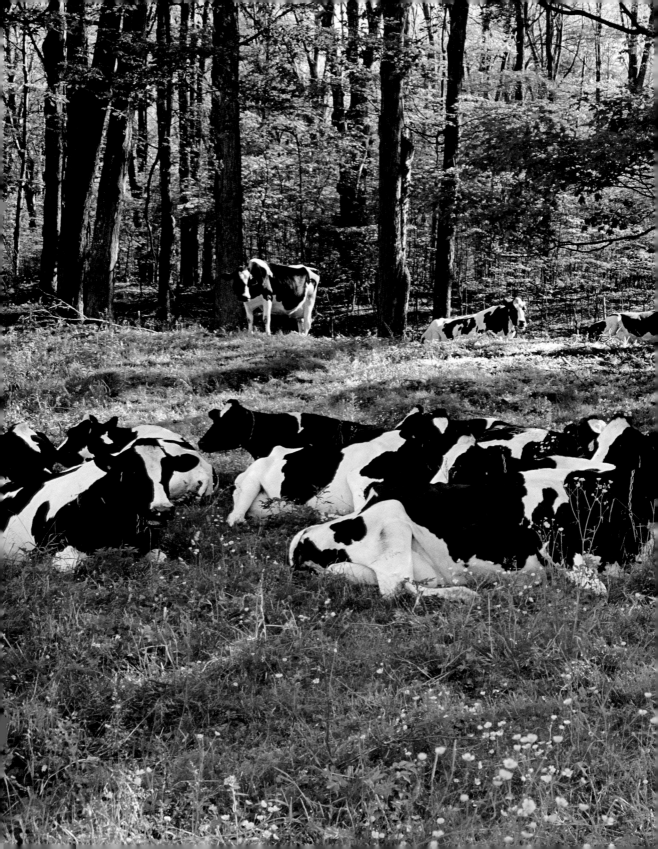

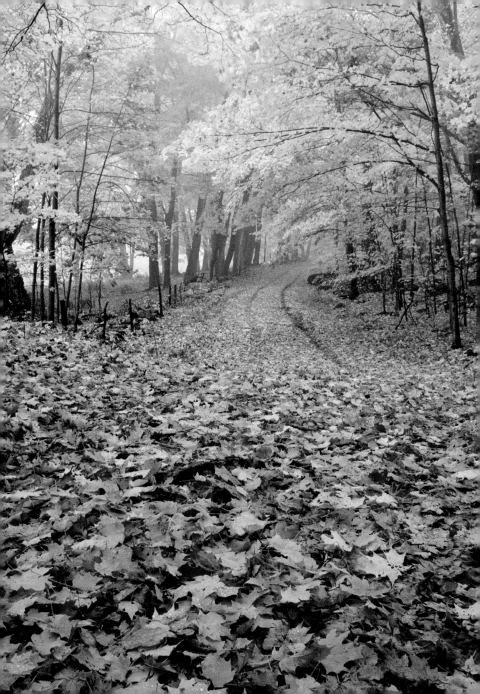